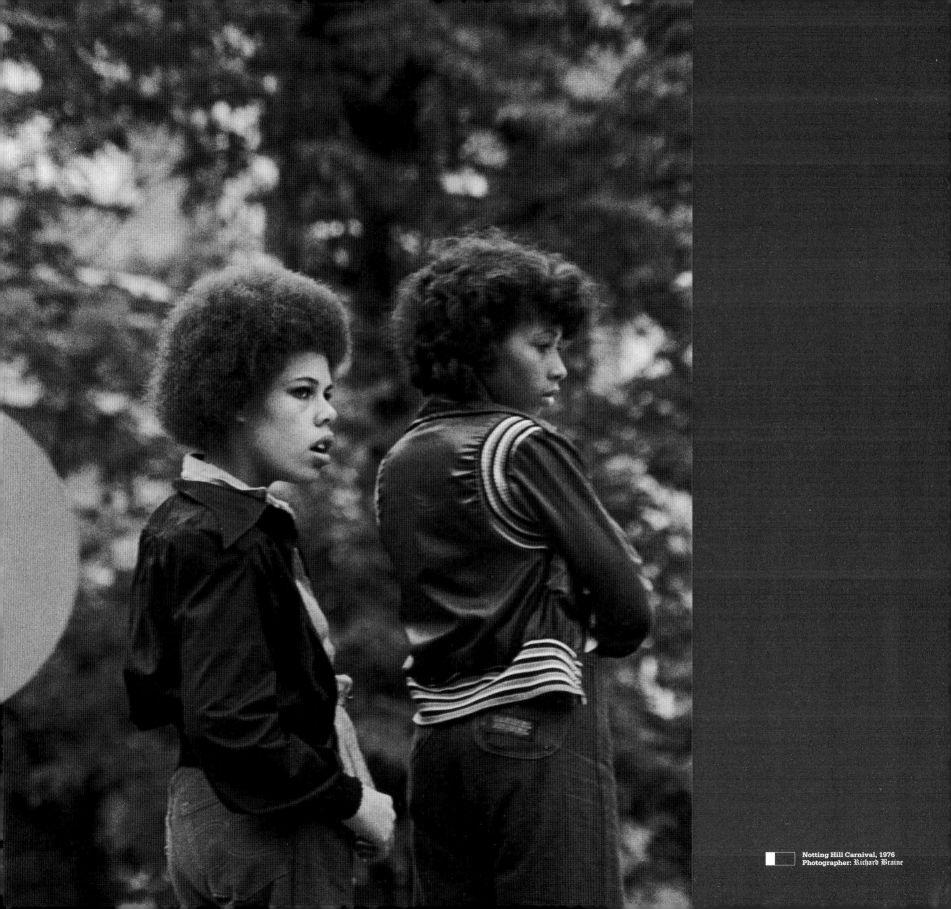

Foreword

Steve and Jake at PYMCA

Seen came about because we had amassed a
wealth of unseen photos, taken by both known
and unknown photographers, documenting the
lives of black British subcultures over the last four
decades. We realised that there were few books
on such an important subject, so we felt honour
bound to get one published.

All youth subcultures are criminally under
represented, considering that they are such
a massively important phenomena. The people
in these photos influence everything from
fashion and design to music and advertising.
But, they are rarely given the recognition
they deserve. What are often seen as passing
fads can become nationally, and in some cases,
internationally influential movements, which
bubble up from the clubs and streets to
reinvent the mainsteam.

EkowEshun

The girl with the copper-coloured hair and the golden-brown skin blows a kiss to the camera. The two teenage boys beside her are stripped to the waist to show off their heavily-toned pectorals and the thick gold chains hanging from their necks. Outside a Job Centre a line of men queue patiently, displaying a spry, quotidian elegance; especially the Rude Boy second from the front in the pork pie hat, sunglasses and Fred Perry; for him dignity is a pair of well-pressed trousers. A skateboarder practises tricks in the concrete bowl of an urban roundabout. Silhouetted in the dying glow of a sunset his afro becomes, for a brief instant, a halo.

There is nothing remarkable about any of these scenes. Walk down the street or go to a club and you'll see a hundred similar incidents. Adolescent flirtations, stiff-backed attempts to retain self-respect, games being played in the last of the sunlight. Indeed, what's special about these, and the rest of the moments in this book is their very ordinariness. Seen is a visual record of the style and fashions of young black Britons, born and raised in this country from the 60s and 70s onwards. Unlike many of our parents, we didn't arrive here suitcase in hand, wearing our Sunday best and shivering against the cold. Our relationship with Britain is more intimate and less formal than theirs. We know the possibilities this country holds. And we know its prejudices too. Yet Seen isn't an attempt to create some kind of official history of black style and youth culture. Neither is it trying to redress negative representations of black people with images of smiling, happy unity. To put it another way, this is not a whitewash. Seen is about who we are, not who we should be.

This is also a book that tell us somthing about Britain itself, and the way that black culture has moved from the margins of mainstream society to occupy its very centre. Although the photos shown here aren't chronologically ordered you can still see how things have changed. It's clear in the difference between the wary glances outside the Job Centre, circa the early 1980s, and the images from the late 90s and 2000s. UK Garage is the soundtrack of young Britain. The sexy girls and sharply dressed boys run tings.

I'm not suggesting by this that it's time to get the bunting out and start passing round the party hats. Racism hasn't died out in this country just because the nation's youth show an enthusiastic preference for Moschino jeans and Genius Cru. After all, this is still the country where Stephen Lawrence and Damilola Taylor were murdered; where each year 20,000 people suffer racist assaults and over 200,000 experience racial abuse or insults. But Britain is a different place today to the nation that once laughed so heartily at the "Black and White Minstrel Show" on TV and, in

Many of the photos in Seen are shot at night. They're pictures of Dreads and Soul Boys, Ravers and B-boys, Two Step crews, transvestites and gangs of girls in tight tops and spray-on skirts. By dark, it seems, we are all exhibitionists. Yet just as revealing are the pictures taken by day. They suggest more complex realities beyond the simple unifying pleasures of music and dance.

A group of teenage Skinheads in knee-high DMs and flight jackets lean against a wall. Among them is a black kid, hands shoved deep into his jeans, dressed identically to his friends and indistinguishable from them in all but one crucial way. A gang of leather-clad Bikers line their high-powered 750cc motorcycles up against the side of the road. Only when they remove their helmets is it apparent that they're all black. In a hairdressing salon, a girl with elaborately teased and coloured hair waits to surrender yet more of her time to the stylist's ministrations. It's as if she has carefully weighed up an equation where

x = boredom of waiting, and y = necessity of regular visits to the hairdresser so as to maintain upkeep of hair, and found that neither x nor y is greater than z, which stands for the amount of pleasure gained by possessing a head-turning, eye-popping, truly stand-out hair style.

As such pictures show, the choices we make over how we look or who we mix with aren't incidental. Style matters; and not simply because everyone in their own way likes to look good, but rather as a consequence of the double bind black people have discovered comes with living in a predominantly white country.

As a member of a minority each of us stands out when we walk down the street. Yet at the same time, mainstream society often prefers to see us as part of an amorphous community rather than as individuals. We are both visible and invisible. Under those circumstances, riding with a Biker gang, spending hours at the hairdresser's or choosing to become a Skinhead are important statements of self-identity. They're about

So the photos in this book are as much to do with what separates black people in Britain as what we have in common. Each image is an assertion of individuality, and each offers a different, sometimes contradictory, version of what it means to assert our own style, while growing up black in Britain. Collectively they amount to a portrait of a culture in constant motion, full of differences, which rather than divide us, draw us closer together. And although these images have been taken over four decades, they're of lives being played out in the present; not because anyone wants to flee the past or is fearful of the future, but because they're trying to express themselves each day to the full. This is no history book then. How could it be, when each photo lasts forever.

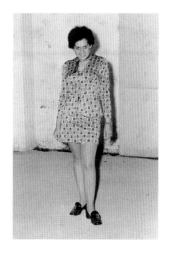
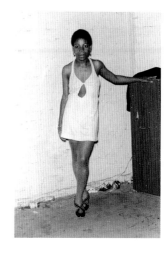
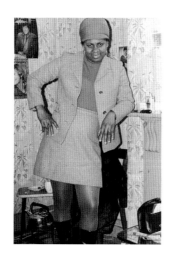
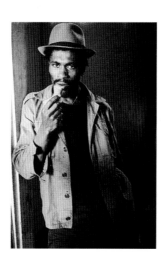
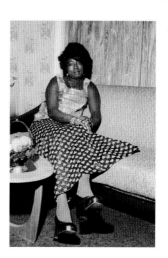

South London, 1998
Photographer: Adrian Wood

The Blackhouse, Manchester, 1973
Photographer: Dennis Morris

The Blackhouse, Manchester, 1973
Photographer: Dennis Morris

Hackney, circa 1974
Photographer: Dennis Morris

West London, 1977
Photographer: Dennis Morris

Dalston, 1976
Photographer: Dennis Morris

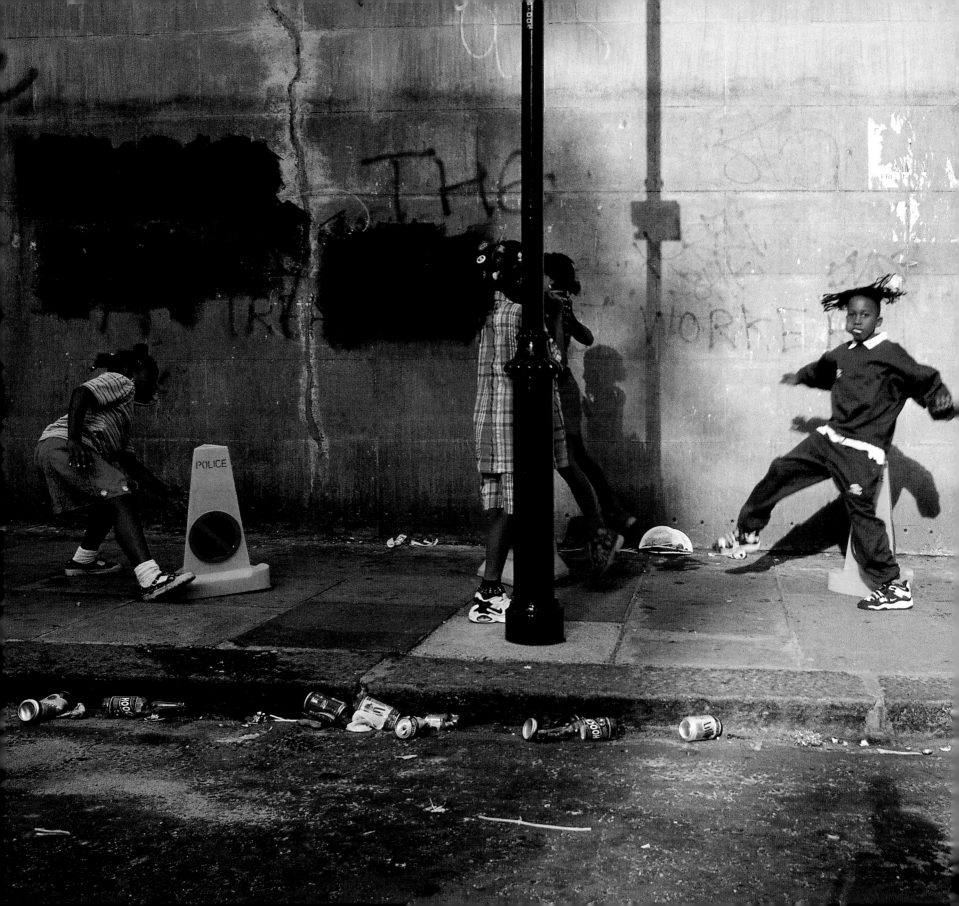

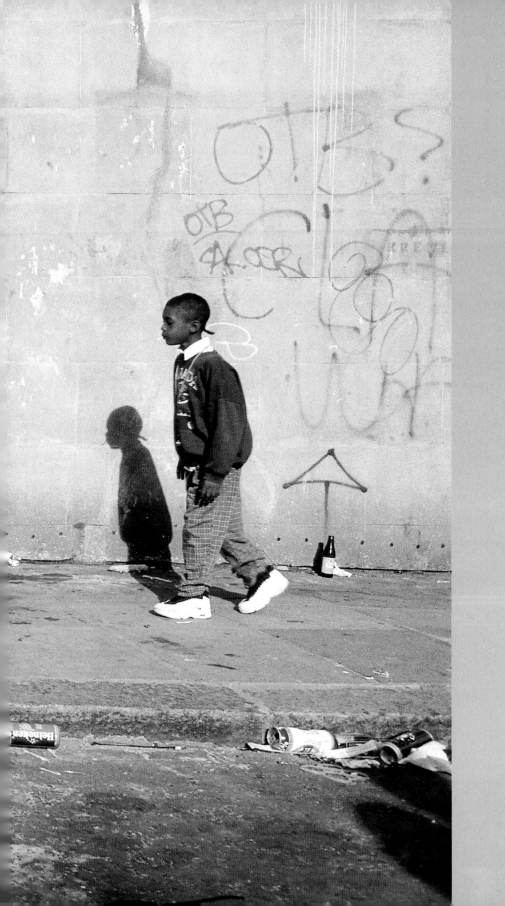

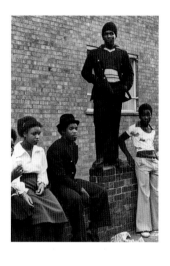 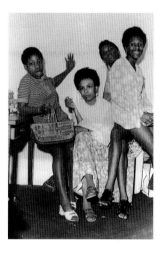 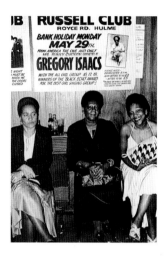

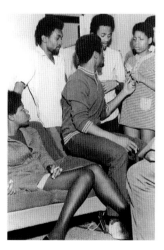 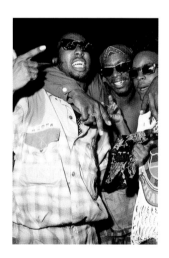 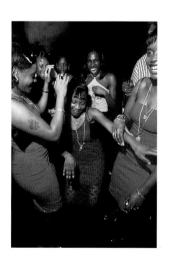

Notting Hill Carnival, 1975
Photographer: Richard Braine

The Blackhouse, Manchester, 1973
Photographer: Dennis Morris

Russell Club, Hulme, 1975
Photographer: Dennis Morris

The Blackhouse, Manchester, 1973
Photographer: Dennis Morris

Slow Motion @ Maximus, London, 1991
Photographer: David Swindells

Twice As Nice @ The End, London, 2000
Photographer: David Swindells

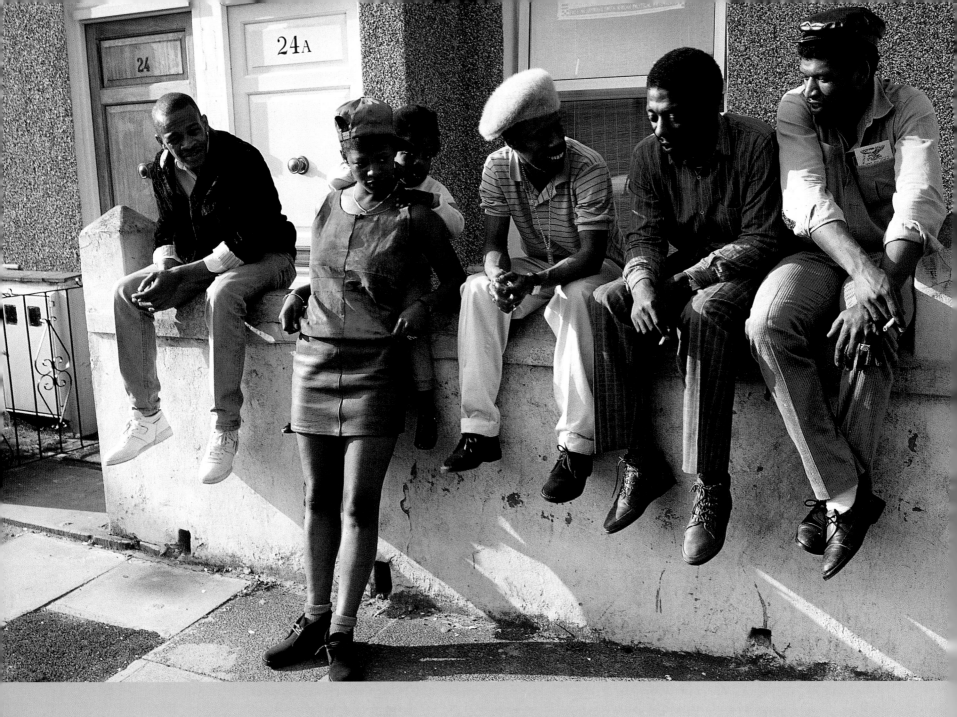

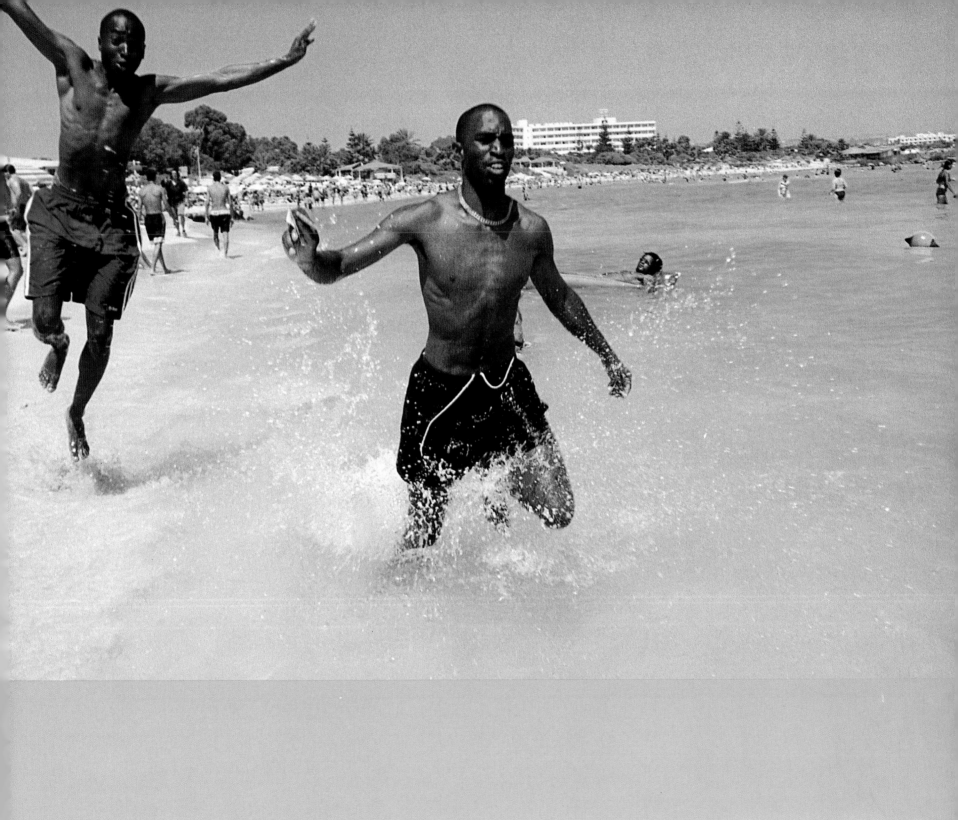

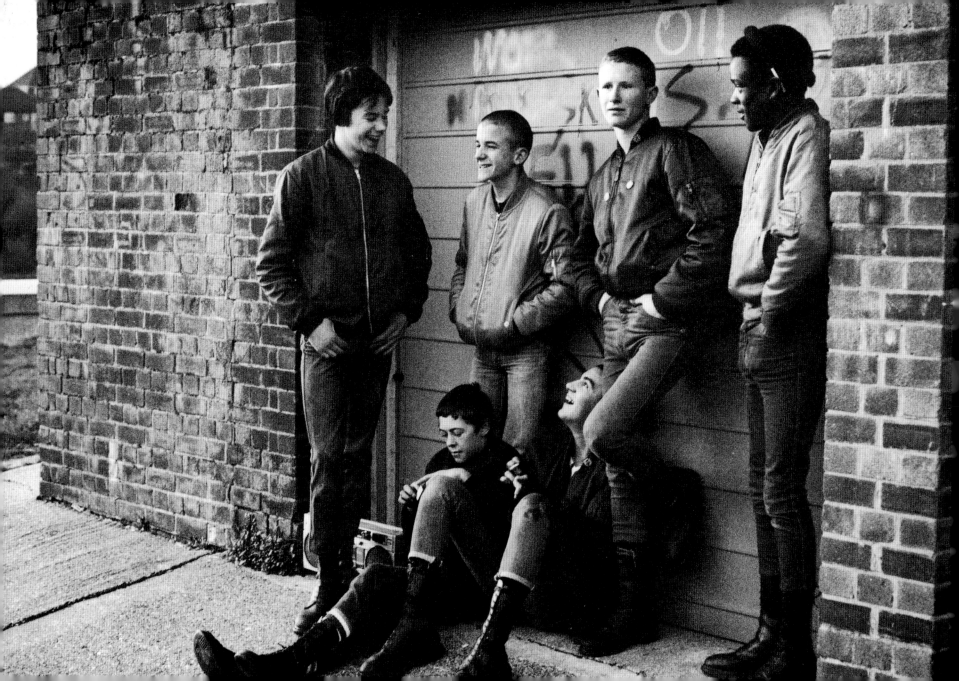

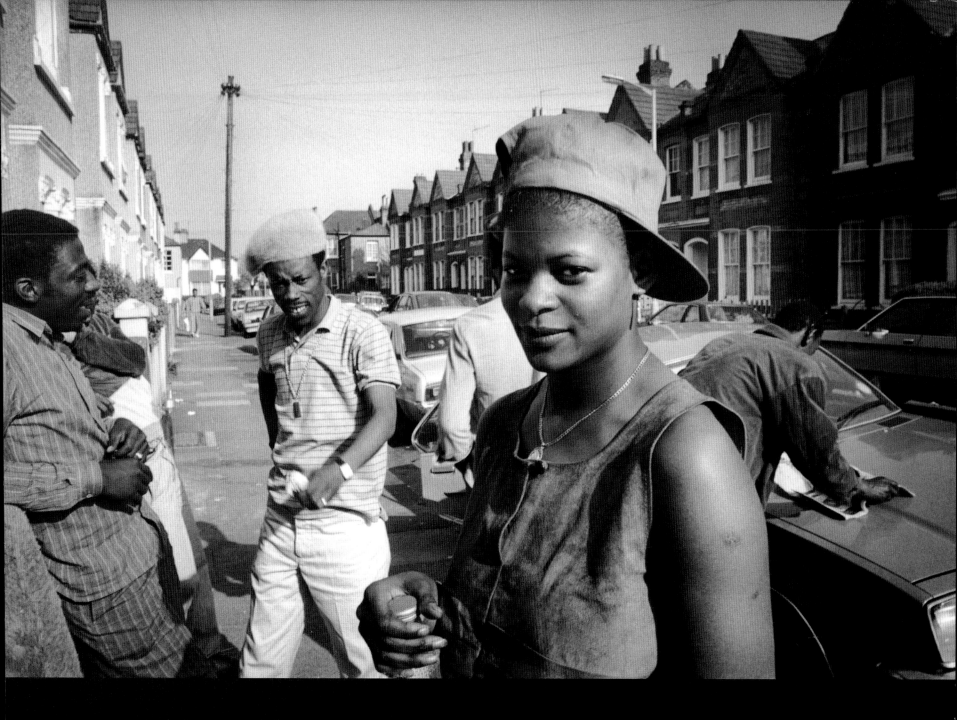

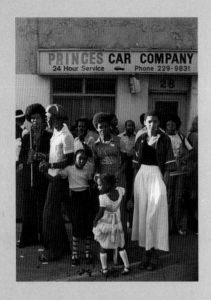

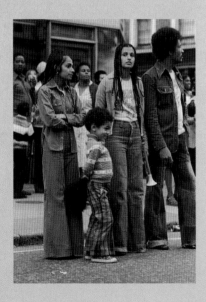

Notting Hill Carnival, 1975
Photographer: Richard Braine

Notting Hill Carnival, 1976
Photographer: Richard Braine

Notting Hill Carnival, 1976
Photographer: Richard Braine

Notting Hill Carnival, 1975
Photographer: Richard Braine

Notting Hill Carnival, 1976
Photographer: Richard Braine

Notting Hill Carnival, 1976
Photographer: Richard Braine

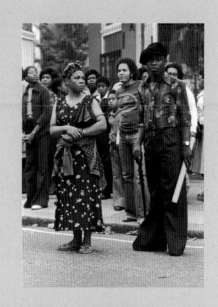
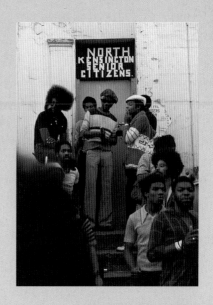
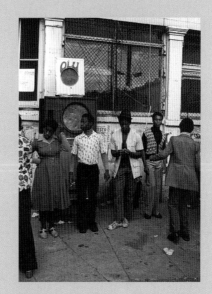
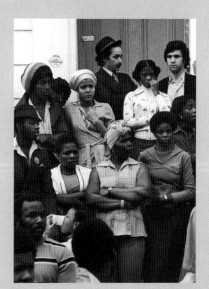

Raid, The Specials, 1980
Photographer: Jill Furmanovsky

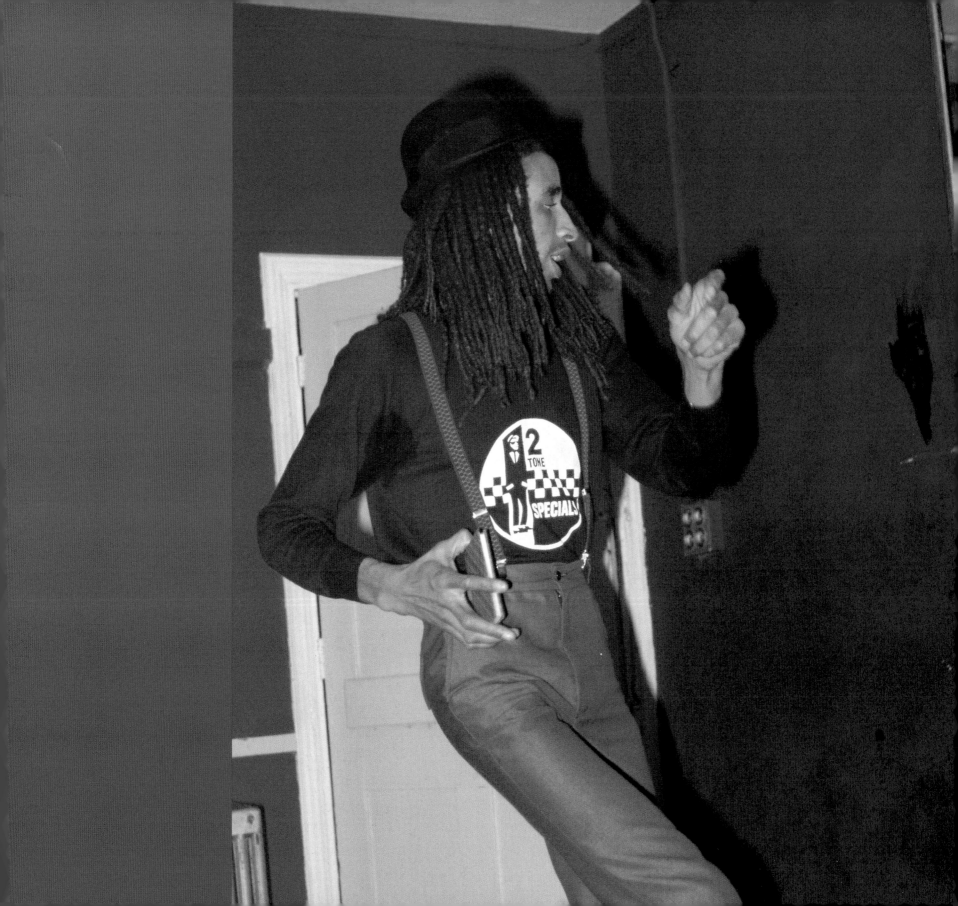

Brixton, 1998
Photographer: Liz Johnson-Artur

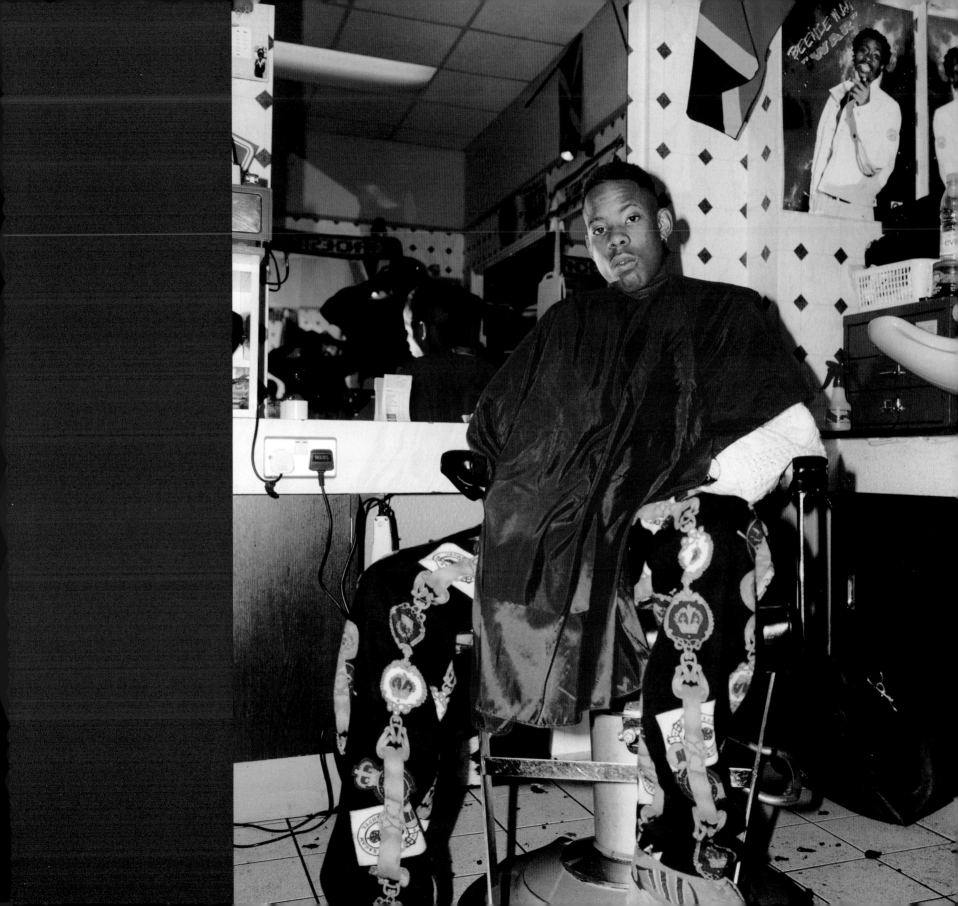

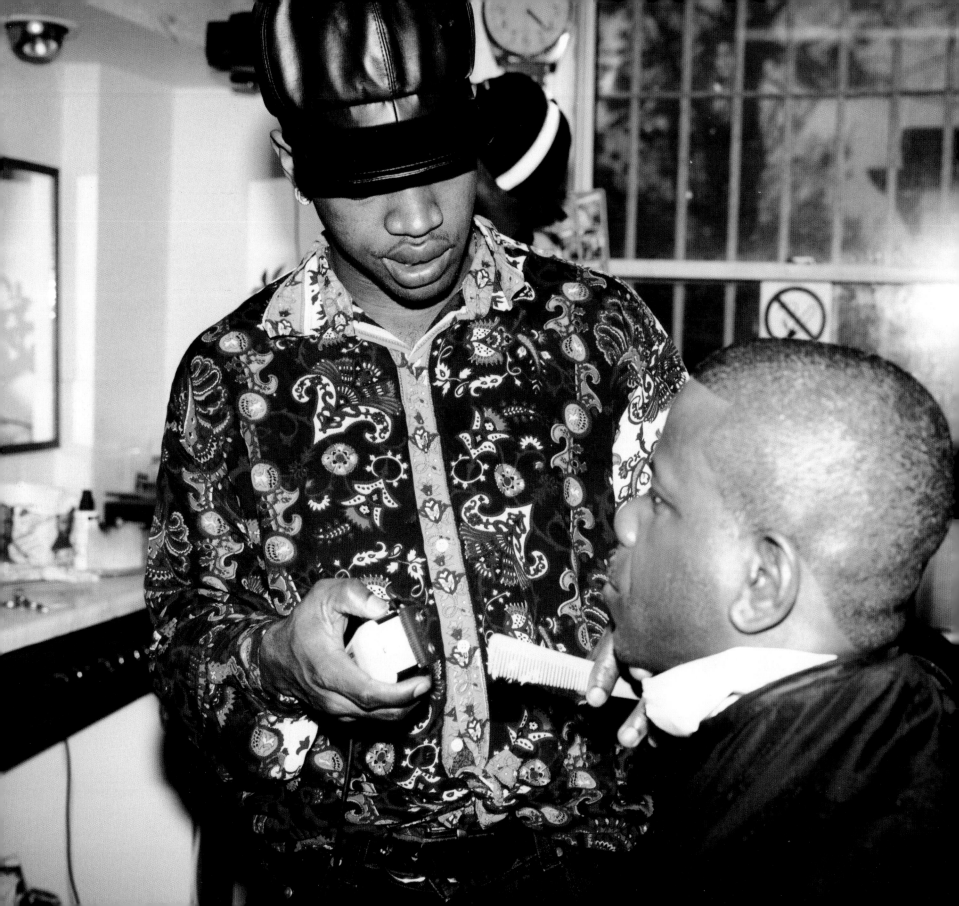

Lewisham, 1997
Photographer: Liz Johnson-Artur

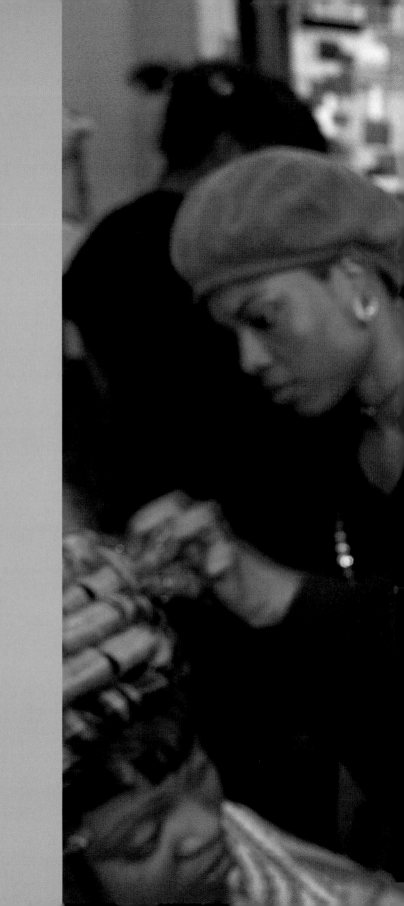

Dalston, 1995
Photographer: Des Willie

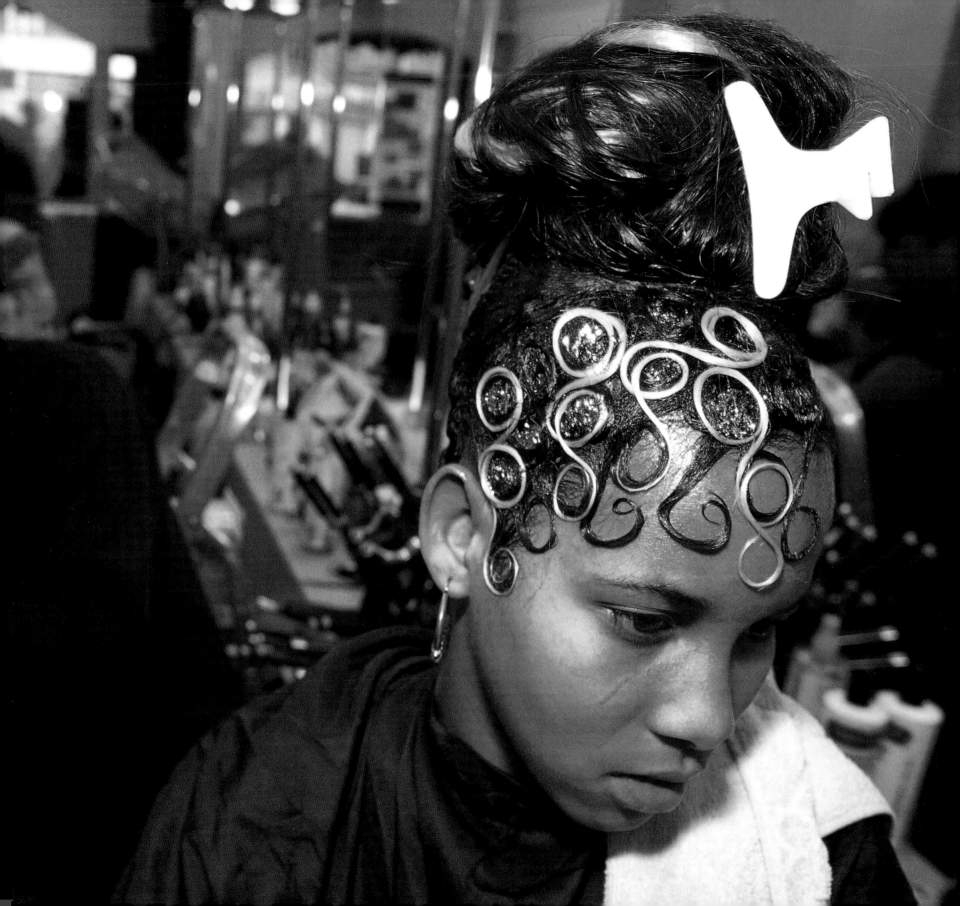

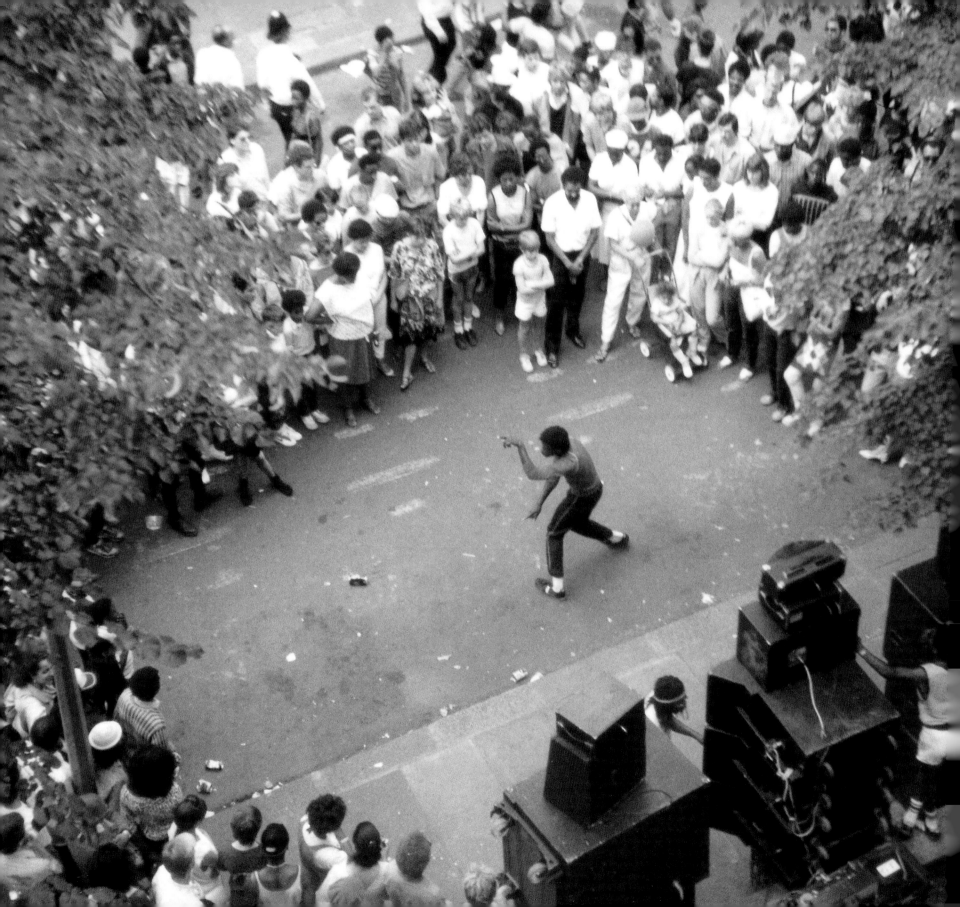

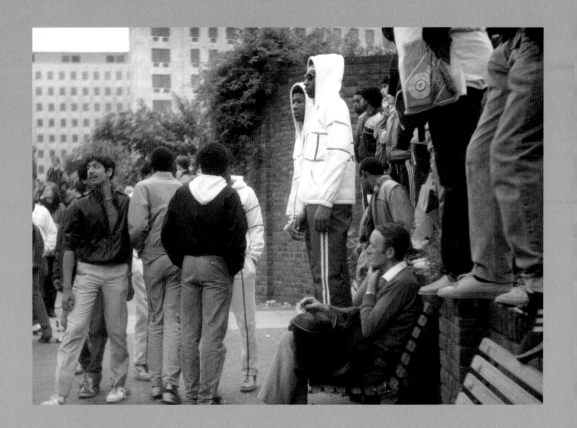

Good Times, Notting Hill Carnival, 1984
Photographer: Steve Caesar

Southbank, London, 1983
Photographer: Steve Caesar

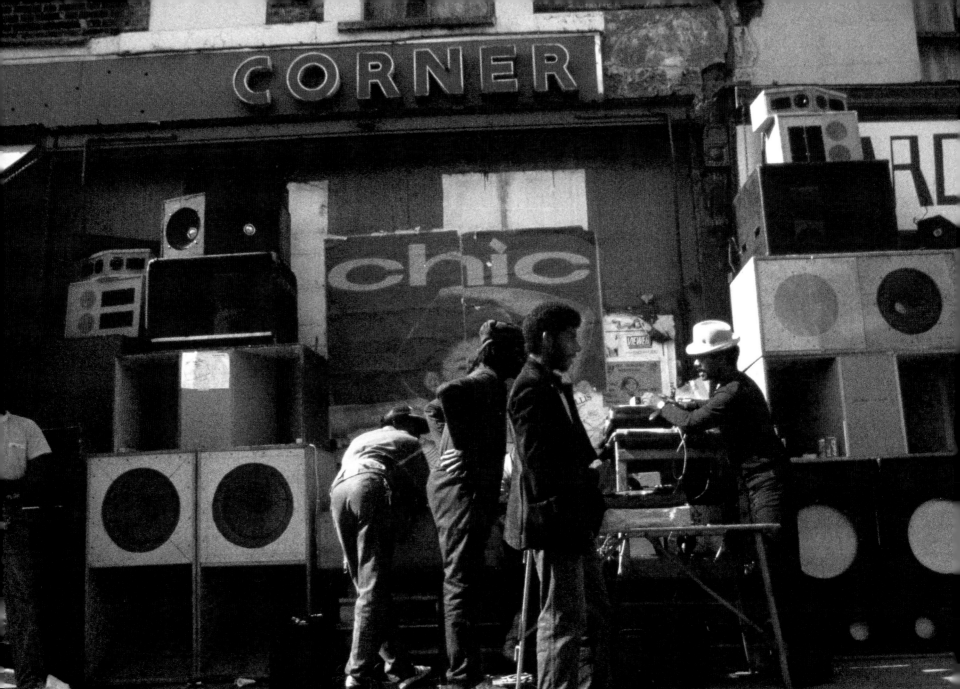

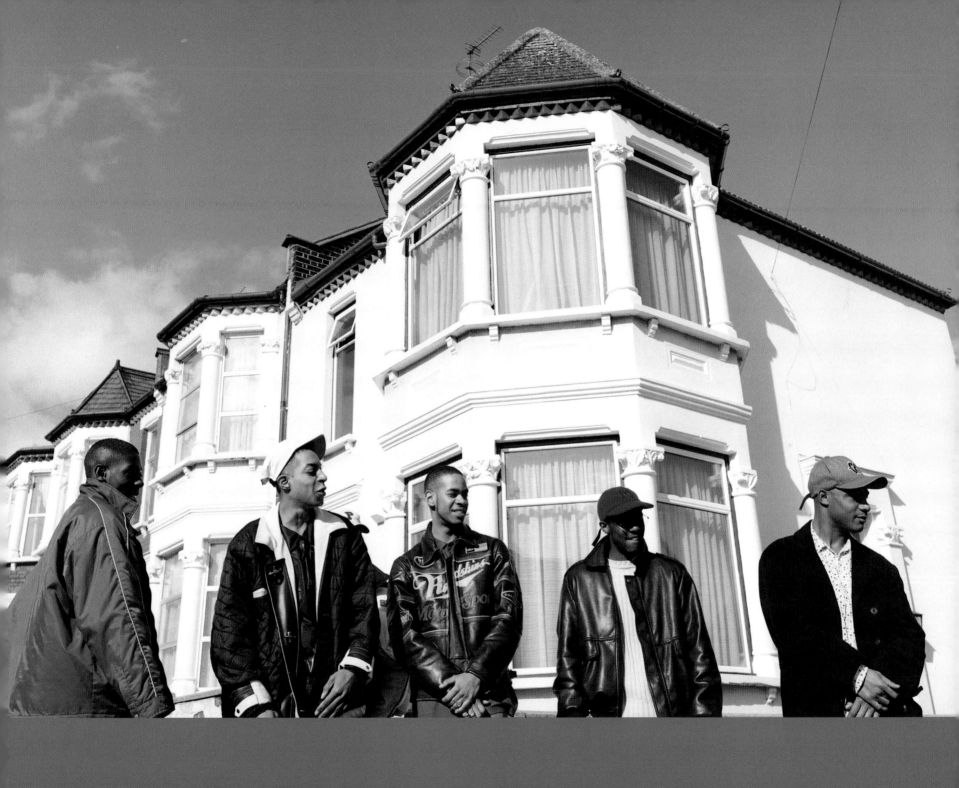

Notting Hill Carnival, 1986
Photographer: Normski

Slice A Life, Harlesden, 1998
Photographer: Paul Donohue

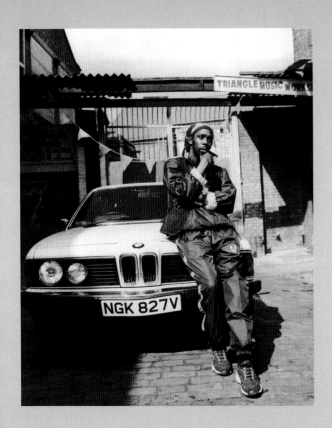

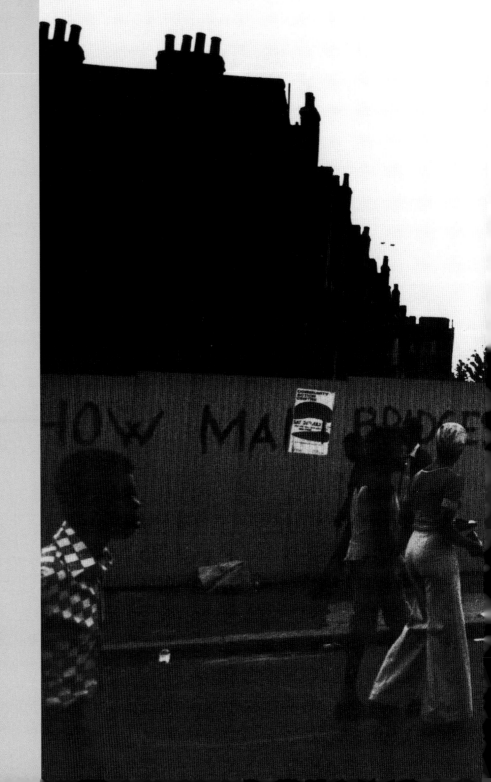

Triangle Studios, Stoke Newington, circa 1997
Photographer: Liz Johnson-Artur

Notting Hill Carnival, 1973
Photographer: Richard Braine

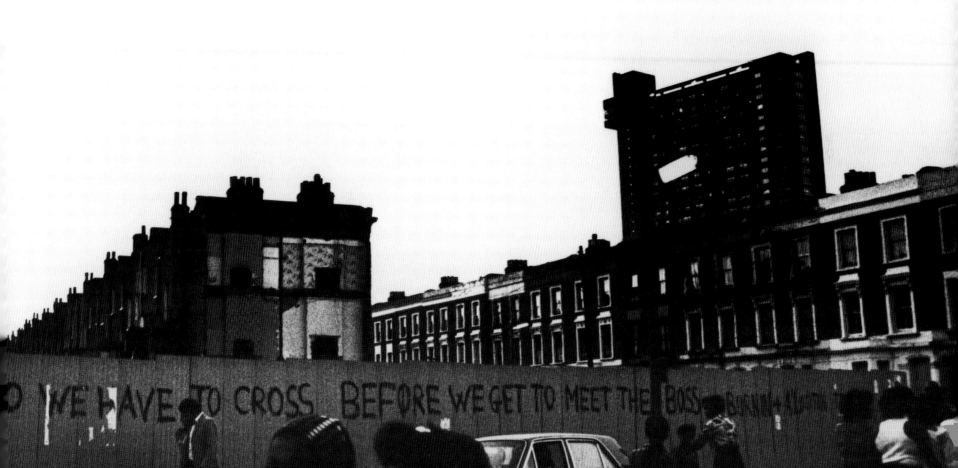

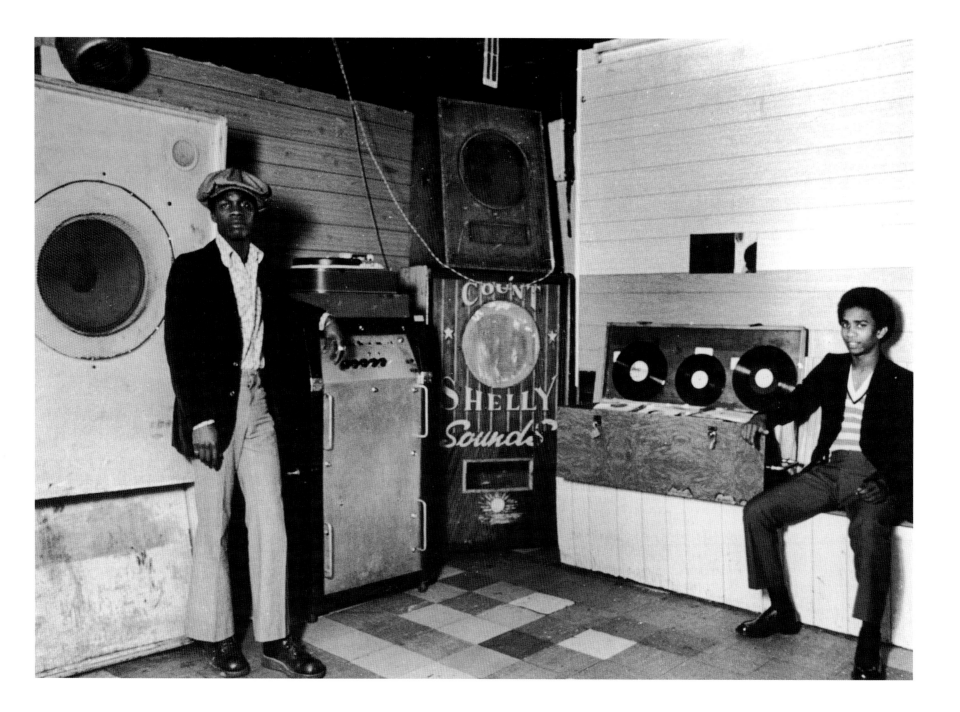

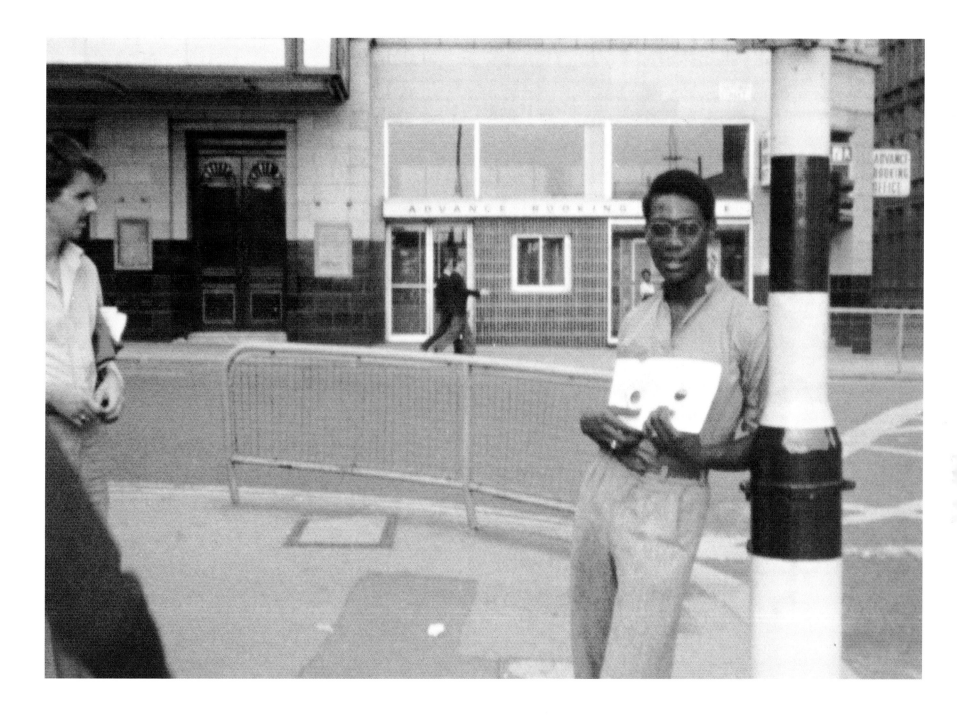

4 Aces, Dalston, 1973
Photographer: Dennis Morris

Whitworth Street, Manchester, 1976
Photographer: Steve Caesar

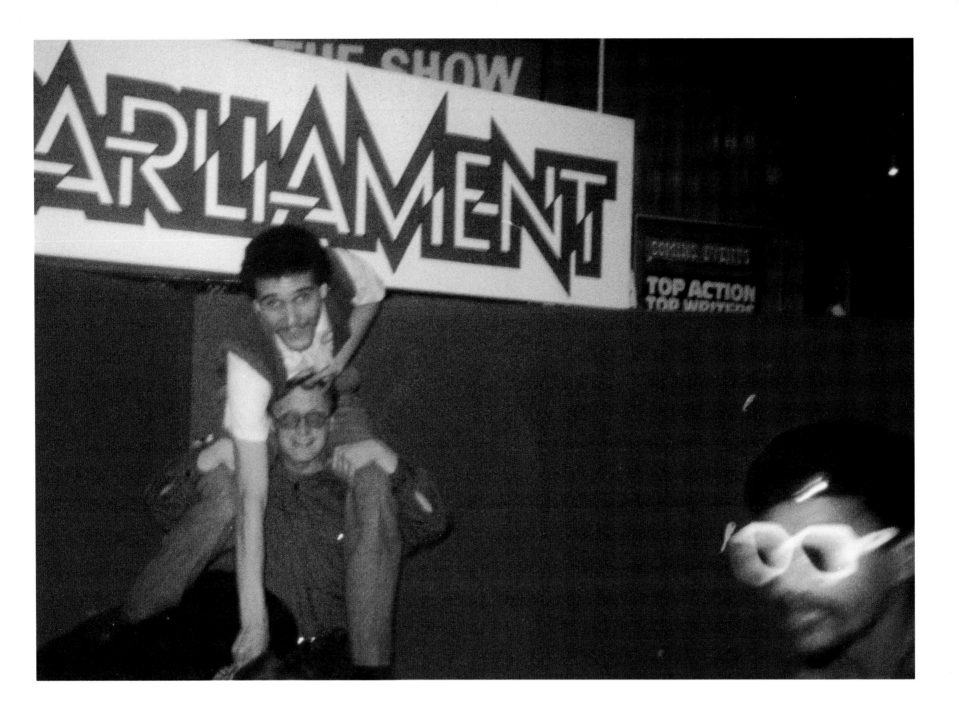

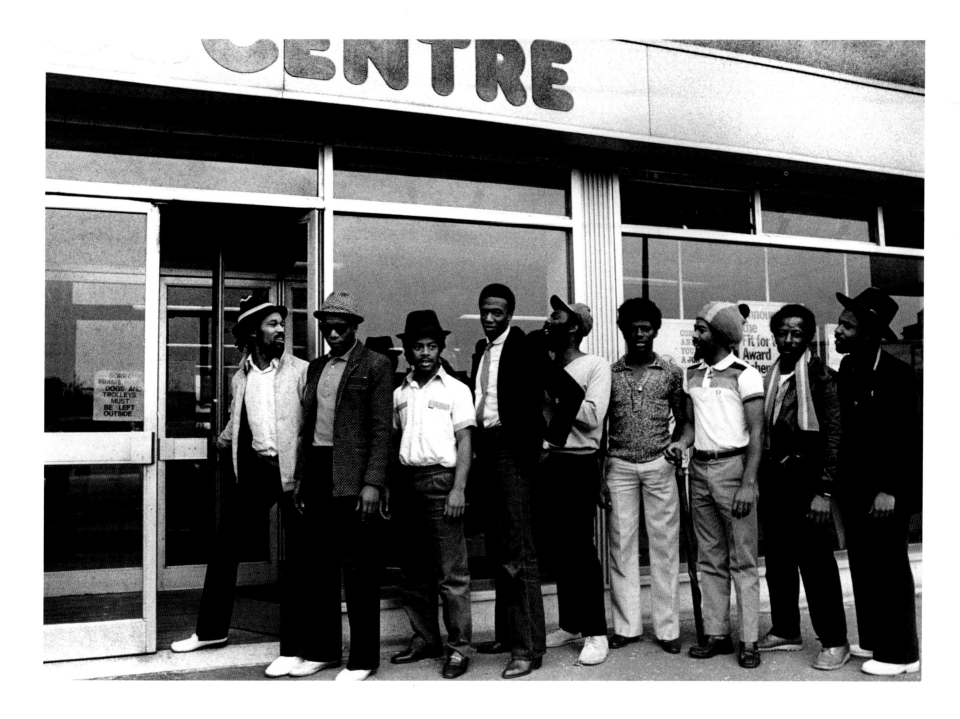

Parliament/Funkadelic, Manchester, 1977
Photographer: Steve Caesar

Matumbi, Brixton Job Centre, early 1980s
Photographer: Adrian Boot

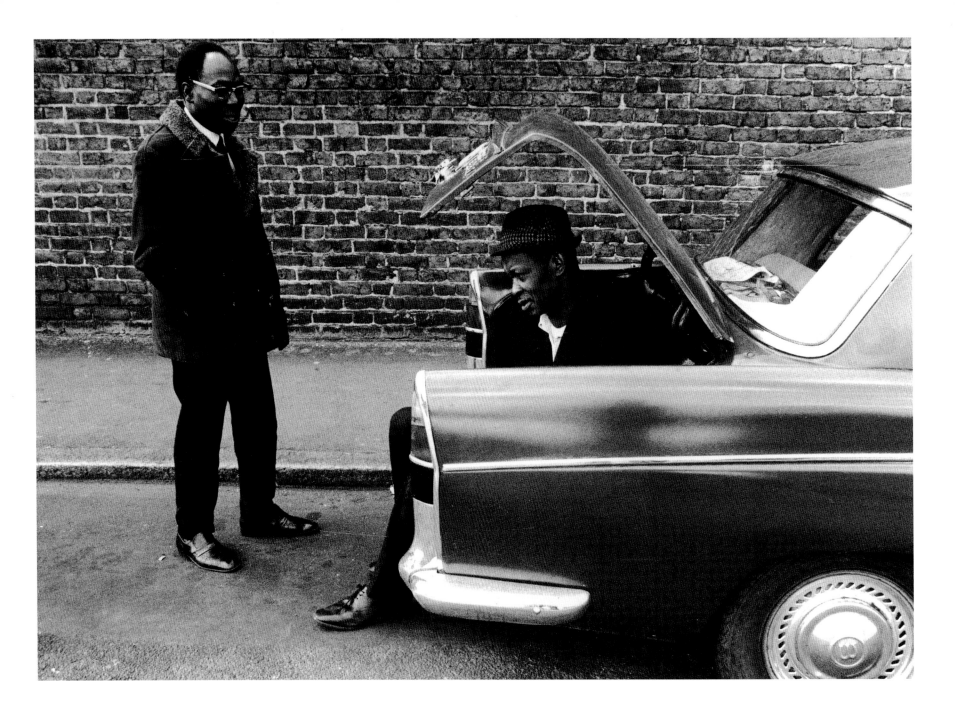

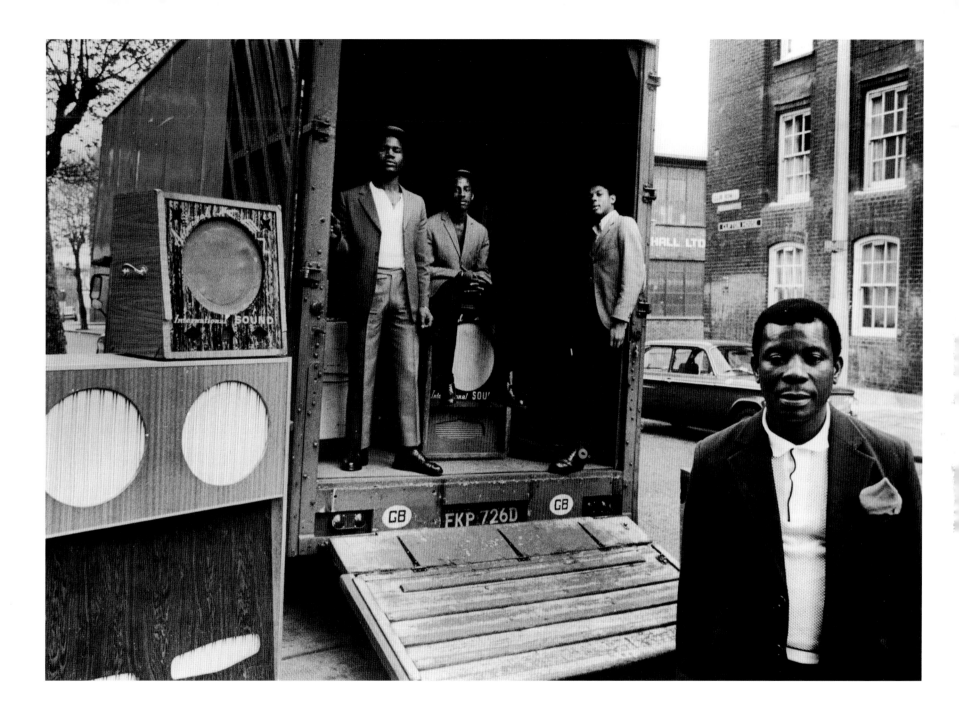

West London, 1977
Photographer: Dennis Morris

The Admiral Ken Sound System, Shoreditch, 1976
Photographer: Dennis Morris

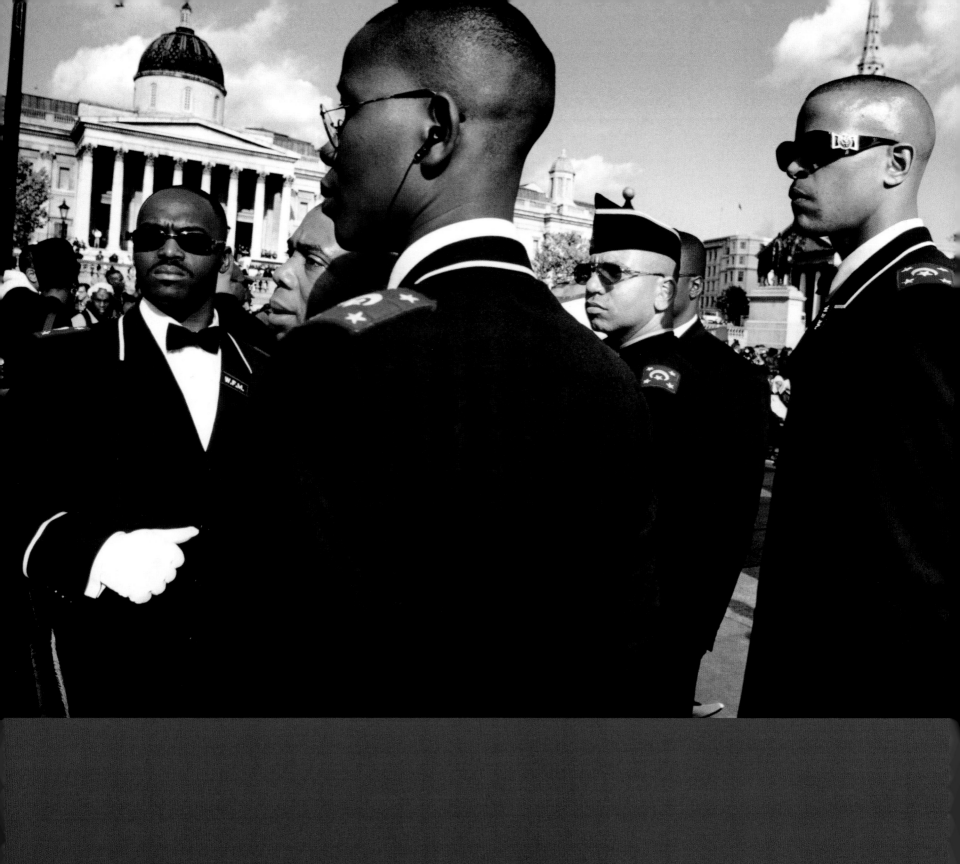

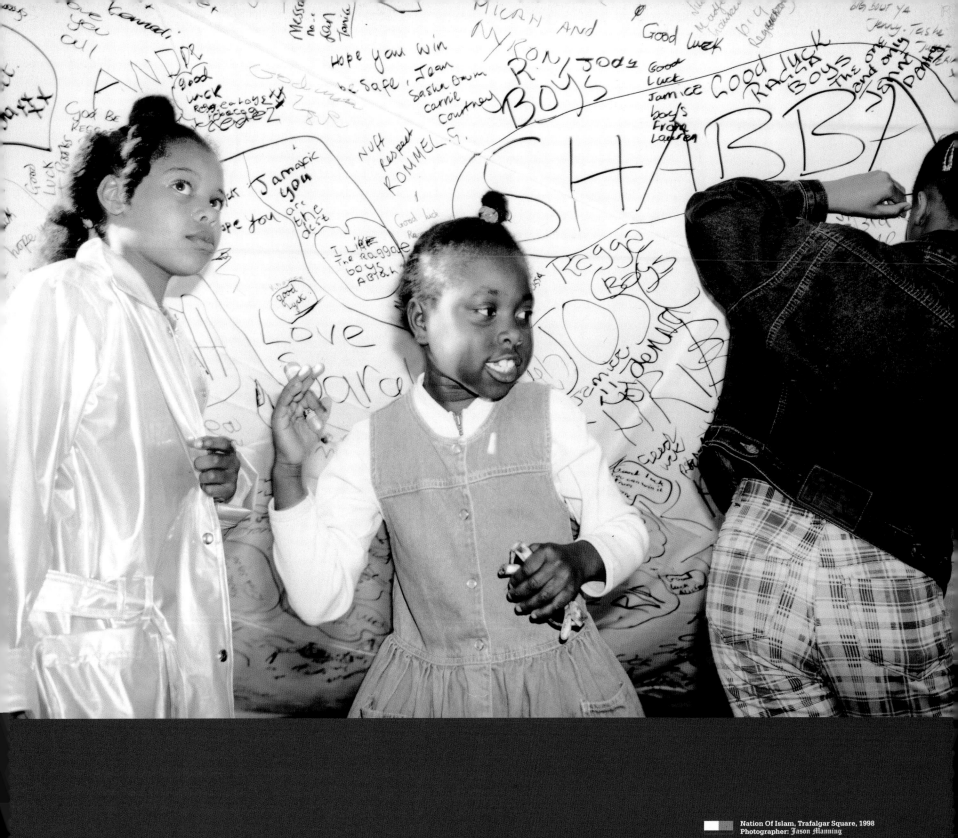

Lincolnshire, 1976
Photographer: Steve Caesar

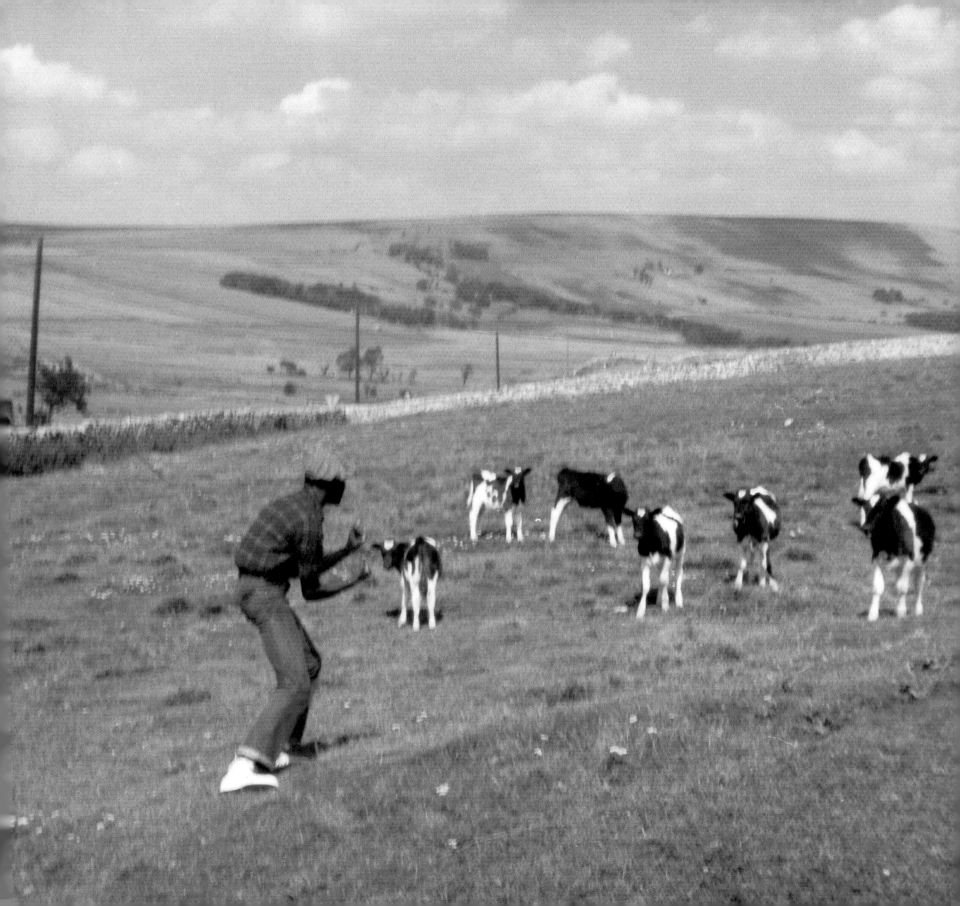

Peckham, 1999
Photographer: Liz Johnson-Artur

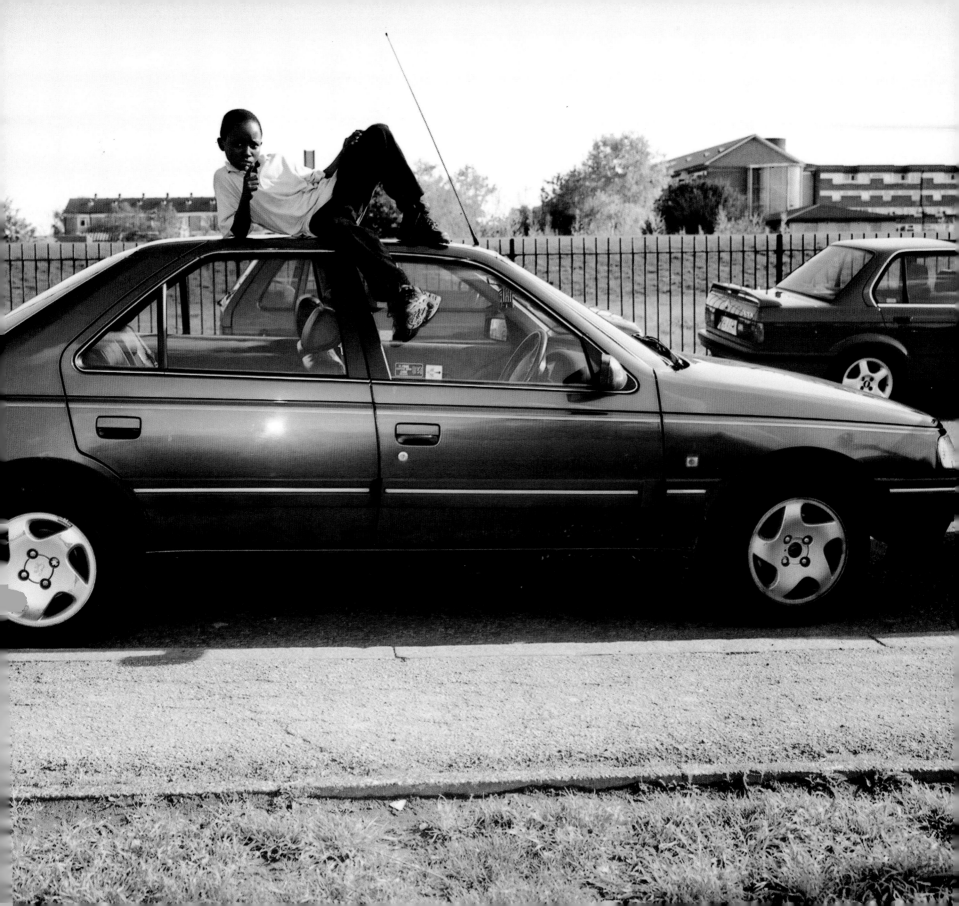

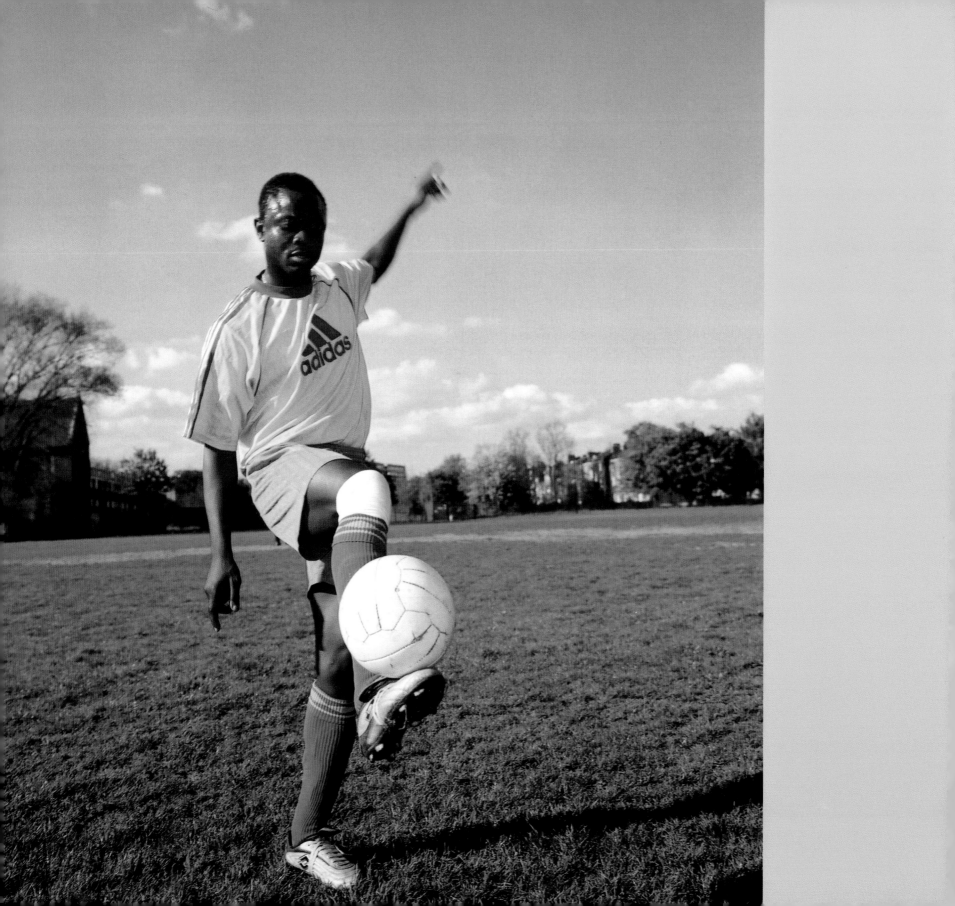

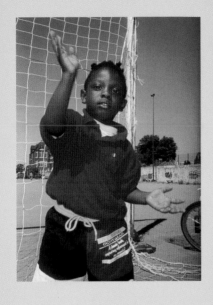 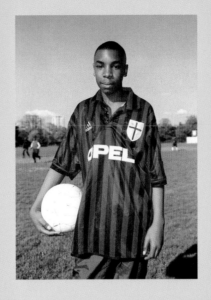 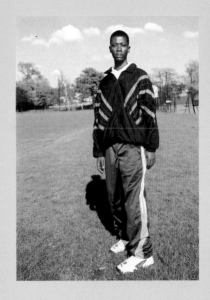

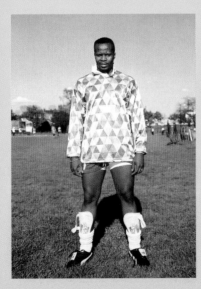 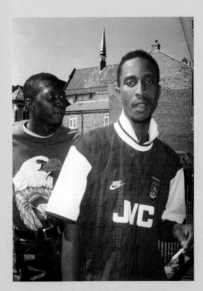 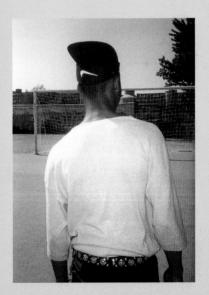

Peckham, 1998
Photographer: Liz Johnson-Artur

Peckham, 1999
Photographer: Liz Johnson-Artur

Peckham 1999
Photographer: Liz Johnson-Artur

Peckham, 1999
Photographer: Liz Johnson-Artur

Peckham, 1998
Photographer: Liz Johnson-Artur

Peckham 1998
Photographer: Liz Johnson-Artur

Peckham, 1999
Photographer: Liz Johnson-Artur

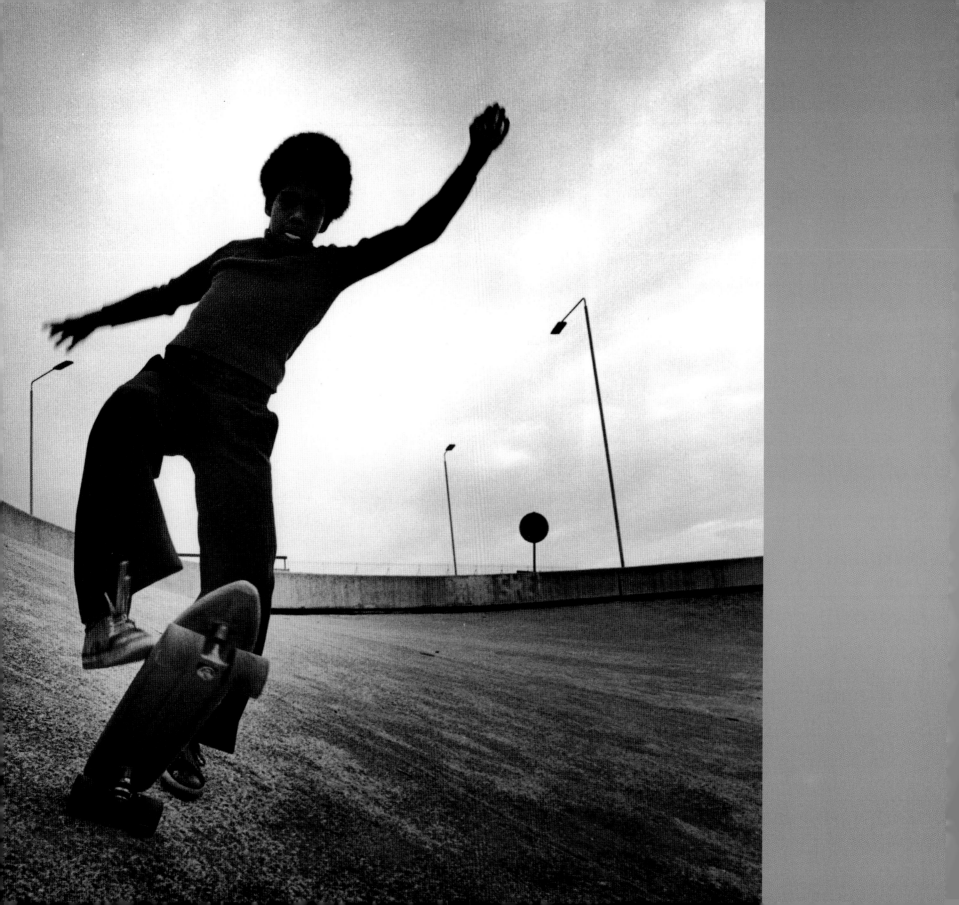

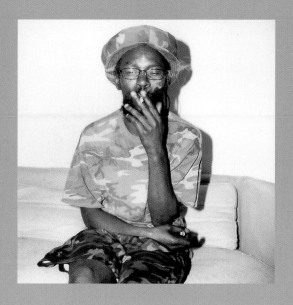
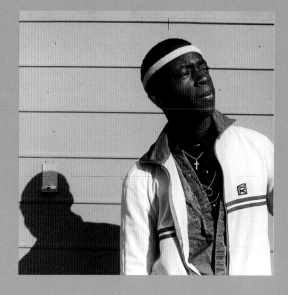
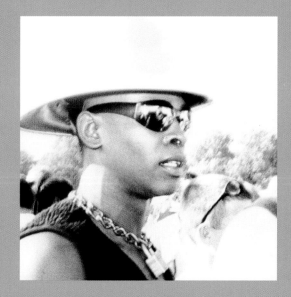
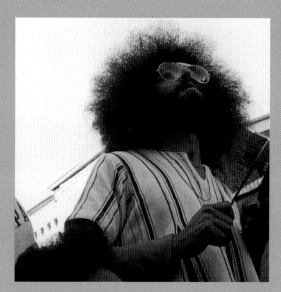

Brixton, 1998
Photographer: Liz Johnson-Artur

High Wycombe, 1984
Photographer: Gavin Watson

Gay Pride, Brixton, circa 1996
Photographer: Liz Johnson-Artur

Notting Hill Carnival, 1975
Photographer: Richard Braine

Wandsworth roundabout, London, 1977
Photographer: Richard Braine

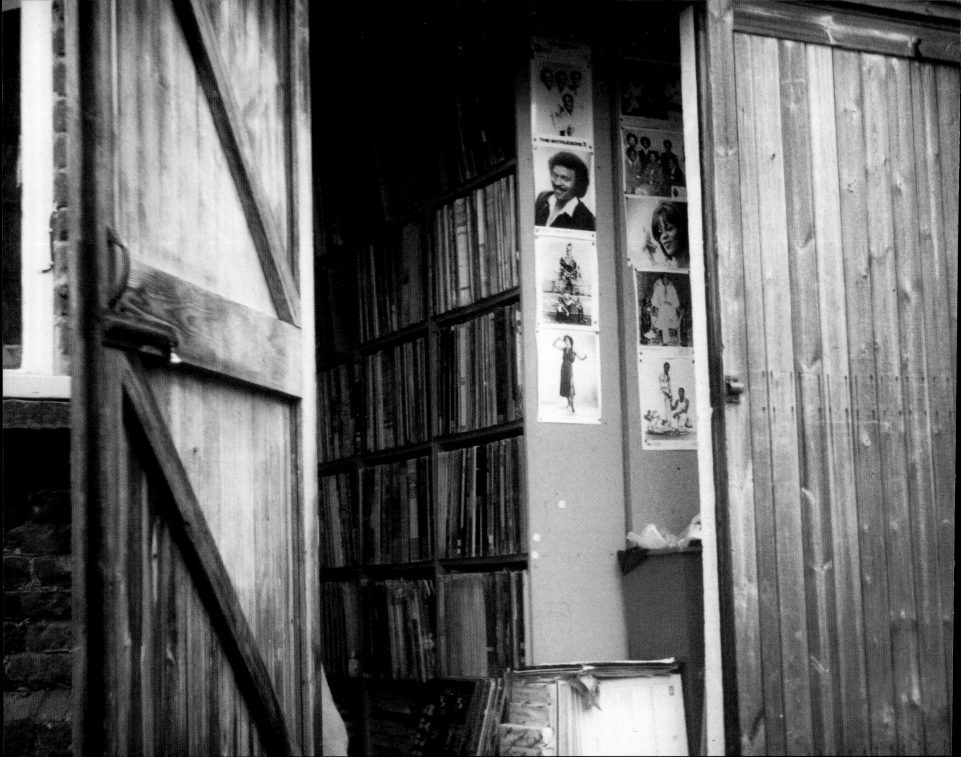

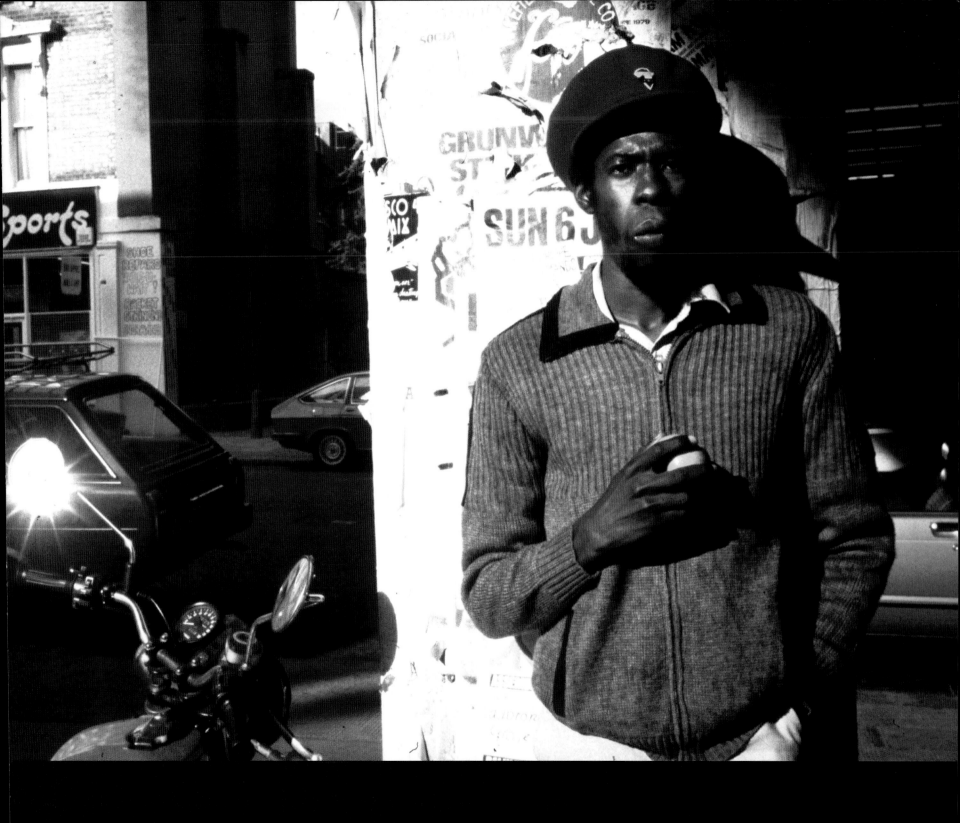

Soul Bowl Records, King's Lynn, 1985
Photographer: Steve Caesar

Michael Smith, Ladbroke Grove, early 1980s
Photographer: Adrian Boot

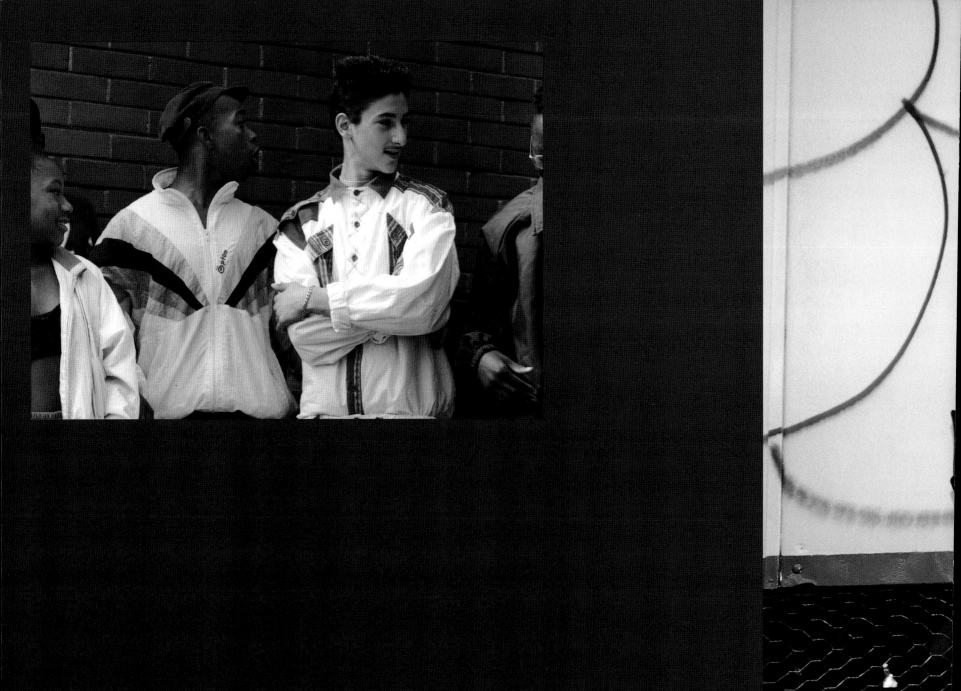

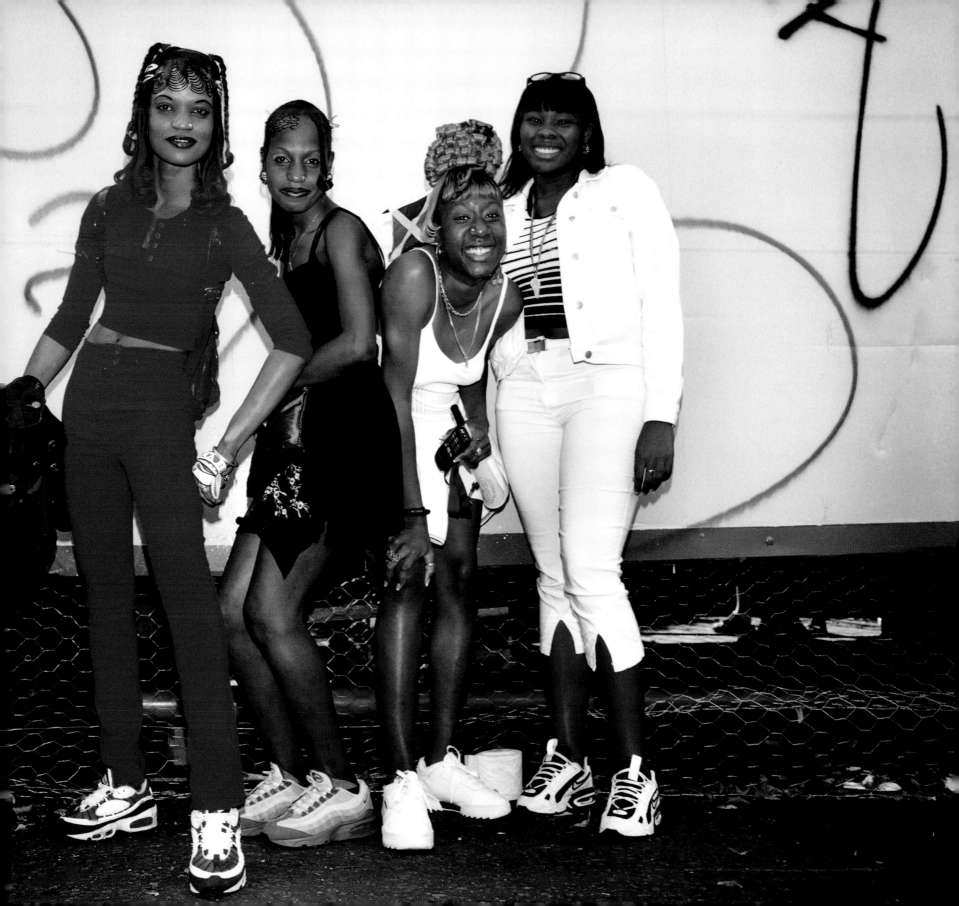

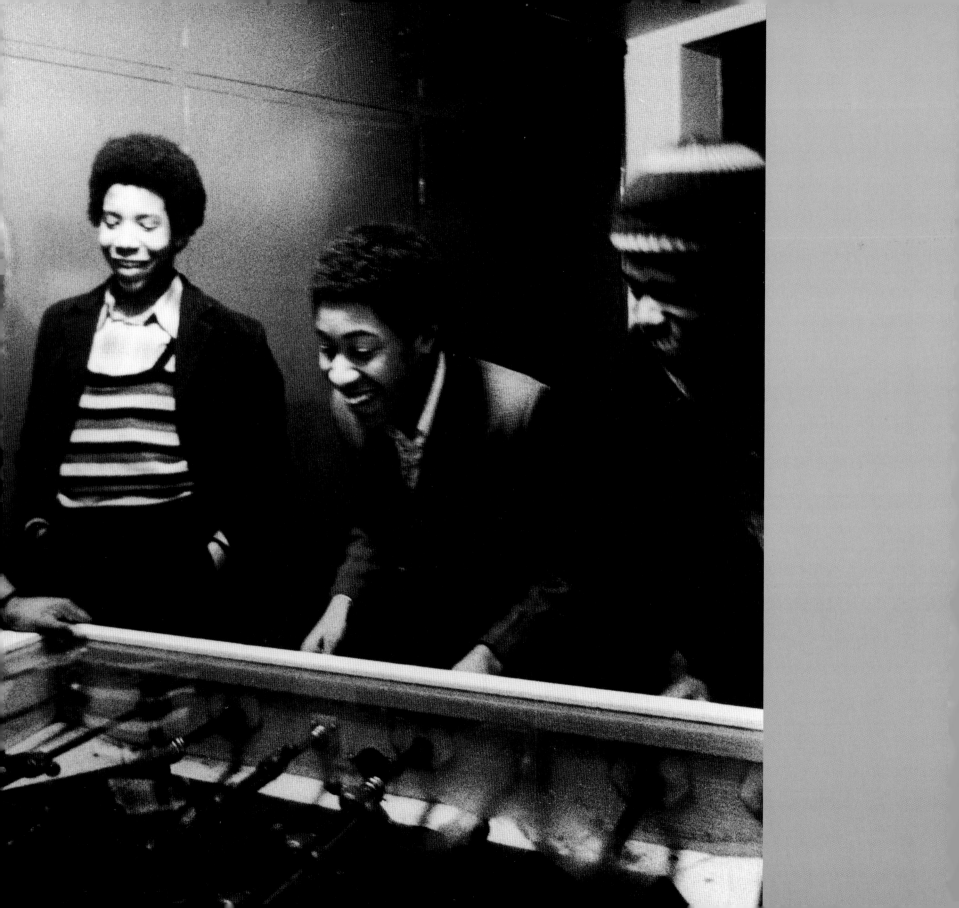

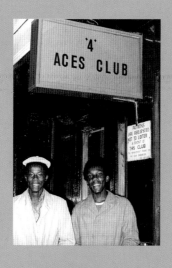

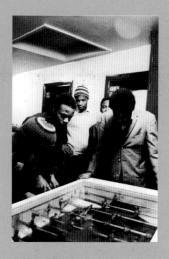

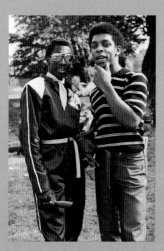

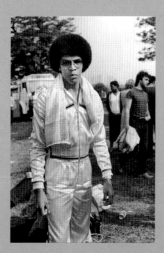

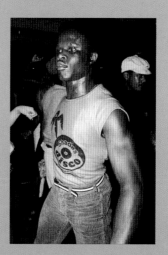

4 Aces, Dalston, 1977
Photographer: Jill Furmanovsky

Shades Disco, Manor House, 1978
Photographer: Jill Furmanovsky

Hackney Youth Club, 1973
Photographer: Dennis Morris

Soul Festival, Caister, circa 1979
Photographer: Jill Furmanovsky

Soul Festival, Caister, circa 1979
Photographer: Jill Furmanovsky

Shades Disco, Manor House, 1978
Photographer: Jill Furmanovsky

Hackney Youth Club, 1973
Photographer: Dennis Morris

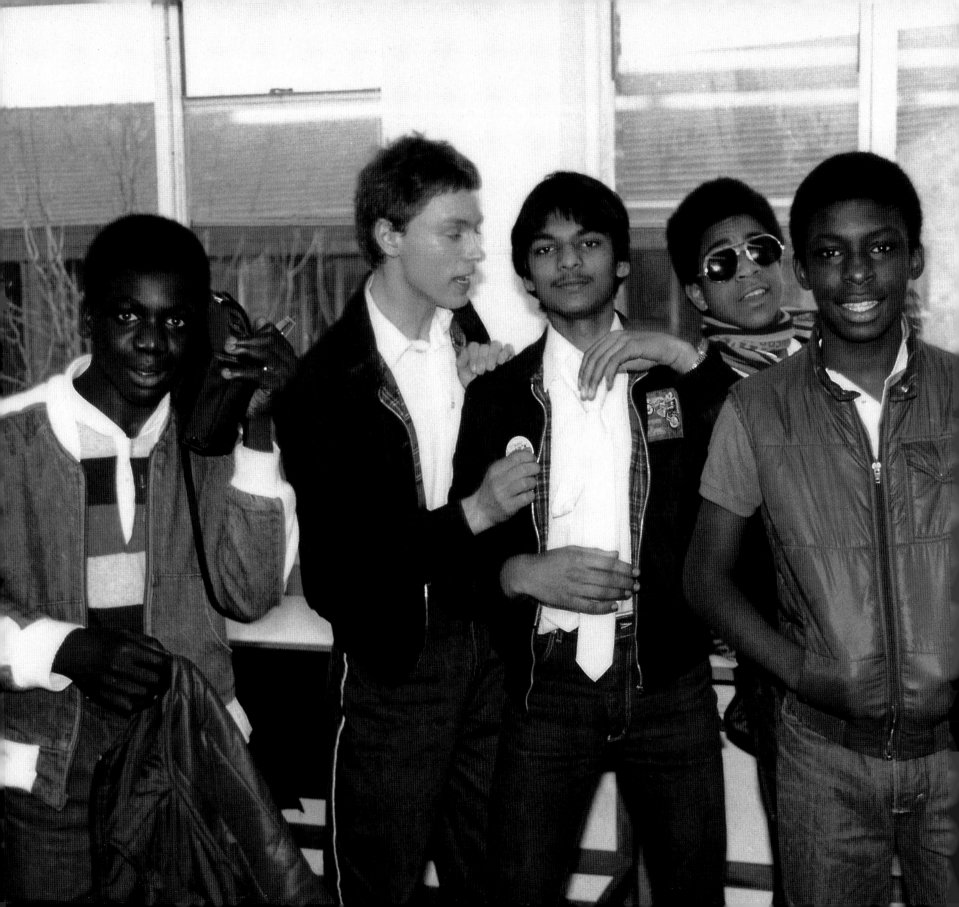

Hatters Lane School, High Wycombe, 1981
Photographer: Gavin Watson

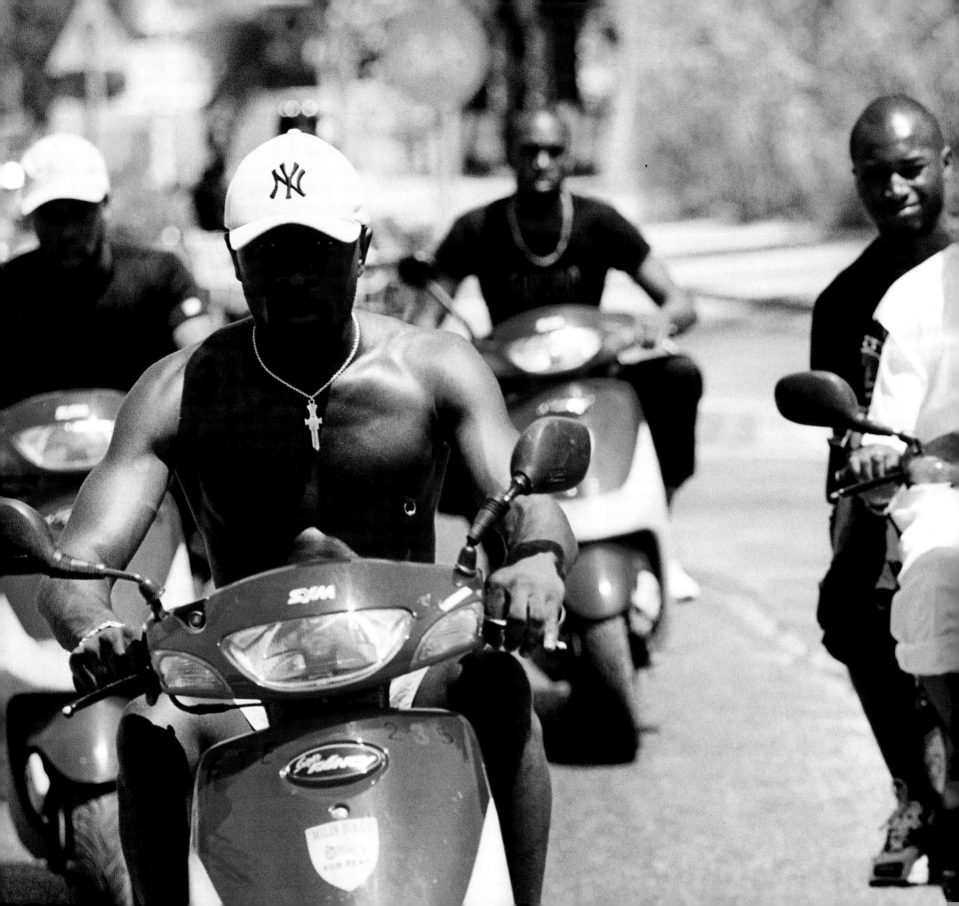

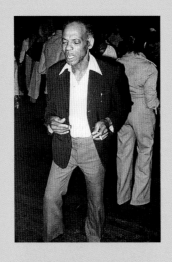
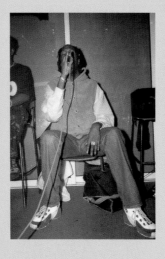
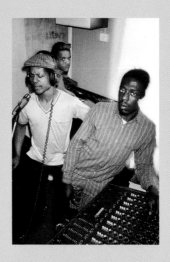

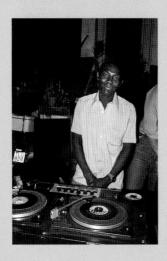
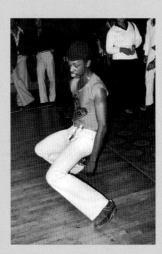
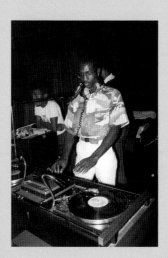

Russell Club, Hulme, 1975
Photographer: Dennis Morris

Bury Cru, Islington, 1998
Photographer: Liz Johnson-Artur

Saxon Studios, New Cross, circa 1988
Photographer: Normski

Silver Jubilee street party, Fulham, 1977
Photographer: Richard Braine

Shades Disco, Manor House, 1978
Photographer: Jill Furmanovsky

Shades Disco, Manor House, 1978
Photographer: Jill Furmanovsky

Norman Jay, Carwash, London, 1988
Photographer: David Swindells

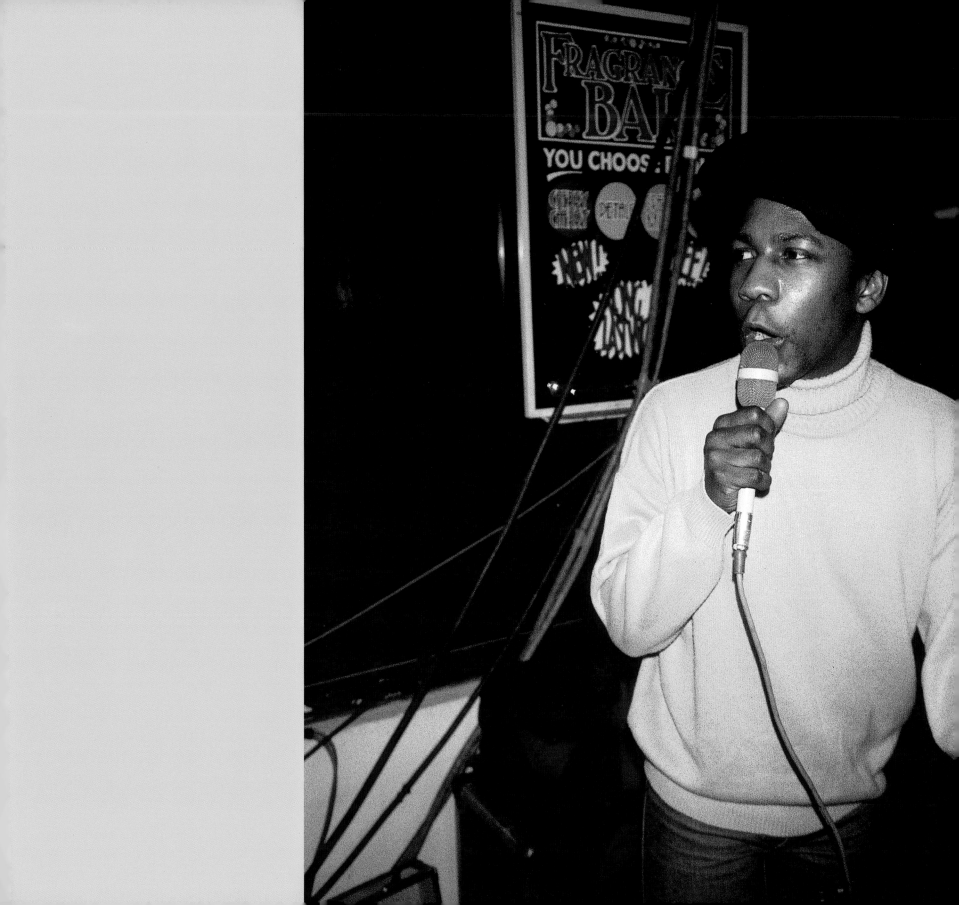

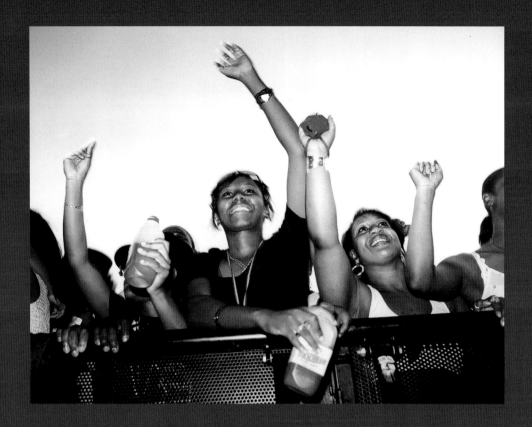

Reggae Sunsplash, Hackney, 1999
Photographer: Liz Johnson-Artur

Notting Hill Carnival, 1999
Photographer: Tristan O'Neill

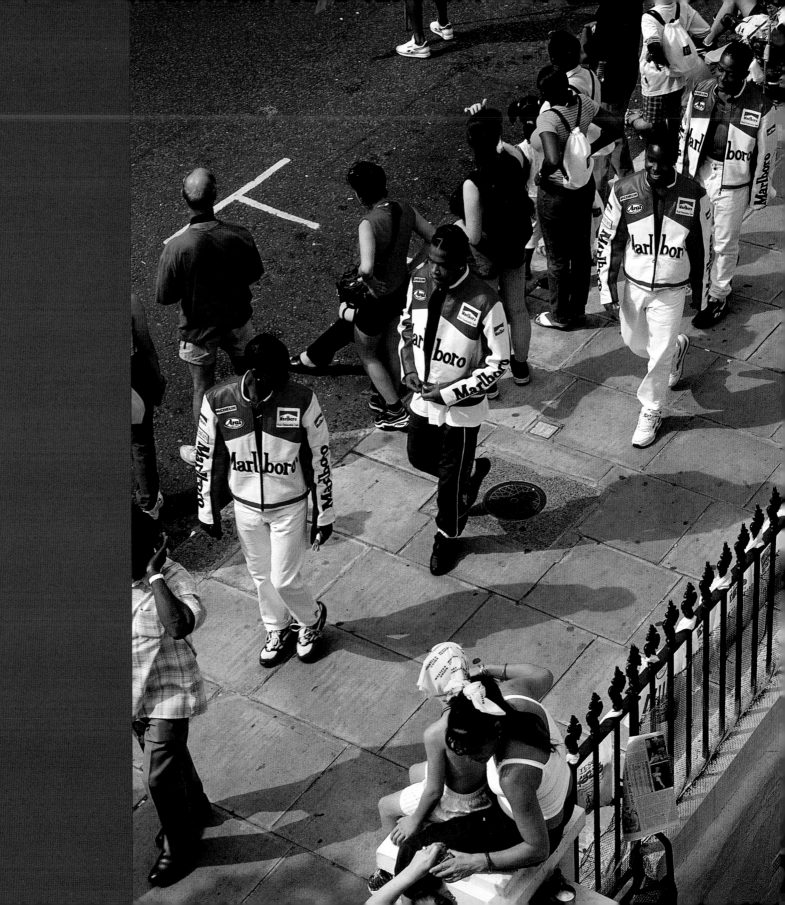

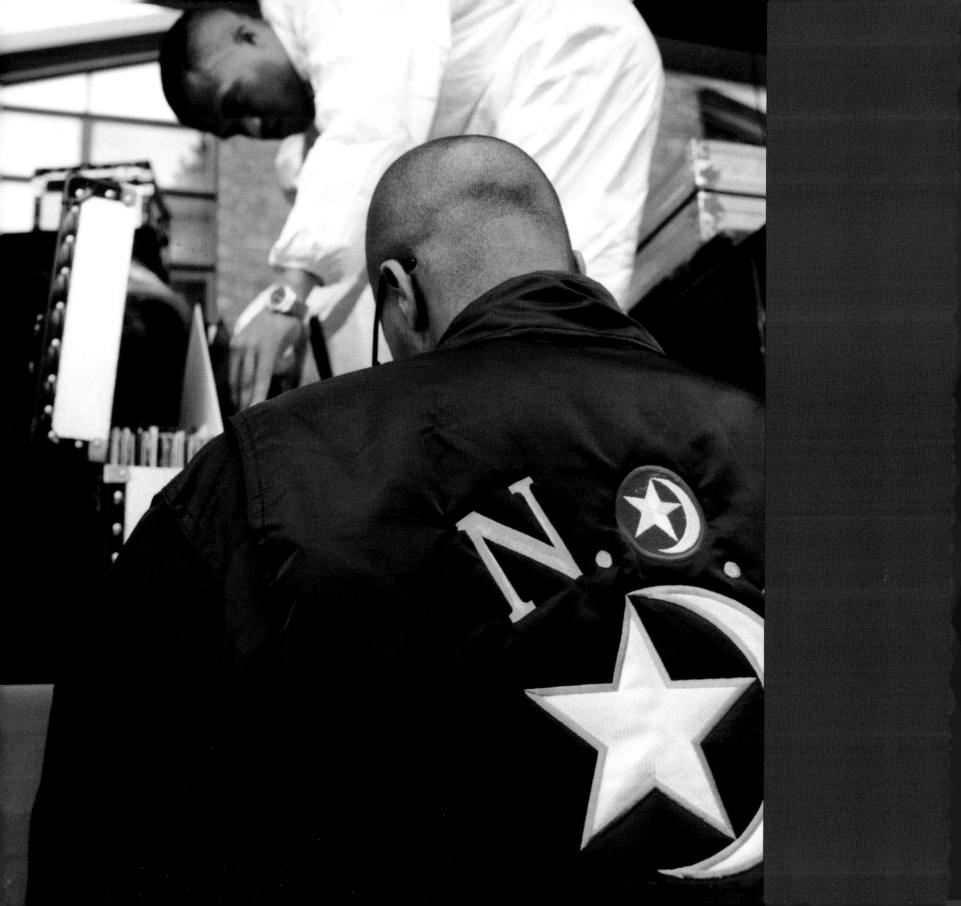

0

Nation of Islam, Notting Hill Carnival, 1996
Photographer: Des Willie

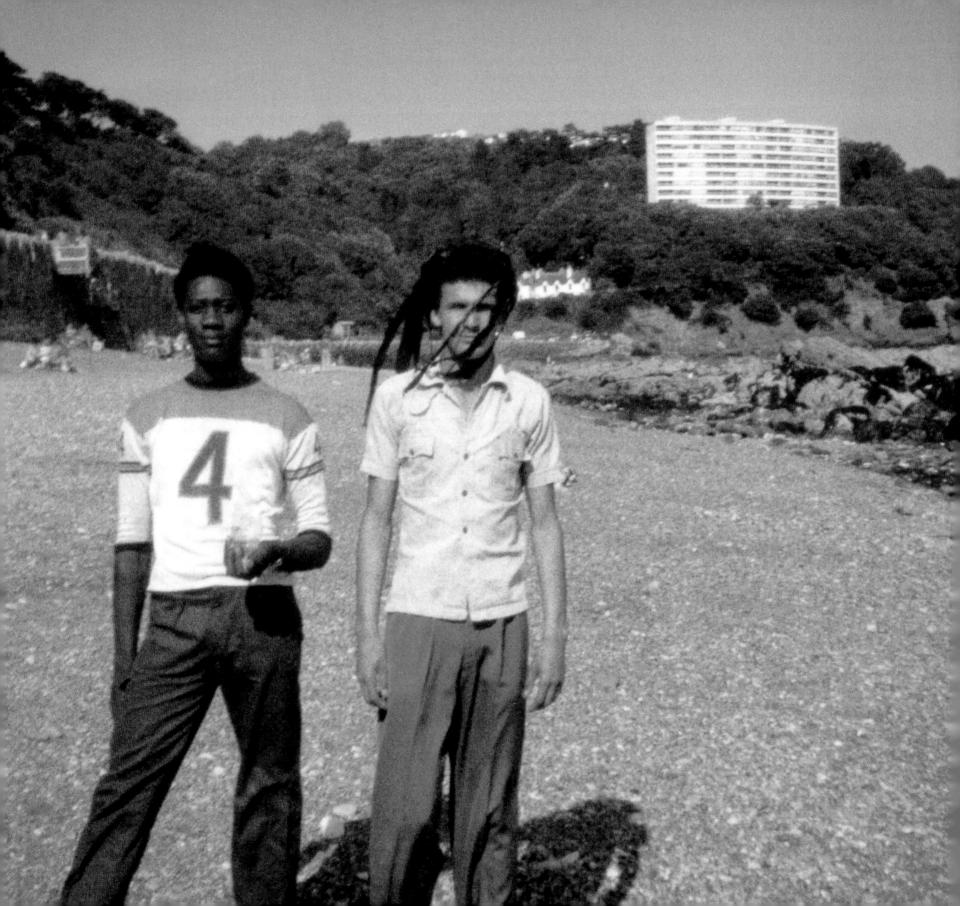

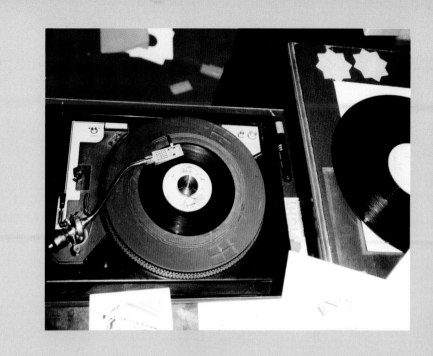

Torquay, 1977
Photographer: Steve Caesar

Treasure Island, Brixton, 1997
Photographer: Liz Johnson-Artur

NormanJay

When everyone around you was in dungarees and dreadlocks and listening to dub reggae, and you bowl down the street in bright yellow or orange jeans, then you're asking for trouble.

As a teenager, in the early 1970s, I was living in Acton, clubbing locally at Hammersmith Palais on a Thursday, West Kensington Bird's Nest on a Saturday, and venturing occasionally into the West End to go to the 100 Club. The music was the Pop Soul of the time: George McReae's "Rock You Baby", Hughes Corporation's "Rock The Boat" and the Three Degrees' "When Will I See You Again".

For going out, the look, especially for black guys, was black double-breasted jackets with silver-plated buttons and a hankie in the top pocket, and there was a place up Kilburn High Road that used to sell them. That's what Soul Boys wore while Reggae Boys were getting into Italian fashion like Gabicci's big, heavy knits with suede fronts. But I was always a Soul Boy. The Soul Boy thing comes from the Mod tradition. It's about attention to detail; looking right and wearing clothes in an understated way as opposed to an overstated way.

When I was nine or ten, the older kids on the street were Mods and they always looked right. Proper tonics, proper brogues bought from the Ivy shop in Richmond Hill; that was my introduction to proper style. Even though I was too young to be a Mod, I understood totally the ethic behind it. I got my first pair of Levi's when I was ten! I got my mum to save up for them. A kid round the corner who was a bit older told me, you don't cut 'em or turn 'em up, you wear 'em in the bath. So I jumped in the bath, they shrunk to fit and they was the living jeans! It was all about attention to detail. You'd wear a Ben Sherman shirt; a tank top from Shepherds Bush Market, always woollen, never nylon; high-waisted bags, tailored, not off the peg; and crepe-soled shoes from Sacha on Kensington High Street, or Ivy brogues.

Then the pre-casual look came in with Lee dungarees and Fiorucci jeans, which had just appeared in London around 1976 when they opened their first shop. But with the rise of sports chic, you'd see the newest clothes on the terraces. All the golfing jumpers, Pringle and Lyle & Scott, would be mixed with accessories from Aquascutum, like the deerstalker hats. If you wanted to belong to the gang or the group at football you had to come correct. So at night I was a Soul Boy dressing-up, but going to football on Saturdays, I'd be in a Levi's jacket, a donkey jacket or Brick Lane sheepskin if it was freezing cold and Doctor Marten boots. And later on, when teams started playing in Europe, trainers became important; from Adidas Forest Hills and Trim Trabs to loads of Pumas and the Diadora Bjorn Borg Elites made out of kangaroo skin leather, each one individually numbered.

But you can look too funky sometimes. Enough times in the 70s, I'd be getting chased down the street and called a black queer, 'cos of wearing certain styles of clothes. So, when I'd been out, on the way back home, I'd have to get changed and put my clothes in a duffel bag. When everyone around you was in dungarees and dreadlocks and listening to dub reggae, and you bowl down the street in bright yellow or orange jeans, then you're asking for trouble. Once in the West End you're safe, but when you're coming back to a parochial, provincial town, you're asking for trouble. But I didn't wanna look the same as anyone else. For me what mattered was looking right.

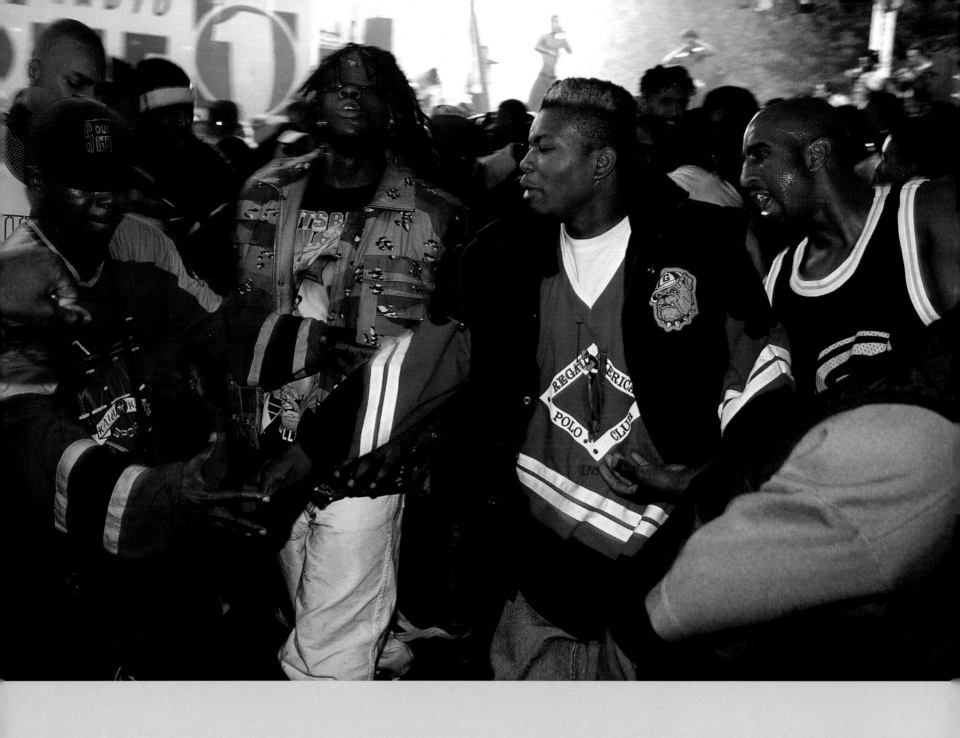

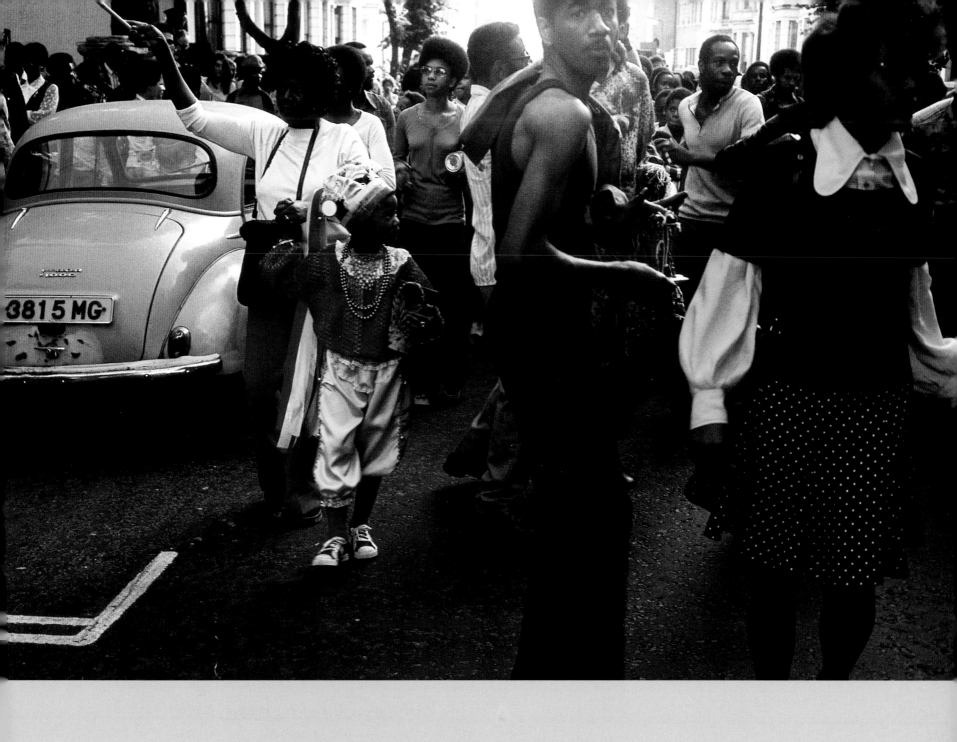

YOU!
K BEAUTIES DO
YOUR THINGS AND
BE *Peaceable*
WHEN LEAVING THIS
CLUB

The Carib Club, Shoreditch, 1975
Photographer: Dennis Morris

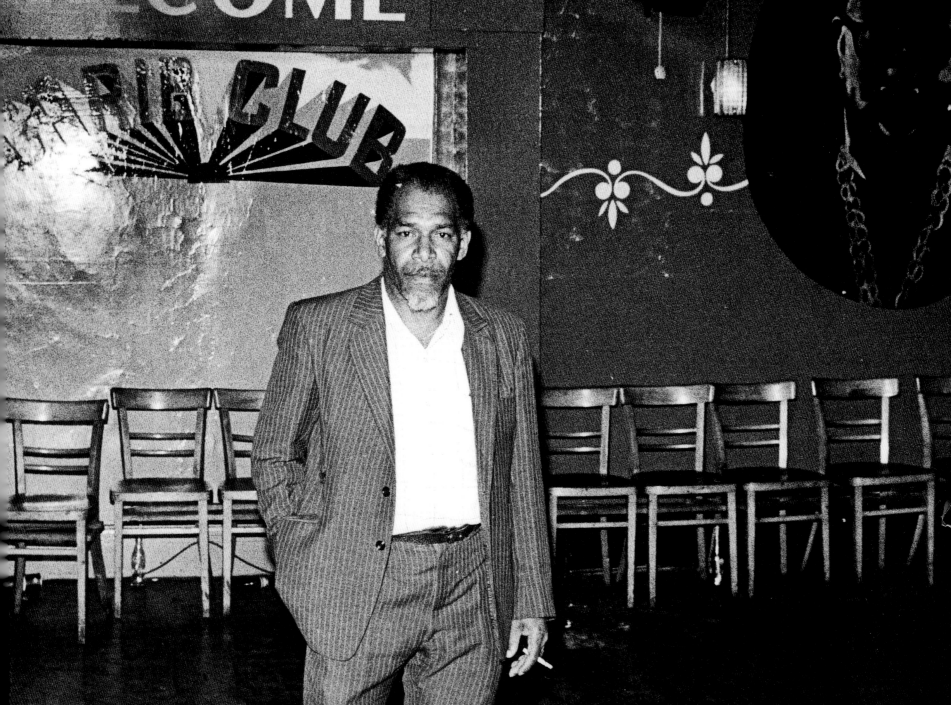

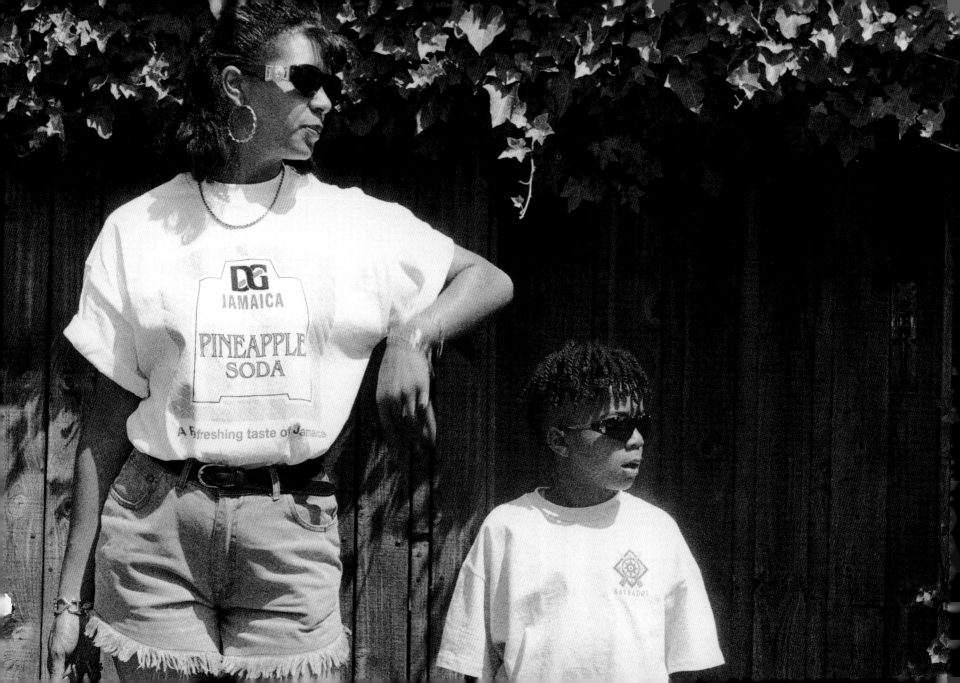

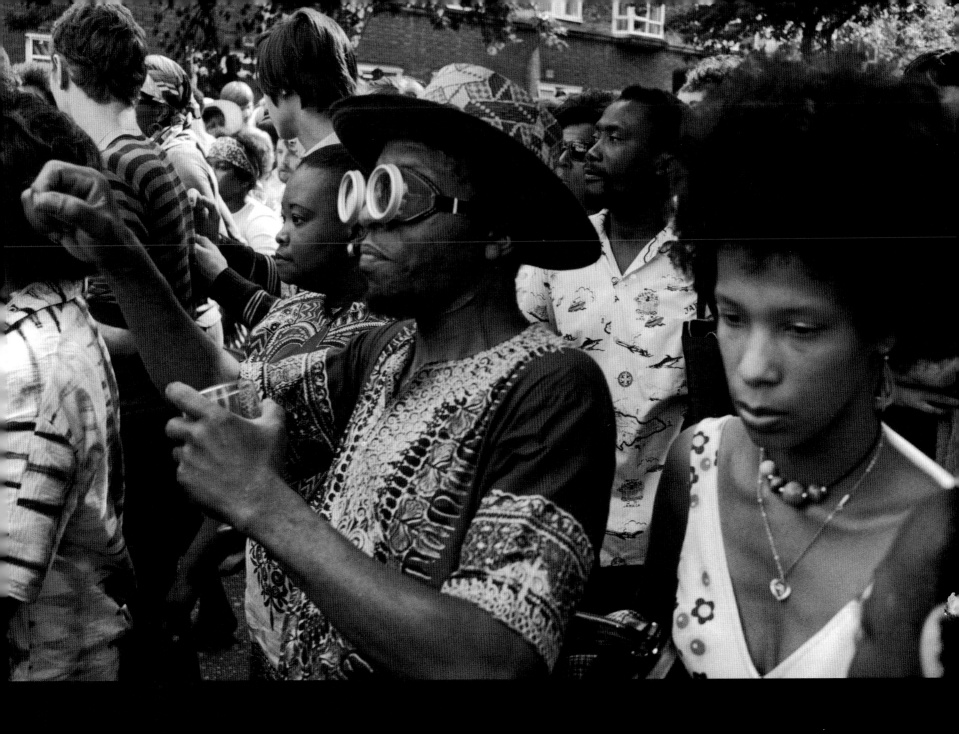

Deptford, 1996
Photographer: Manuela Zanotti

Notting Hill Carnival, 1975
Photographer: Richard Braine

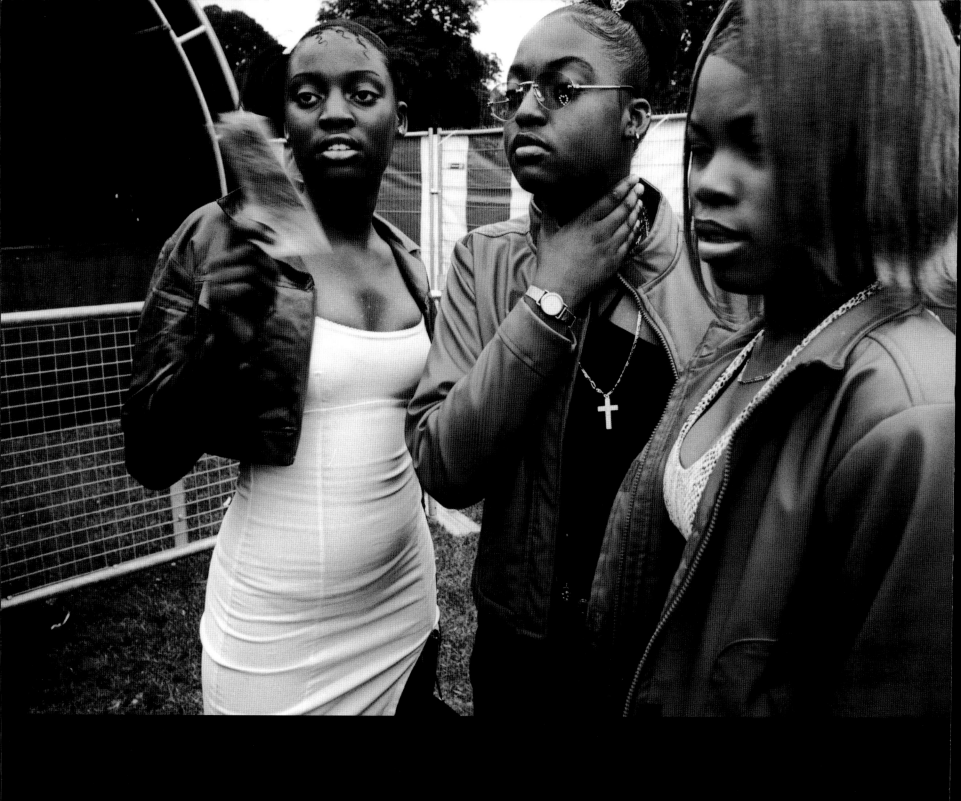

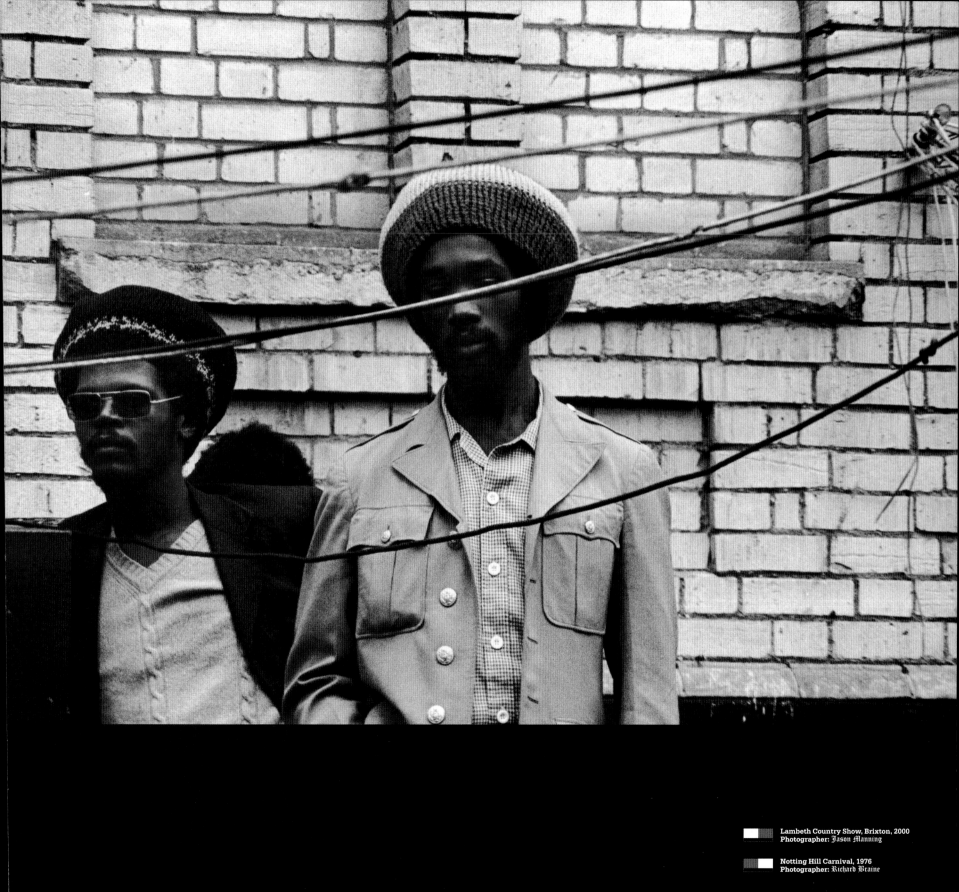

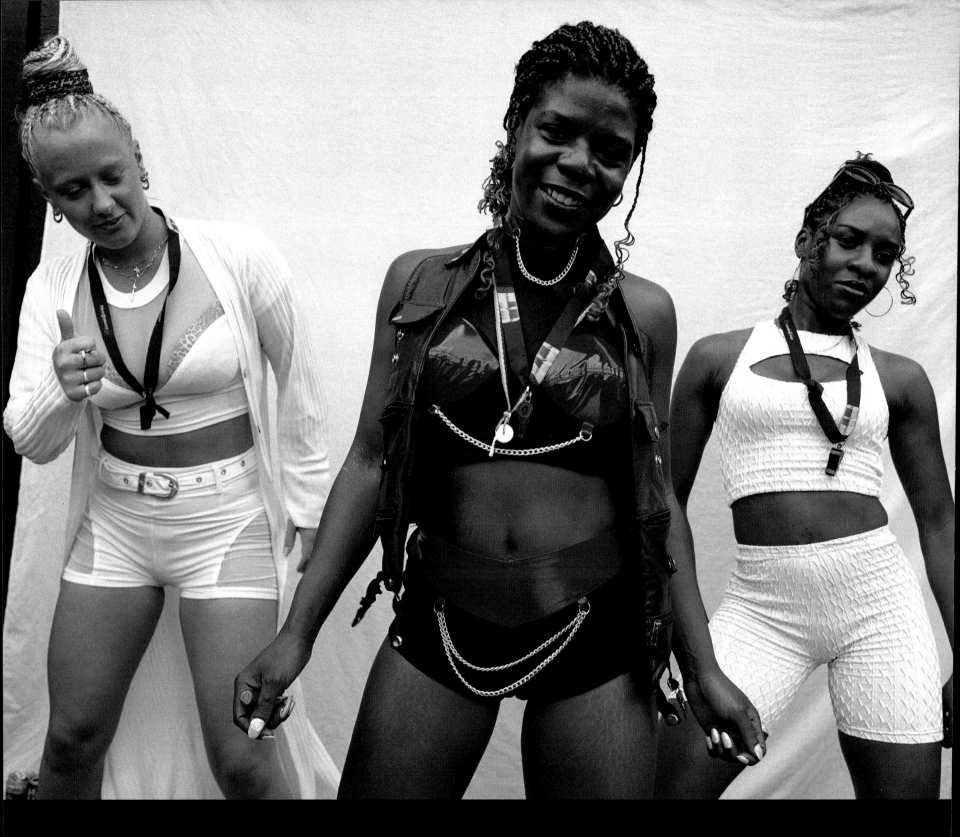

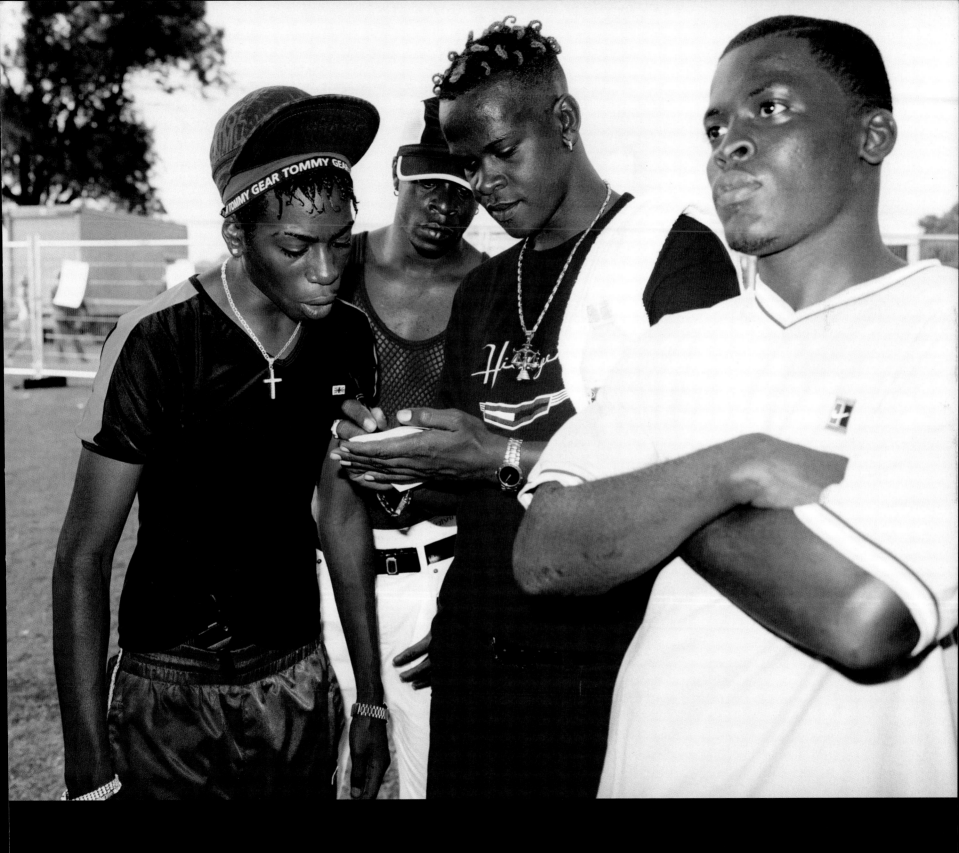

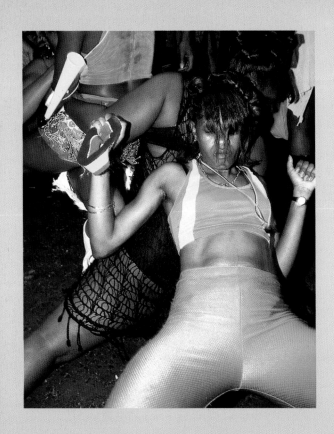

Notting Hill Carnival, 1996
Photographer: Giles Moberly

Notting Hill Carnival, 1999
Photographer: Giles Moberly

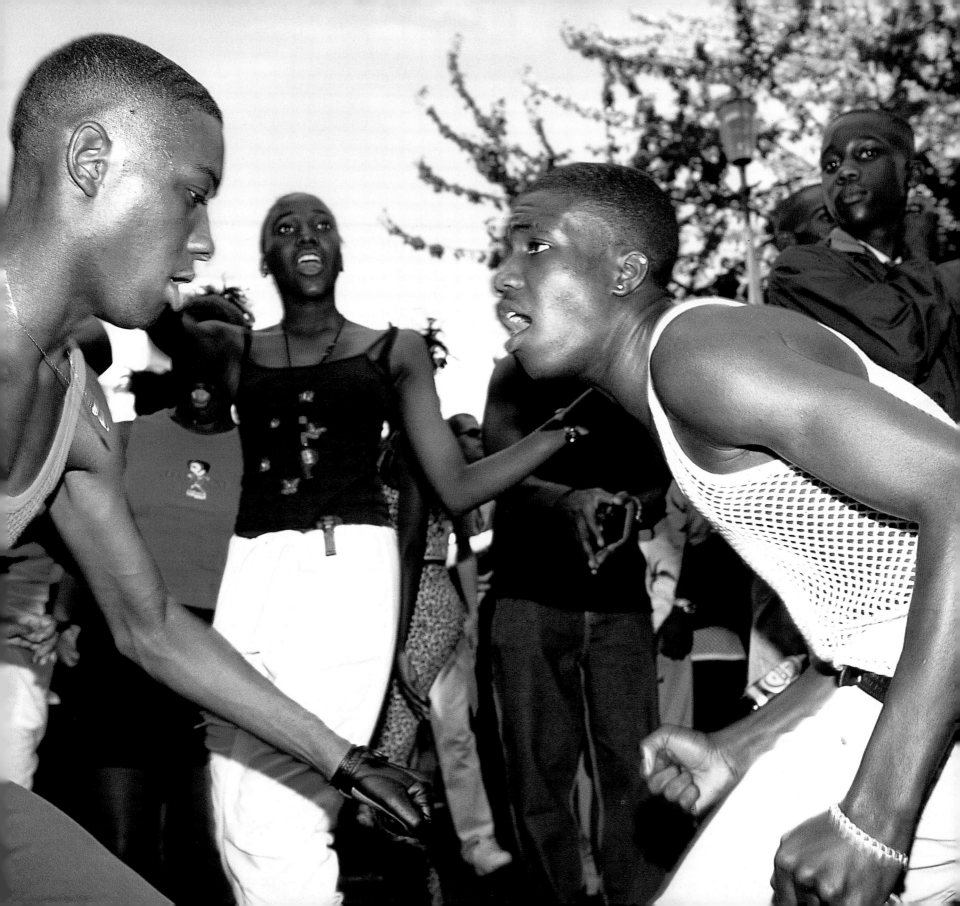

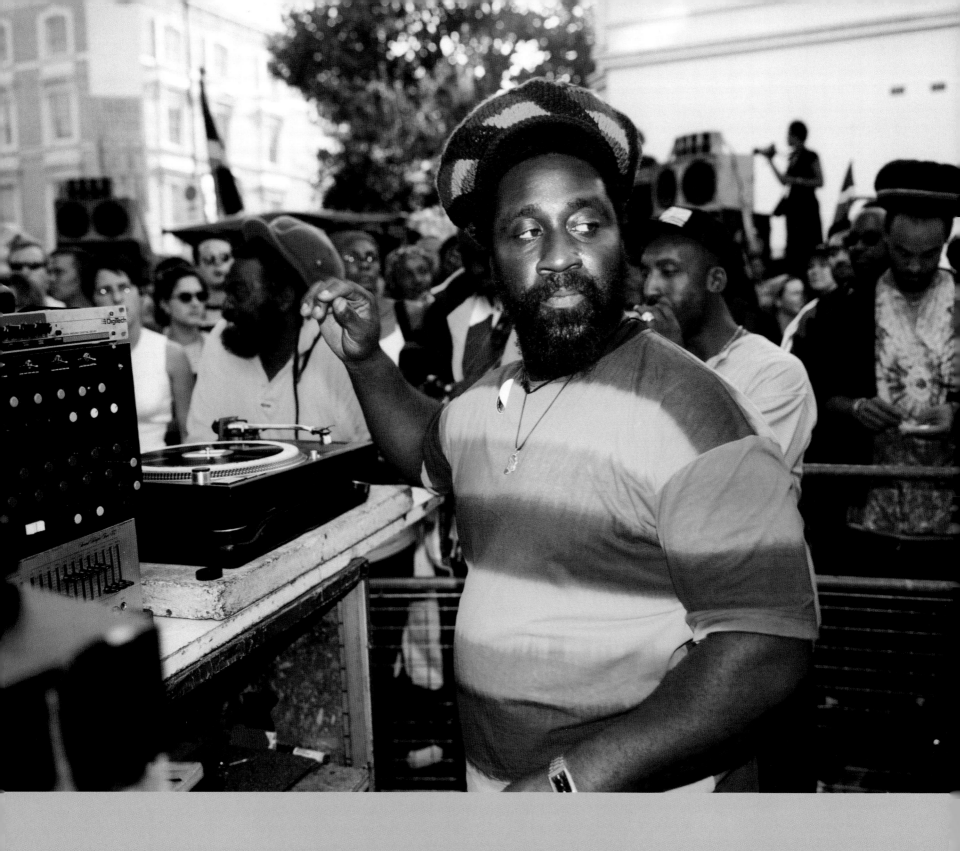

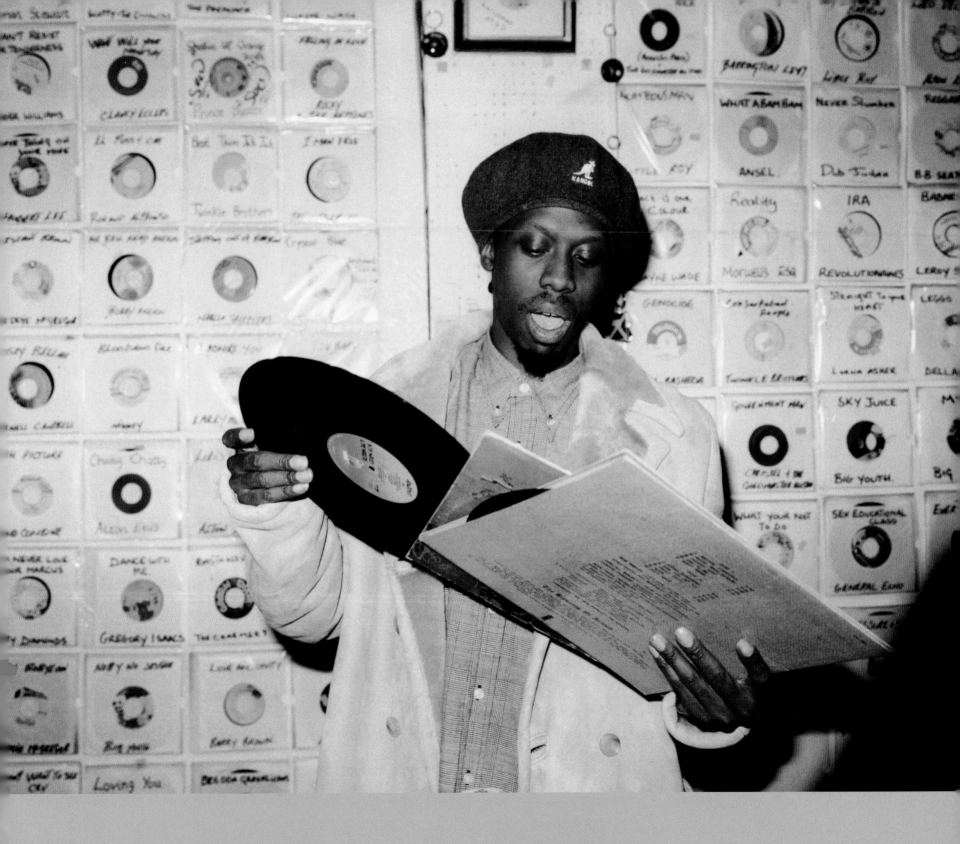

Channel One Sound System, Notting Hill Carnival, 1999
Photographer: Liz Johnson-Artur

Treasure Island, Brixton, 1997
Photographer: Liz Johnson-Artur

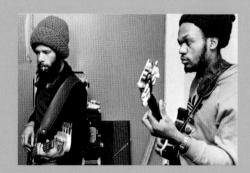

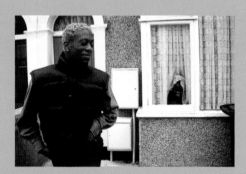

Heptones, West London, 1977
Photographer: Adrian Boot

Steel Pulse, Handsworth, early 1980s
Photographer: Adrian Boot

Leon, Bristol, 1997
Photographer: Courtney Hamilton

Shades Disco, Manor House, circa 1978
Photographer: Jill Furmanovky

Queer Nation @ Substation South, Brixton, 1999
Photographer: Darren Regnier

Twice As Nice @ The End, London, 2000
Photographer: Ewen Spencer

Thunder & Joy @ Raw, Tottenham Court Road, 1995
Photographer: Michael Williams

Harlesden, 1998
Photographer: Liz Johnson-Artur

Twice As Nice @ The End, London, 2000
Photographer: Ewen Spencer

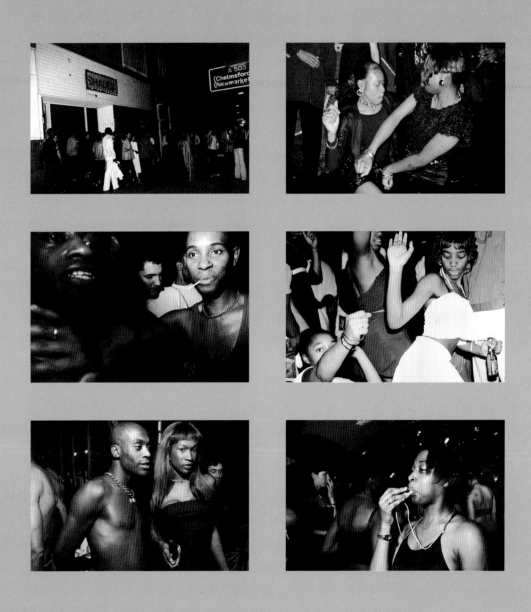

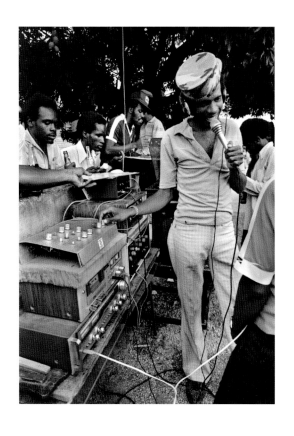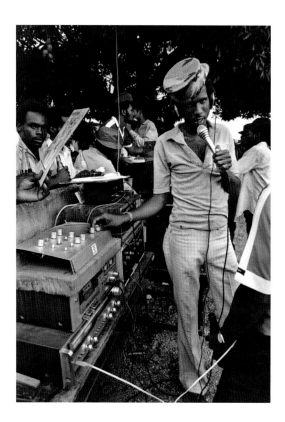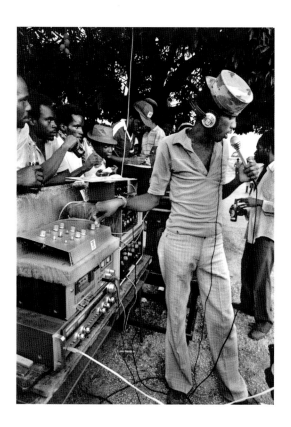

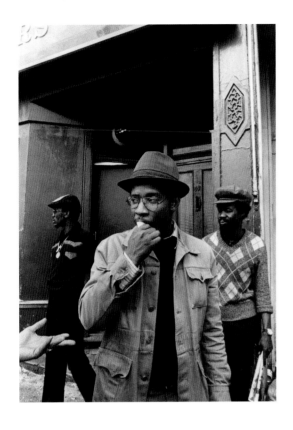
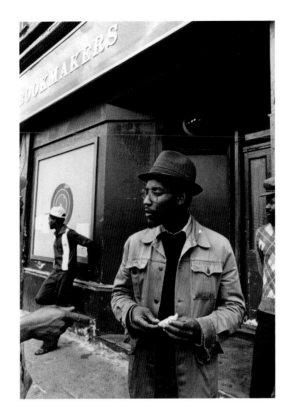
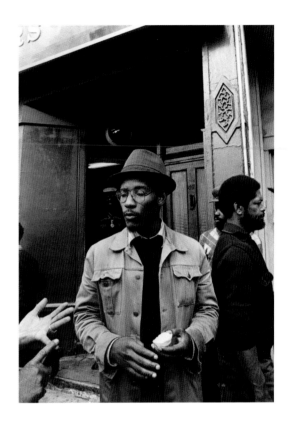

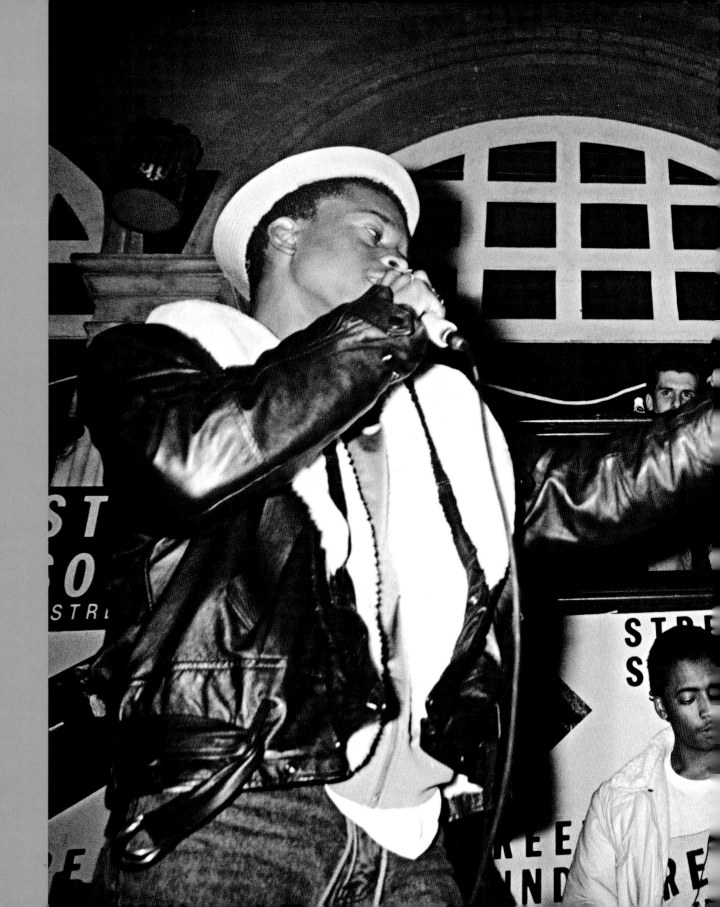

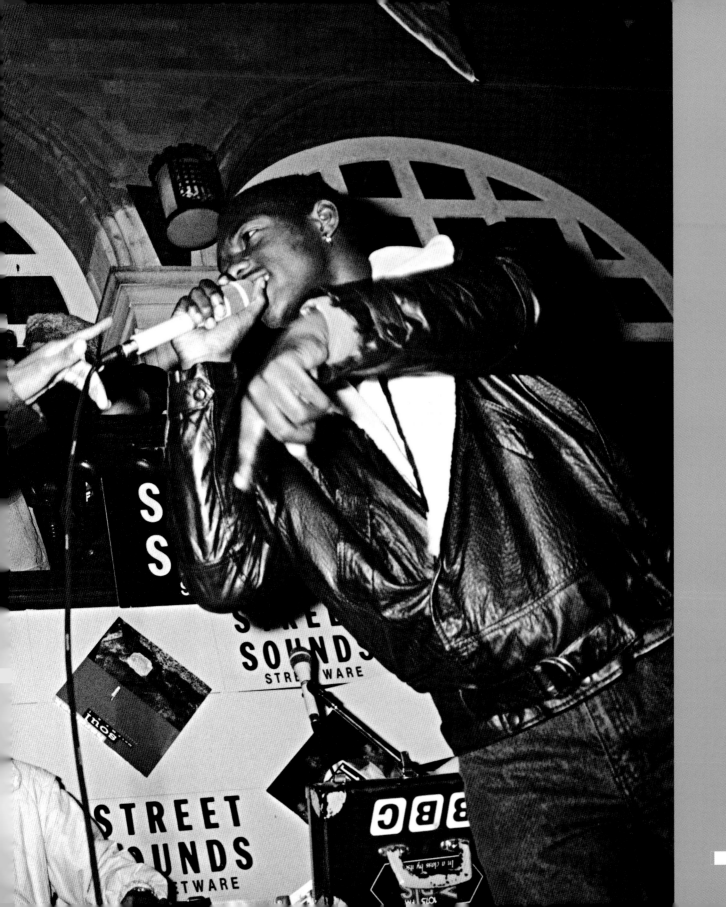

Phase 2, The Limelight, London, 1987
Photographer: Normski

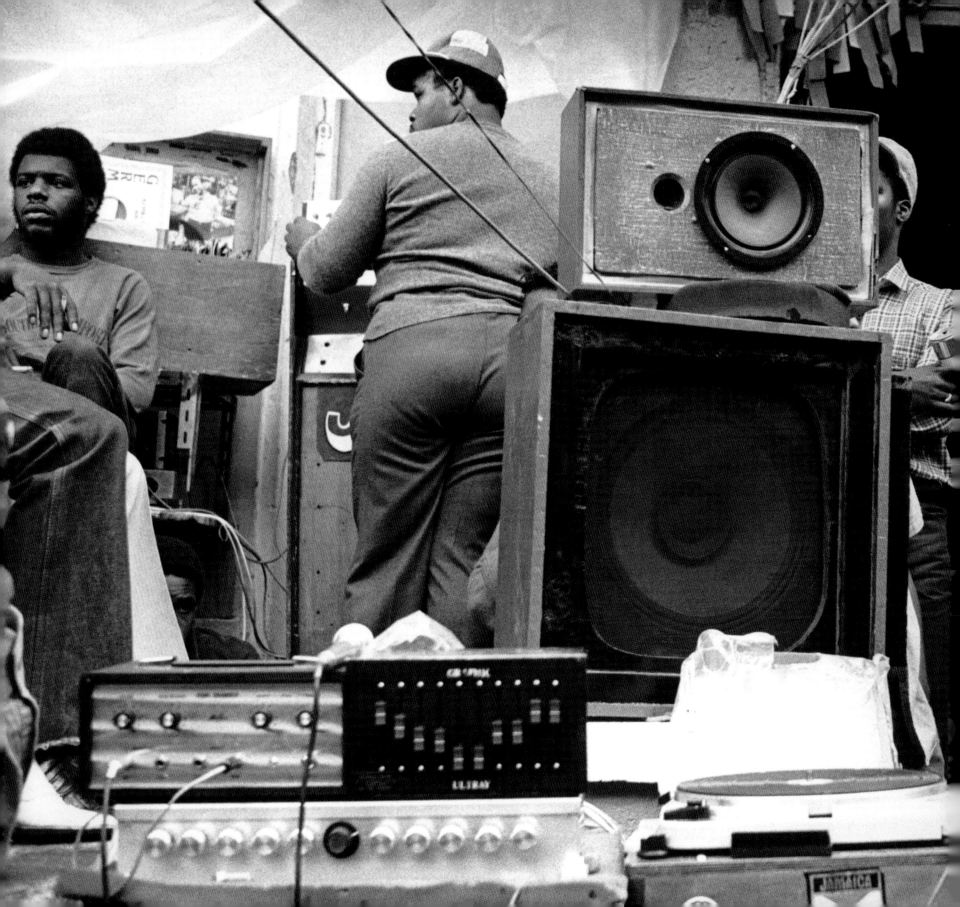

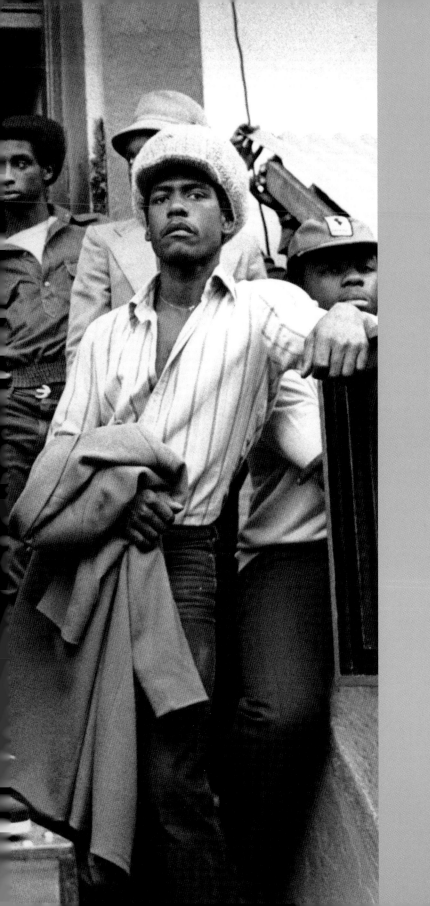

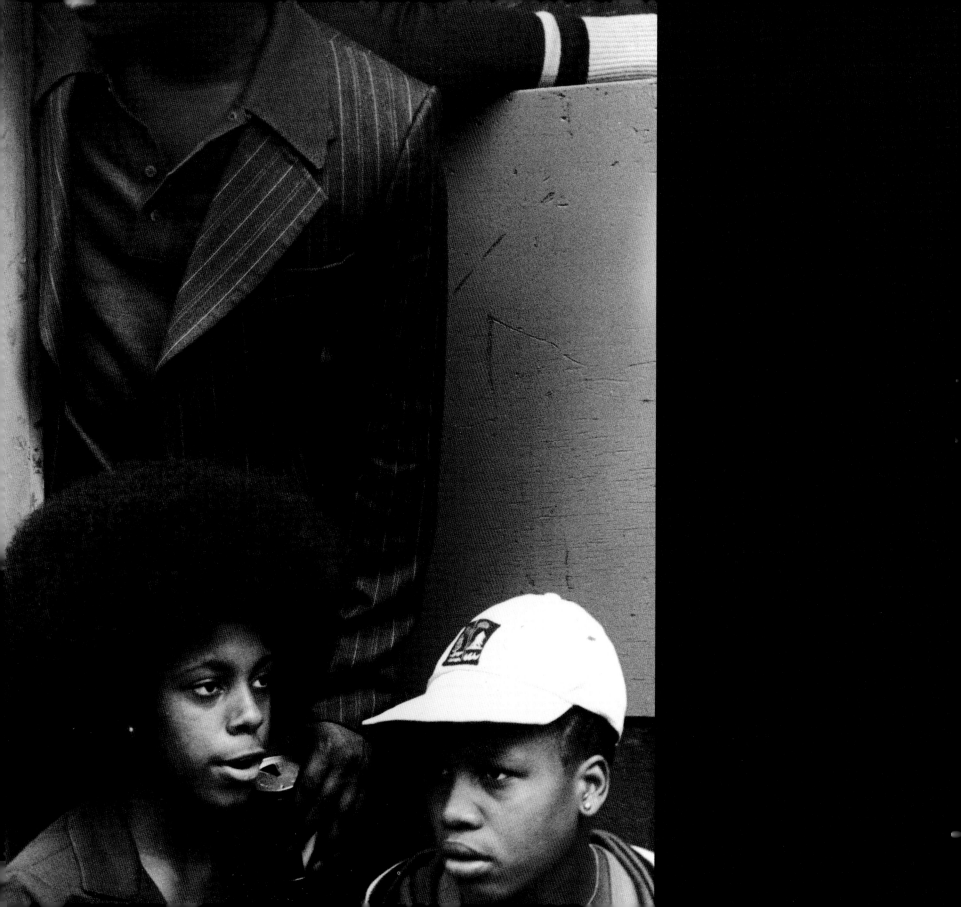

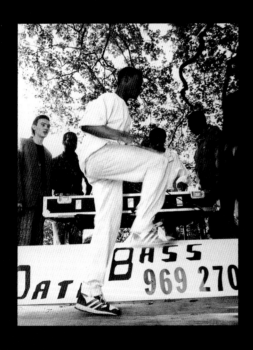

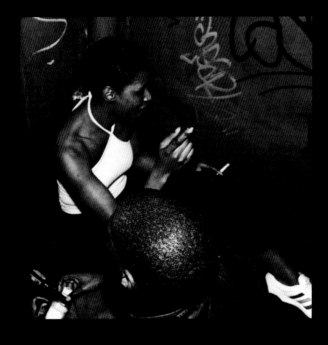

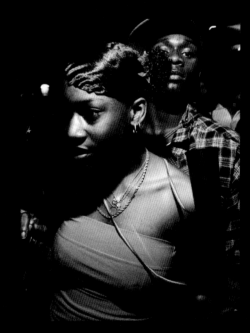

Notting Hill Carnival, 1976
Photographer: Richard Braine

Battersea Park Venture Day, 1985
Photographer: Normski

Rockers Revenge @ The Blue Note, Hoxton, 1998
Photographer: Jason Manning

Notting Hill Carnival, 2000
Photographer: Jason Manning

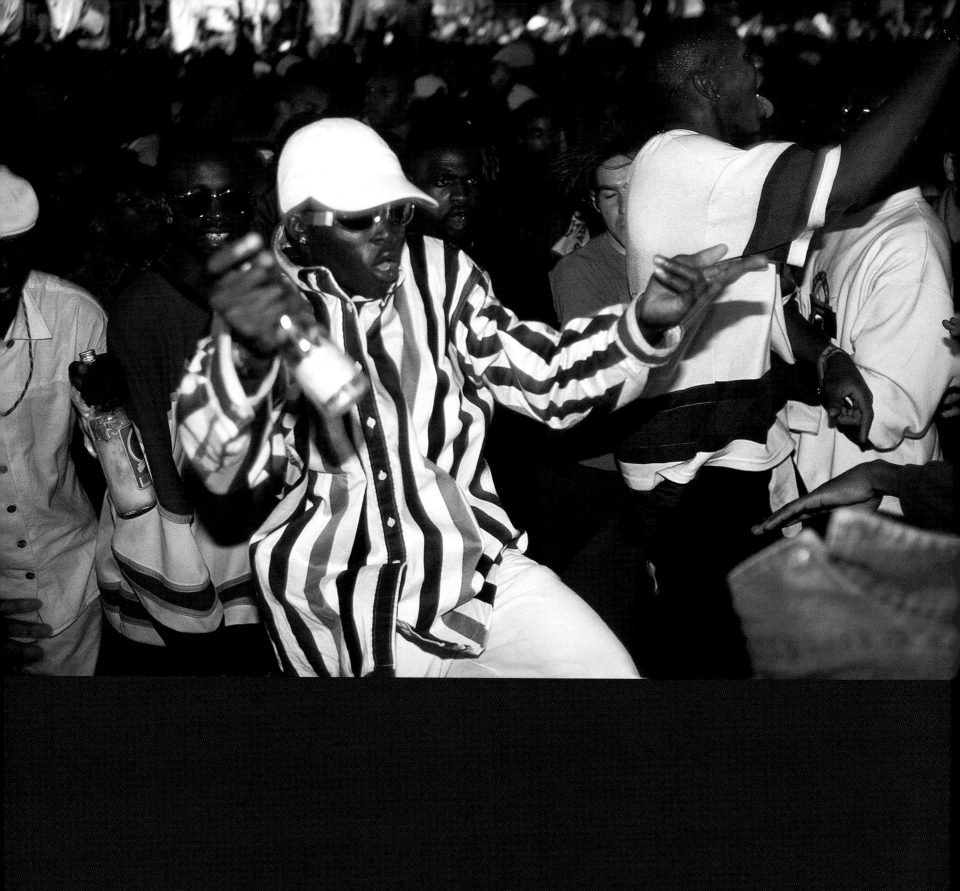

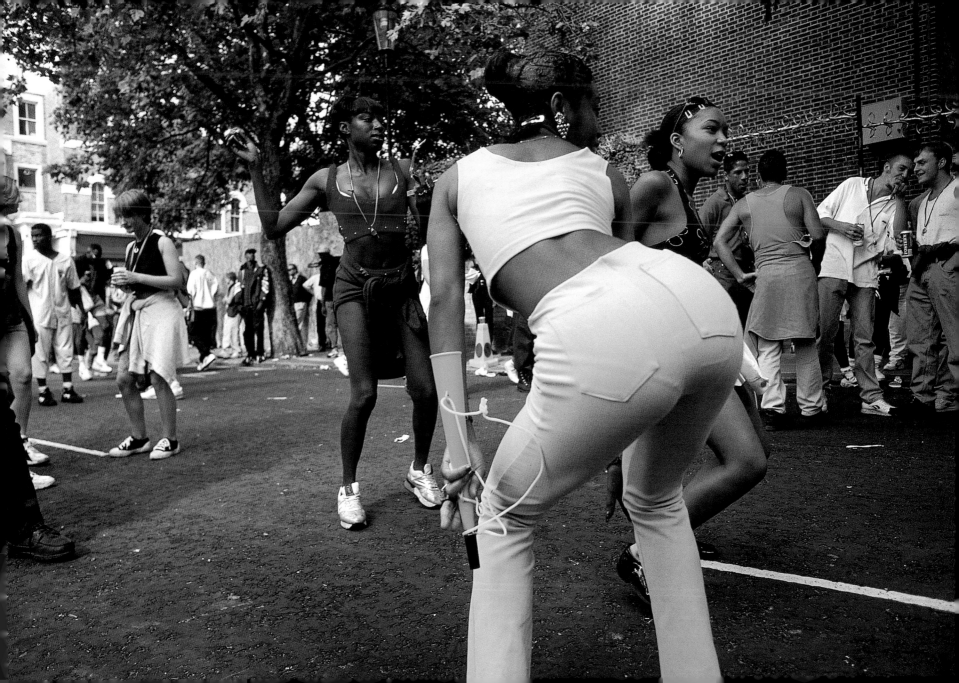

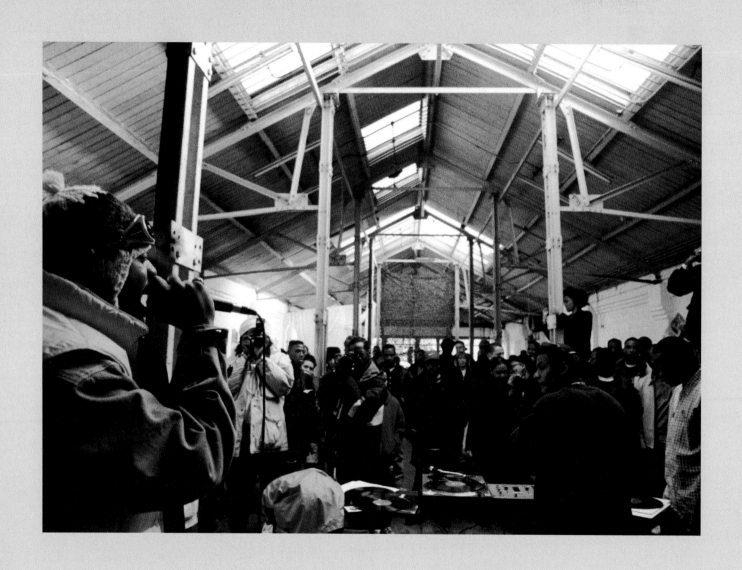

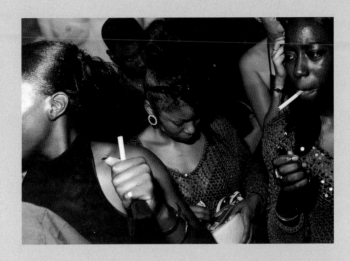

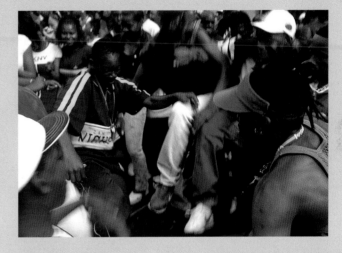

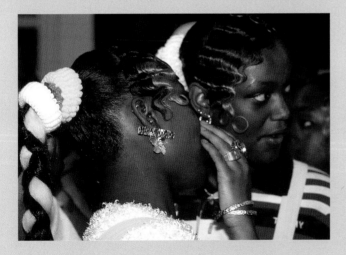

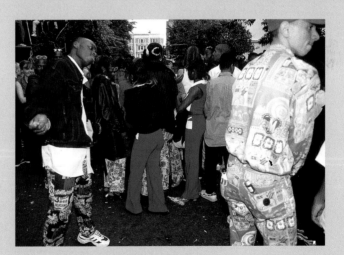

Twice As Nice @ The End, London, 2000
Photographer: Darren Regnier

Notting Hill Carnival, 1997
Photographer: Giles Moberly

Notting Hill Carnival, 1997
Photographer: Giles Moberly

Notting Hill Carnival, 1996
Photographer: Des Willie

Capadonna, Acre Lane, Brixton, 1999
Photographer: Eddie Otchere

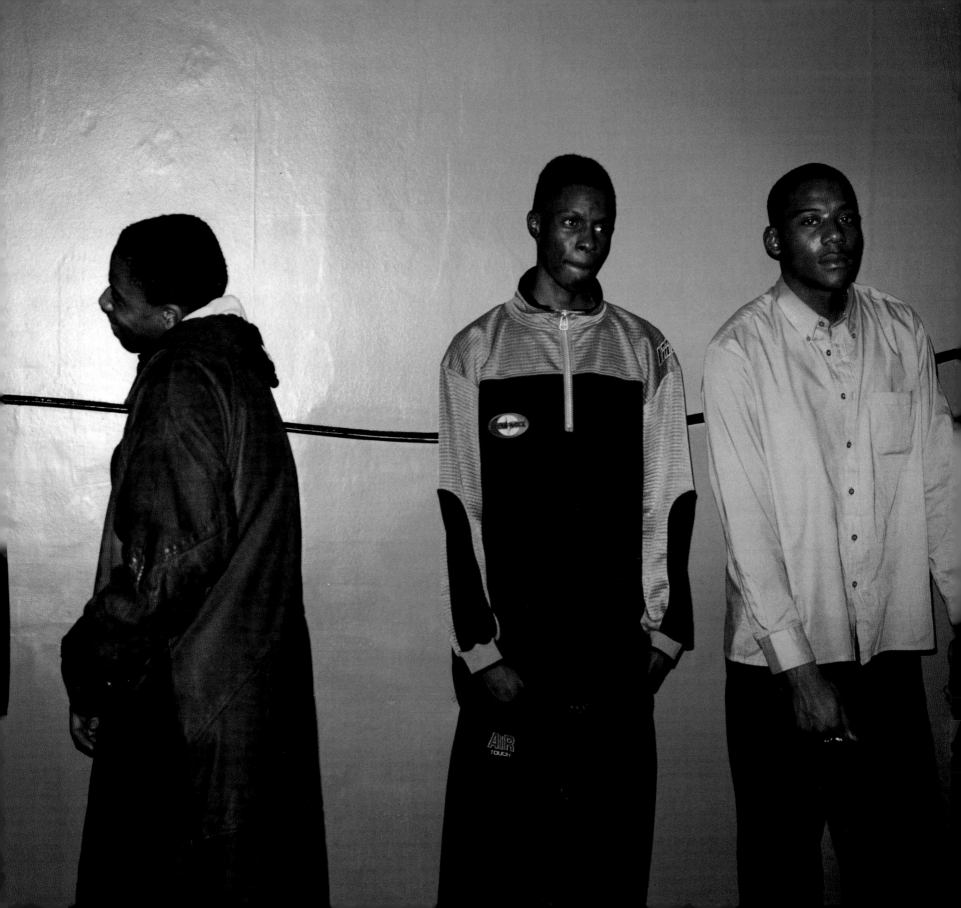

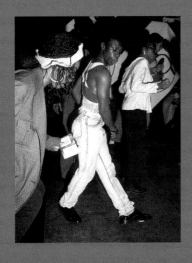

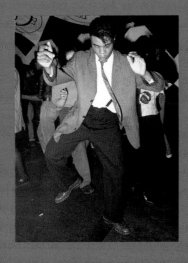

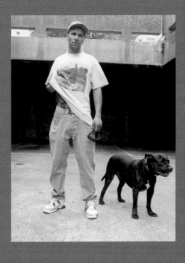

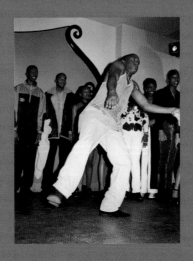

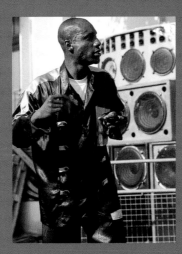

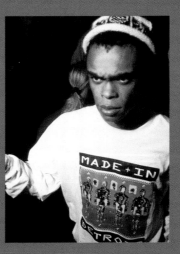

Babylon @ Heaven, London, 1988
Photographer: David Swindells

Babylon @ Heaven, London, 1988
Photographer: David Swindells

Goldie, Kentish Town, circa 1996
Photographer: Eddie Otchere

Peckham, 1997
Photographer: Liz Johnson-Artur

Notting Hill Carnival, circa 1990s
Photographer: Giles Moberly

Knowledge @ SW1 Club, London, 1993
Photographer: David Swindells

Peckham, 1997
Photographer: Liz Johnson-Artur

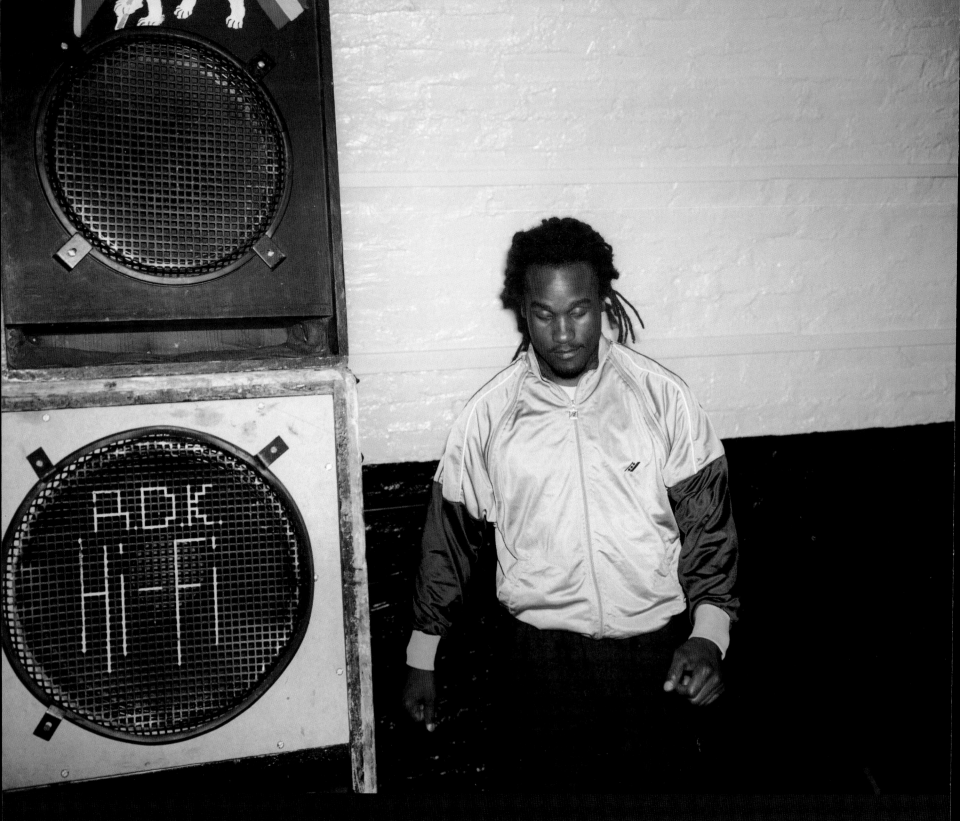

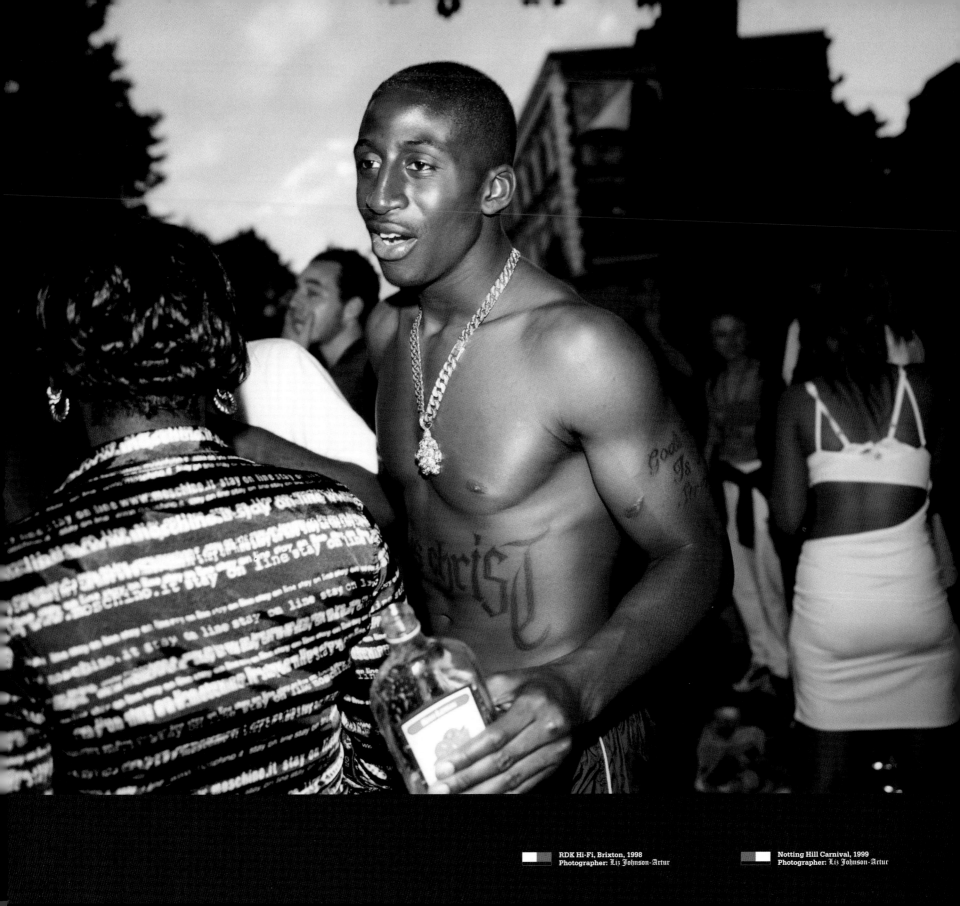

RDK Hi-Fi, Brixton, 1998
Photographer: Liz Johnson-Artur

Notting Hill Carnival, 1999
Photographer: Liz Johnson-Artur

TrevorNelson

I'd look at the DJs and think, wow. I'd look at the crowd and think, wow.
And there'd be a thousand people, all thinking they're the best dancer.

I was brought up in Hackney, but life only really started happening for me when I went to college, and for the first time I was meeting kids of every nationality and from other countries. It was my experience there that led me to go clubbing. Before that I hoarded records, but I didn't really go out. Then, being around all these people, I felt enlightened. I was 18; and that year at college changed my life.

The Electric Ballroom in Camden was the first club I ever frequented. Paul Anderson, the DJ, was a total hero for me at that time. I'd go there every week, queue up, go in and buy a Tango, which was all I could afford. At 10.30pm Paul would come on and he would say the same thing every week; "Paul Trouble Anderson, first one down". That's all he'd say. I'd drop my can of Tango, run on the dance floor and it was pure Electro; ET Boogie, Smurf, Planet Rock, Kraftwerk, he'd even play Michael Jackson's "Wanna Be Starting Something", 'cos it was electronically produced. To me it was like heaven or utopia.

There were guys walking around the club doing the robotic dance and I would just be following them around. It was ridiculous! The club was on two floors with two different styles of clothing. Downstairs, where it was Electro boogie dancing, I had the "Raiders of the Lost Ark" kinda look, which was sick. I would wear, literally, a Harrison Ford hat with a brown, distressed leather flight jacket, ankle boots and trousers tucked into them. At some point you even had the leg warmer action going over the very tight jeans. Upstairs it was jazz fusion, and a lot more serious. You could dance in the same boots, but you'd take your jacket and maybe your hat off. It was a little room and there was an elite who were like the gods; they would tear the floor up. And you did not touch the floor unless you could boogie. You hit the middle if you could really dance; you hit the sides if you were decent, and you danced outside the room if you were intermediate!

For going out I had all kinds of shoes I bought in Carnaby Street; blue patent, pony skin and brown patent. In 1982 you could go to the King's Road and buy some outlandish leopard-skin top with chains and Wild Youth written on it. You could go to Laurence Corner and get your second-hand army gear or a band-leader jacket. And you always had a sports bag 'cos if you lived in Hackney you couldn't walk down the street with any of that stuff on. Hackney was so closeted, so limited in its attitude; you go clubbing half a mile up the road, that was the mentality. You would see the same people everywhere and every party was a reggae party.

So I got more enjoyment out of getting on a bus or a train or a coach and going clubbing all across the country. For me it was all about getting there, meeting tribes from all over the place, and getting changed in the toilets. Loads of guys used to do that. The toilets were crammed with guys getting changed and then hitting the dance floor. I'd look at the DJs and think, wow. I'd look at the crowd and think, wow. And there'd be a thousand people, all thinking they're the best dancer, all really going for it. It was a wicked sight.

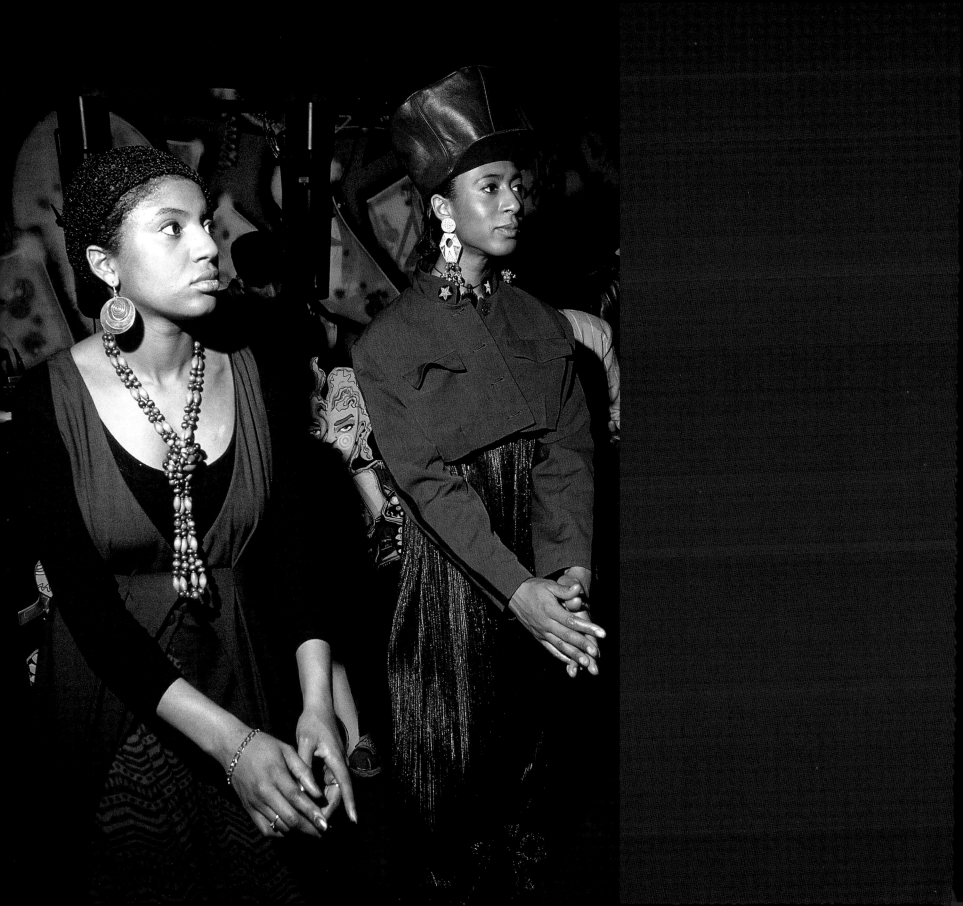

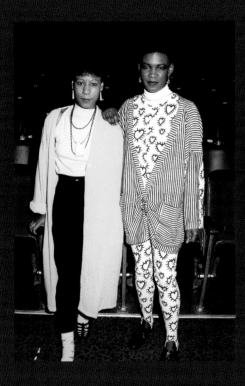

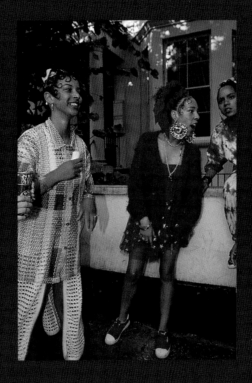

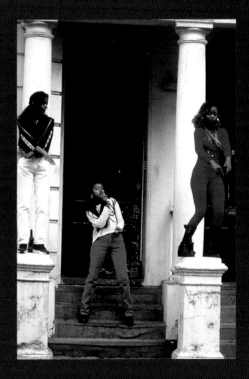

Flipside @ The Iceni, London, 1983
Photographer: David Swindells

Soul Weekender, Bognor Regis, 1986
Photographer: David Swindells

Notting Hill Carnival, 1994
Photographer: Giles Moberly

Notting Hill Carnival, 1995
Photographer: Des Willie

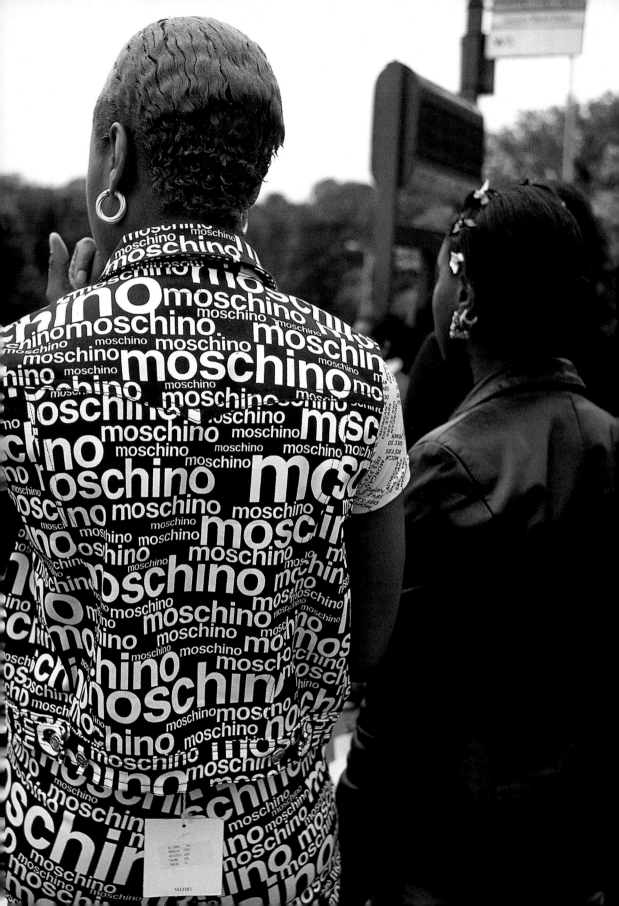

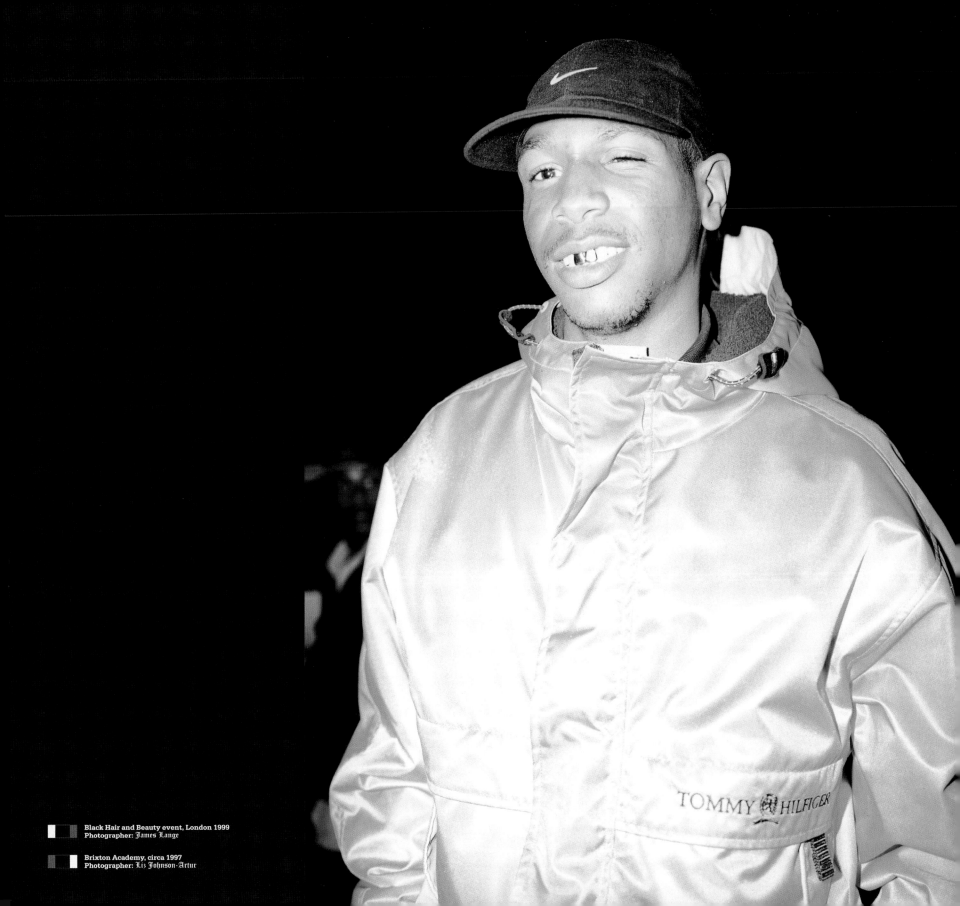

Black Hair and Beauty event, London 1999
Photographer: James Lange

Brixton Academy, circa 1997
Photographer: Liz Johnson-Artur

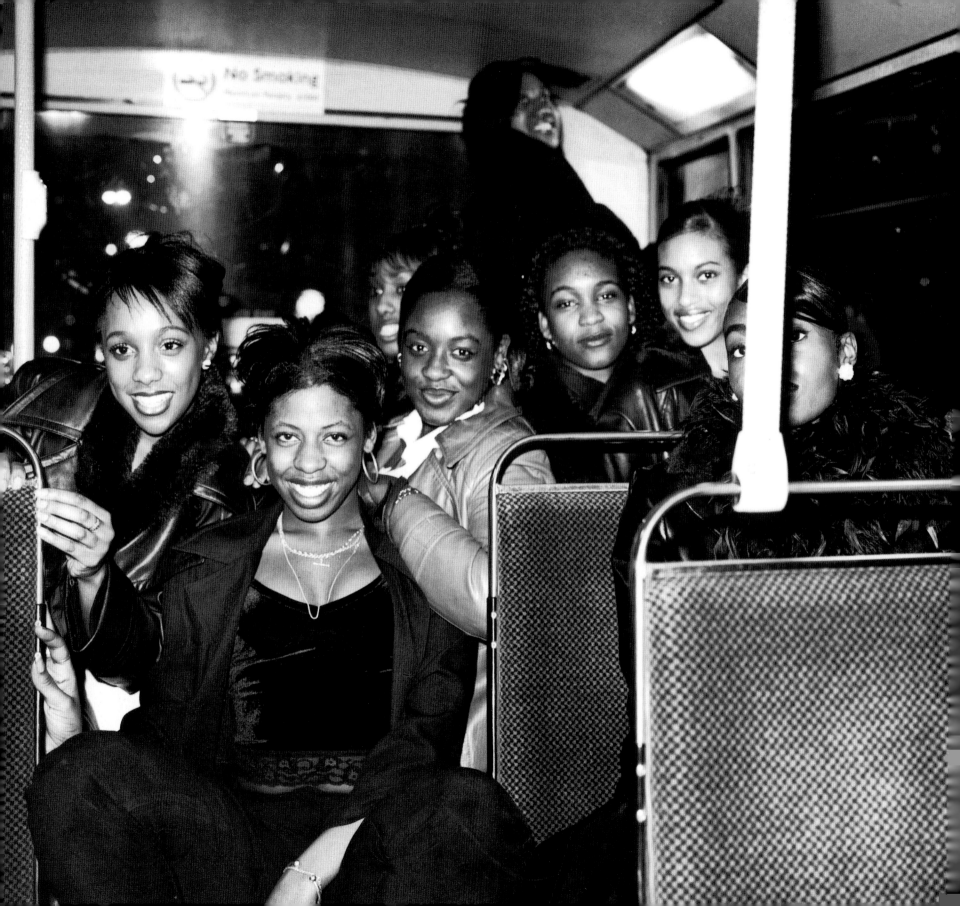

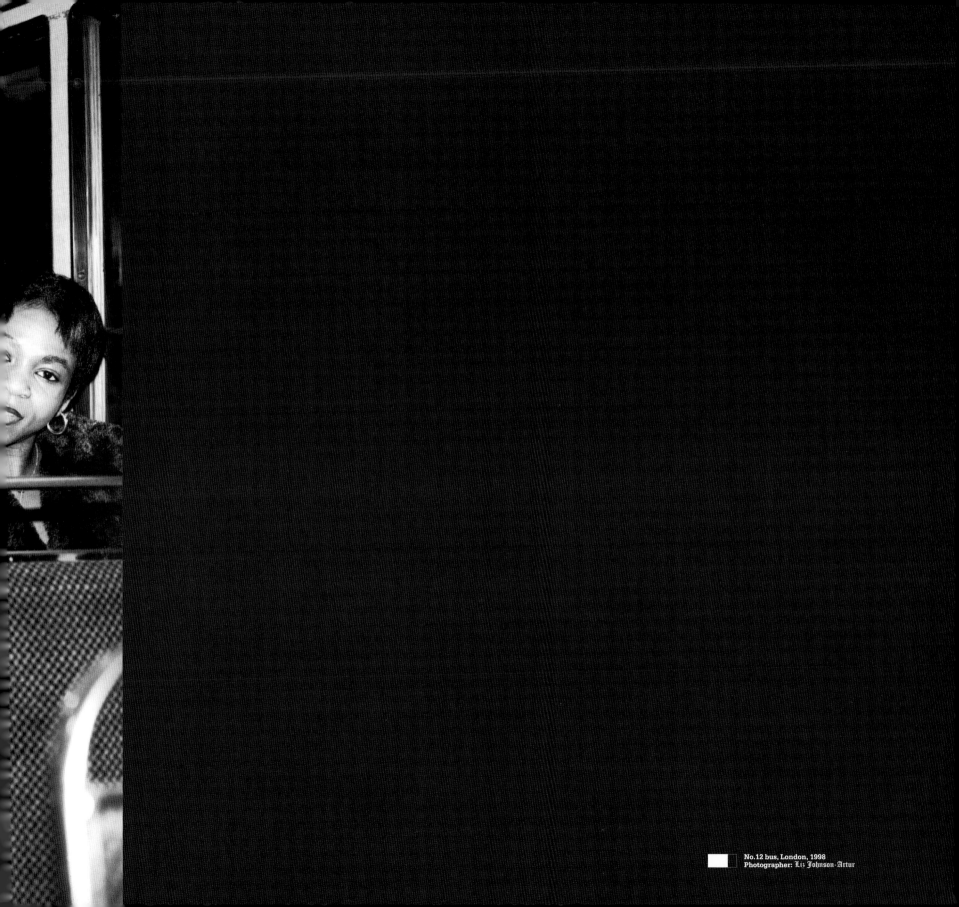

No.12 bus, London, 1998
Photographer: Liz Johnson-Artur

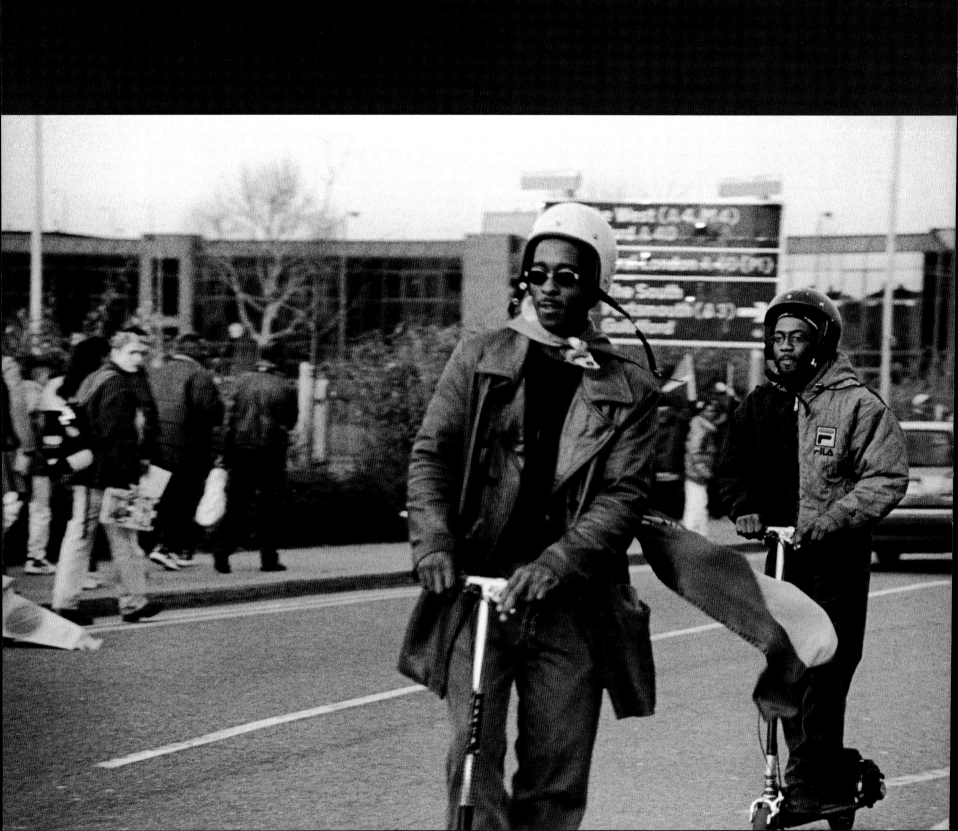

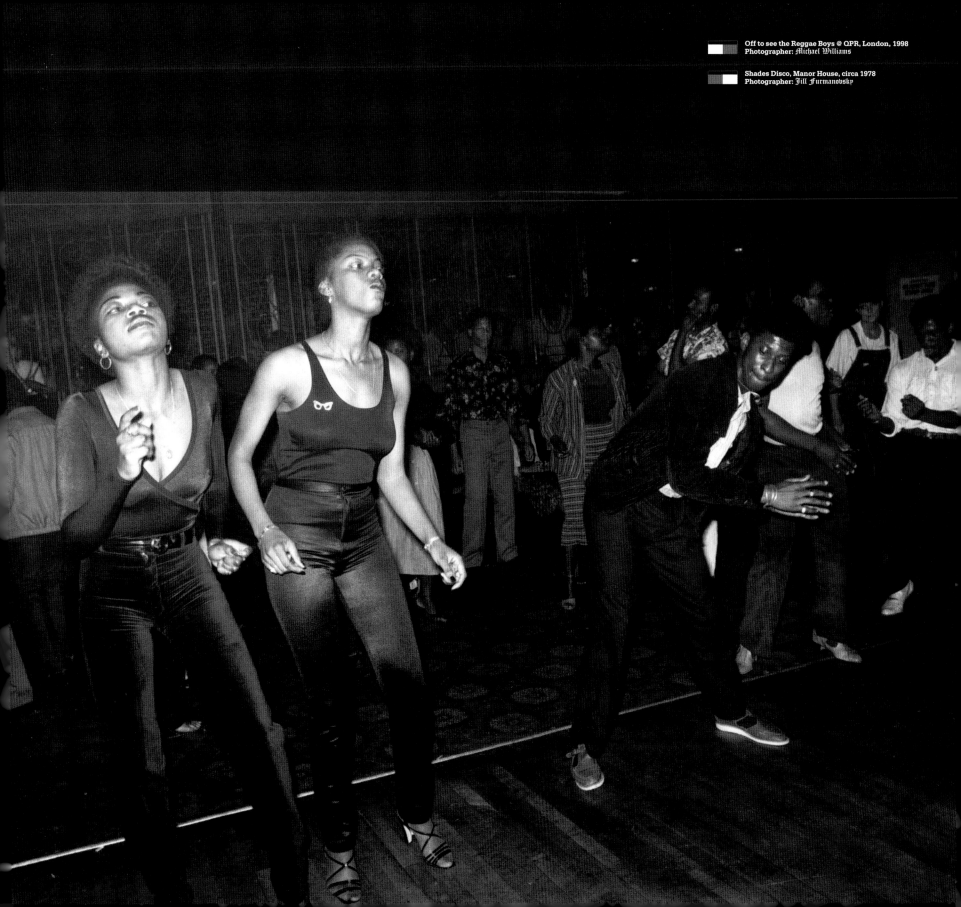

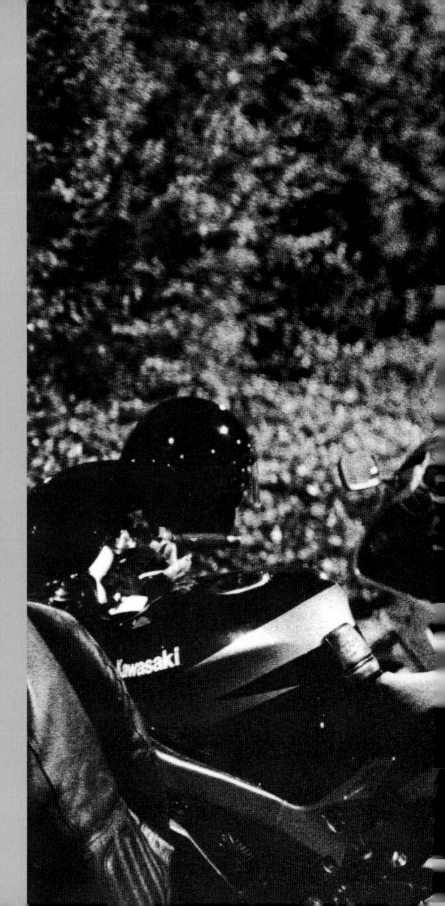

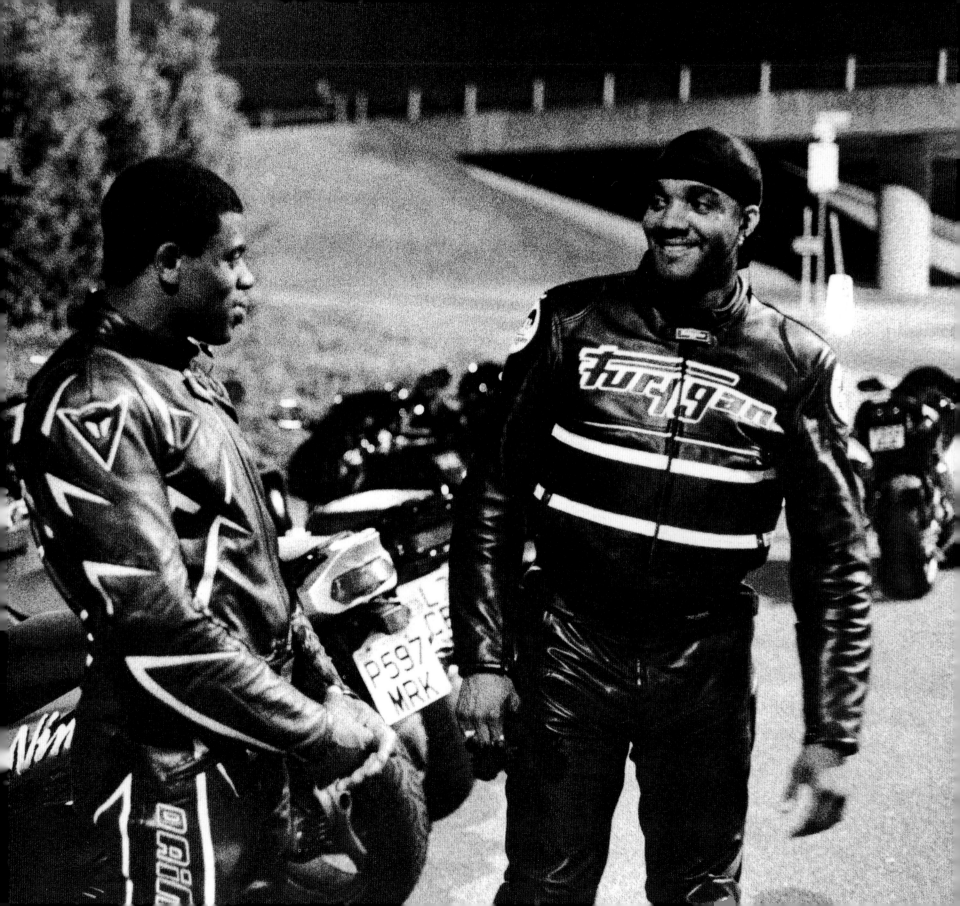

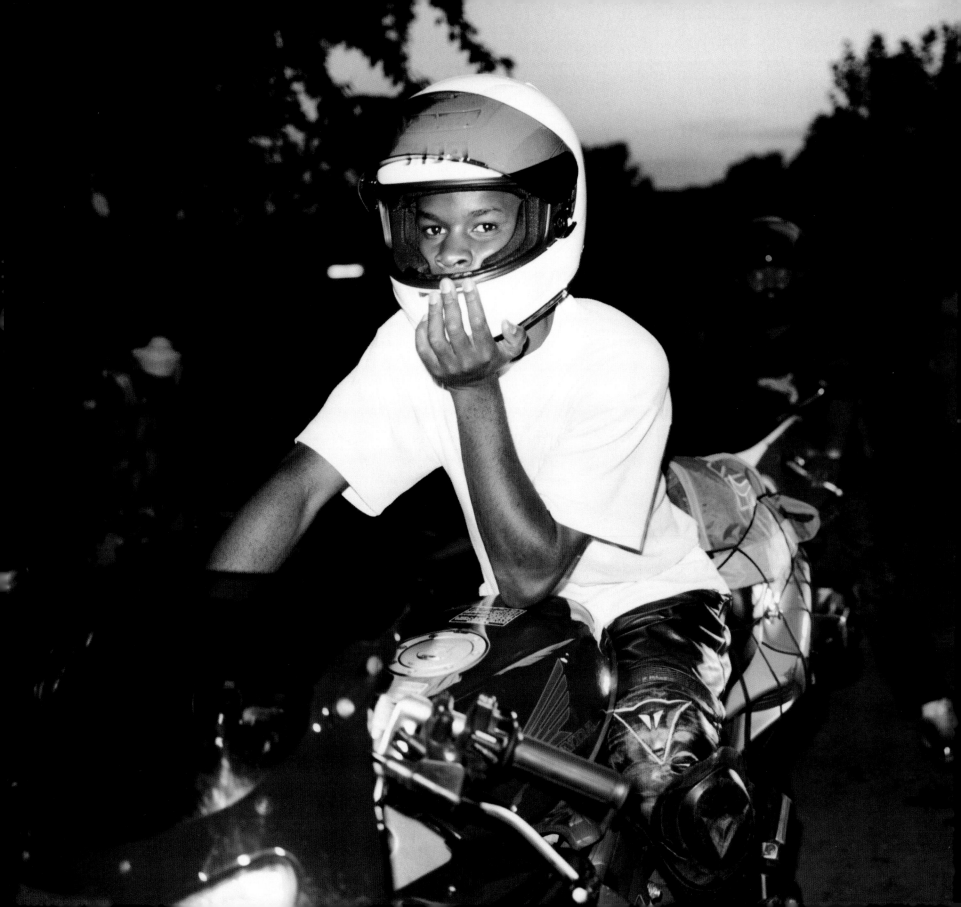

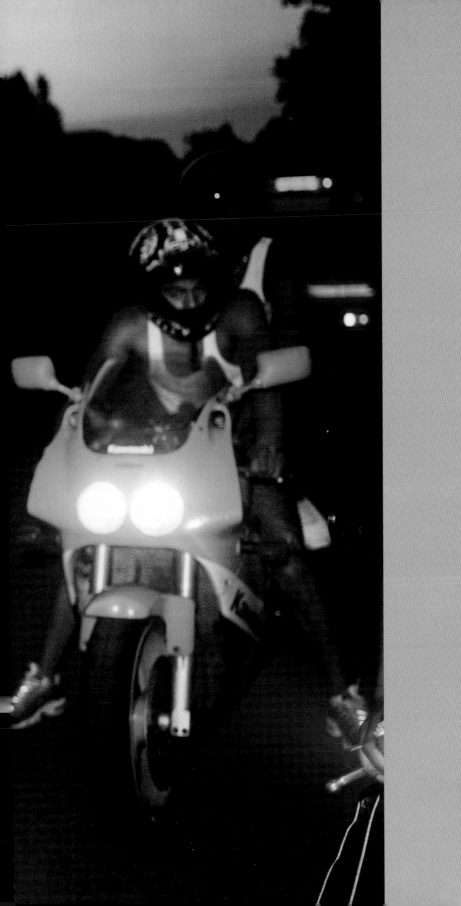

Victoria Park, Hackney, 1998
Photographer: Liz Johnson-Artur

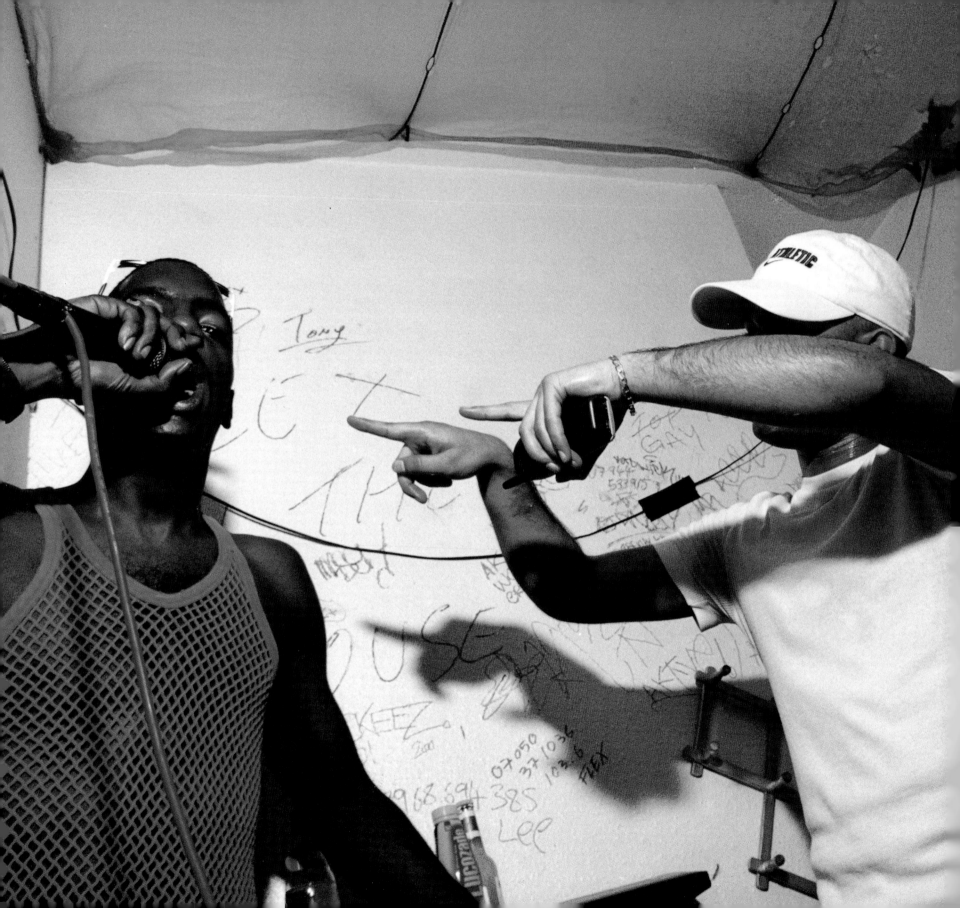

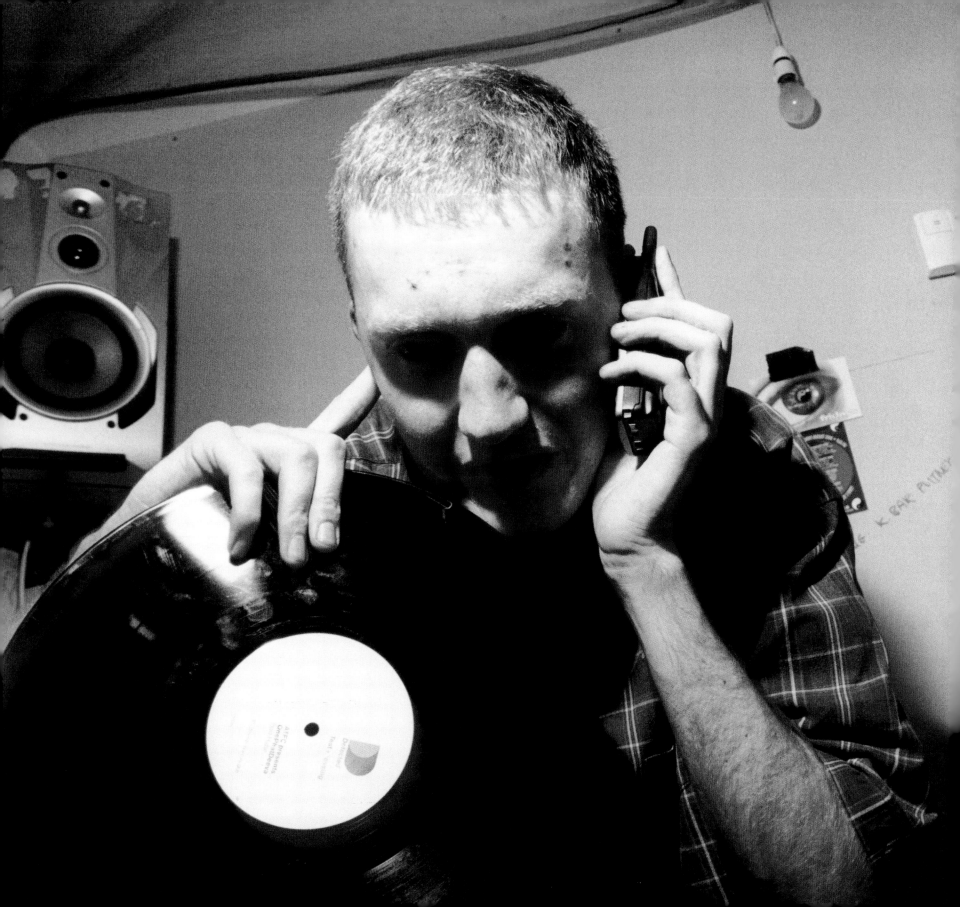

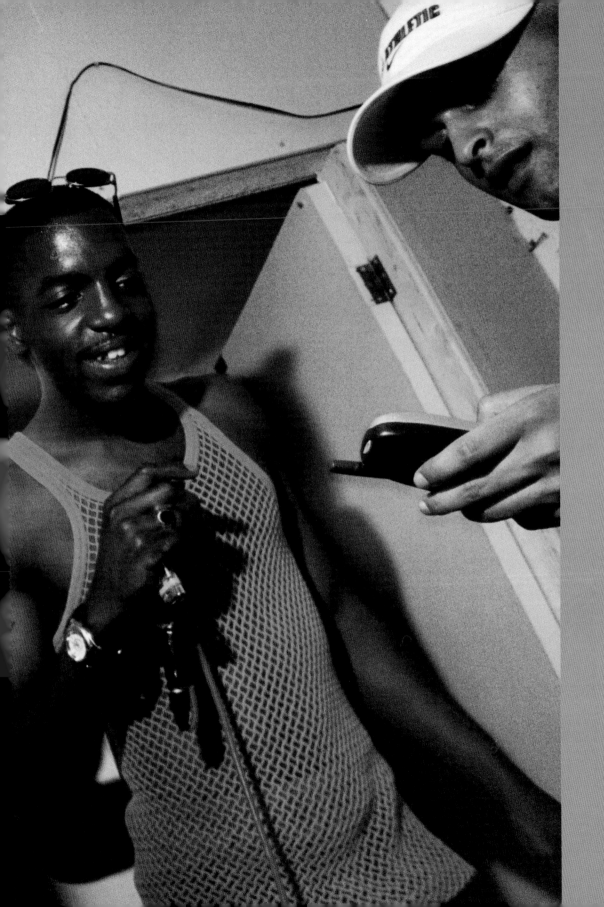

Flex FM, South London, 2000
Photographer: Darren Regnier

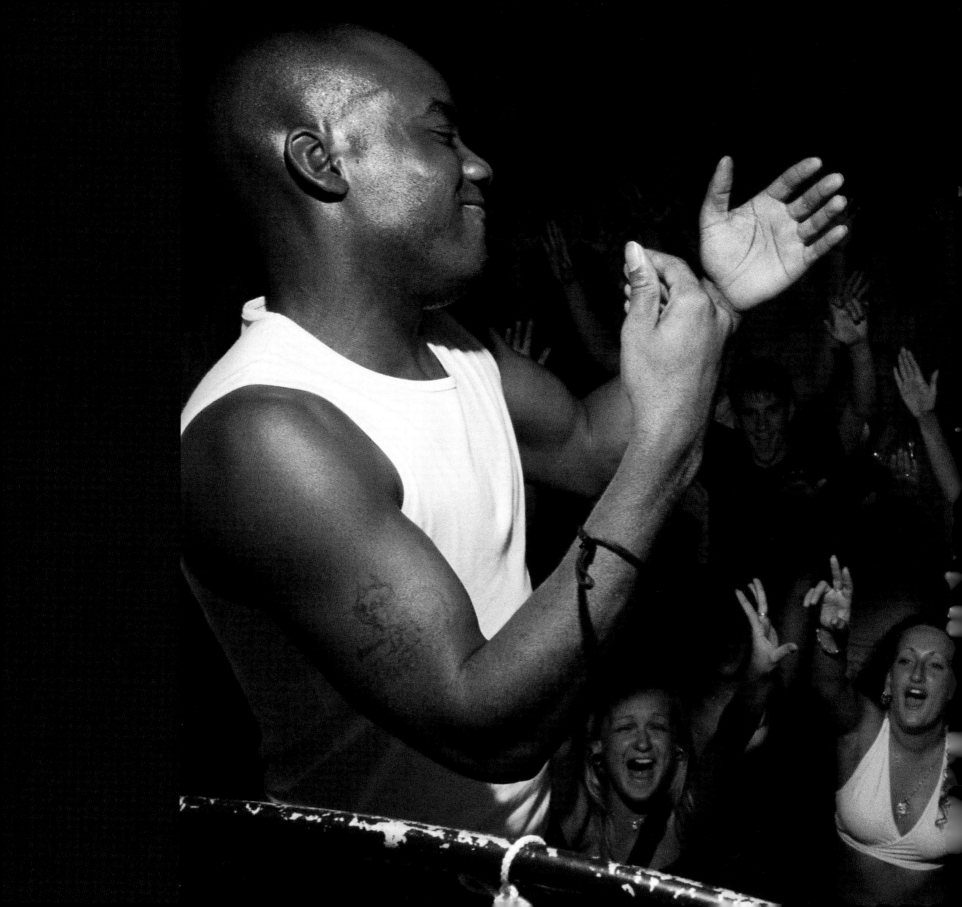

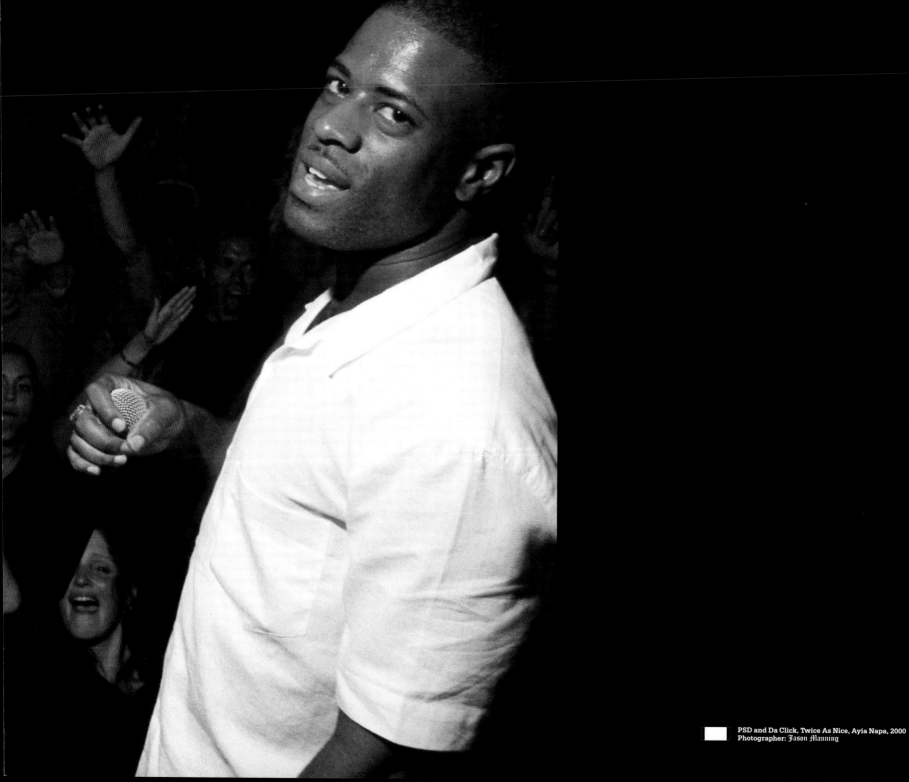

PSD and Da Click, Twice As Nice, Ayia Napa, 2000
Photographer: Jason Manning

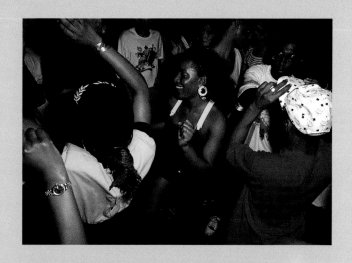

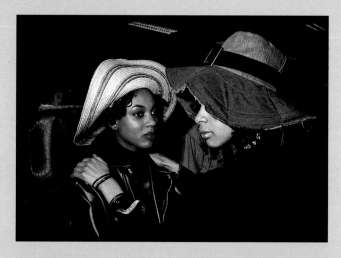

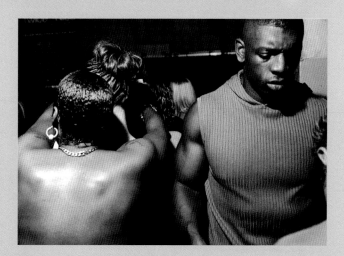

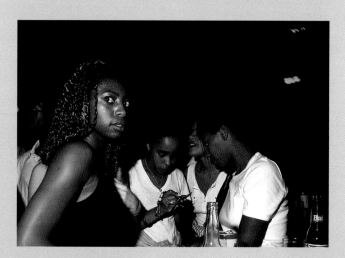

Soul II Soul @ The Fridge, Brixton, 1989
Photographer: David Swindells

Carwash, London, 1988
Photographer: David Swindells

Twice As Nice @ The End, London, 2000
Photographer: Ewen Spencer

Slow Motion @ Maximus, London, 1991
Photographer: David Swindells

Dynamic 3 @ Hip Hop Alliance, Brixton, 1986
Photographer: Normski

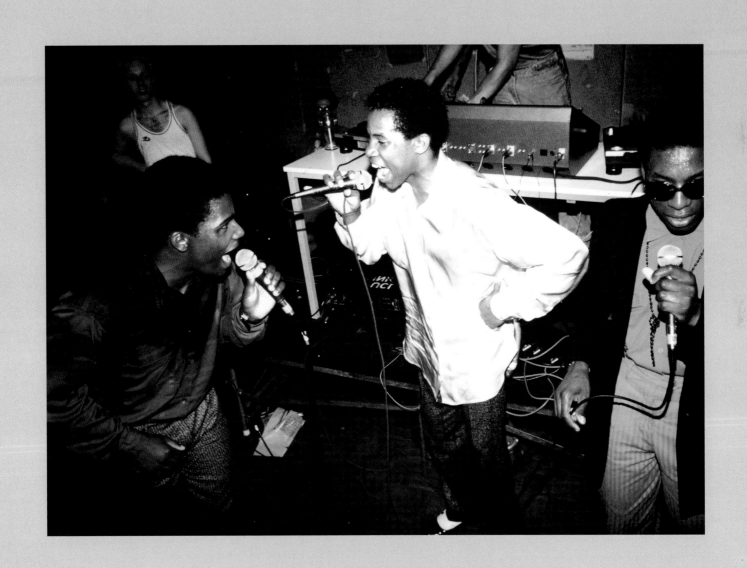

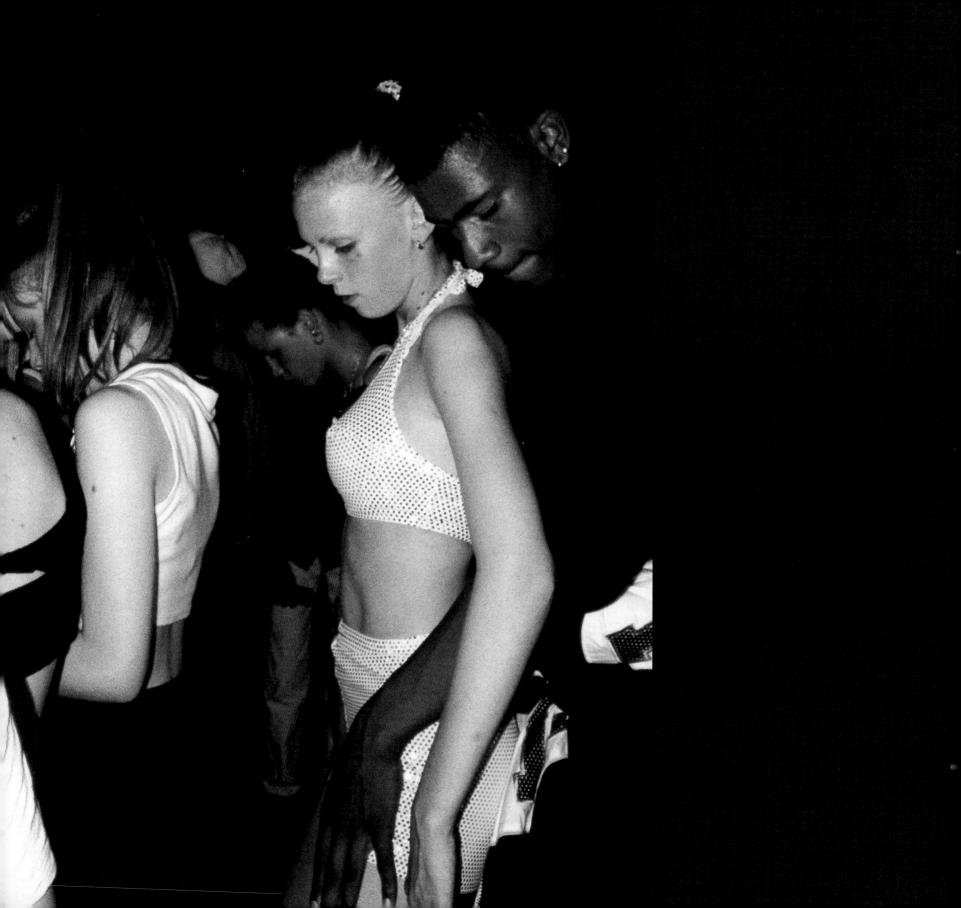

Under 18 Night, Kingston-on-Thames, 1996
Photographer: Courtney Hamilton

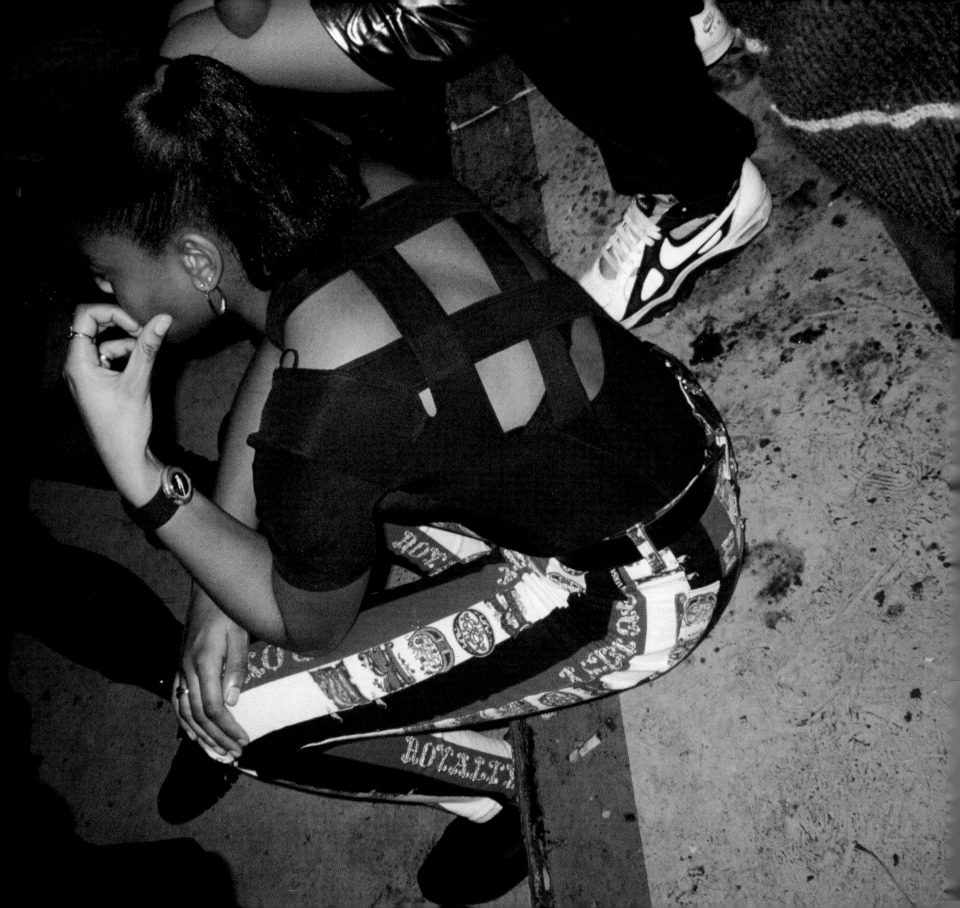

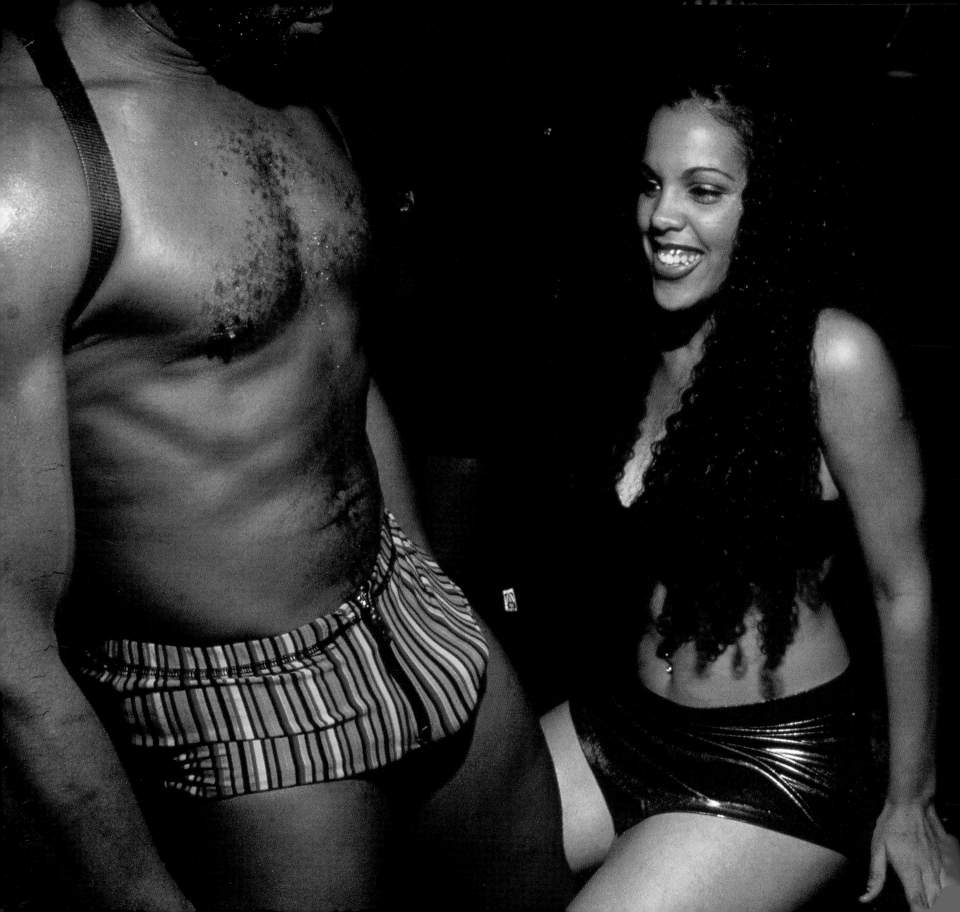

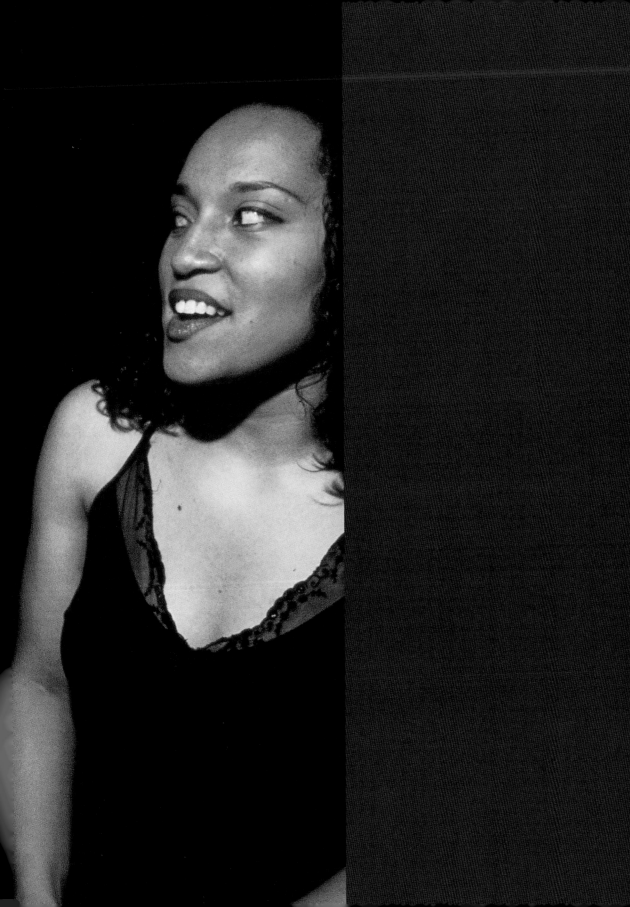

Twice As Nice @ The Colosseum, London, 1999
Photographer: Jason Manning

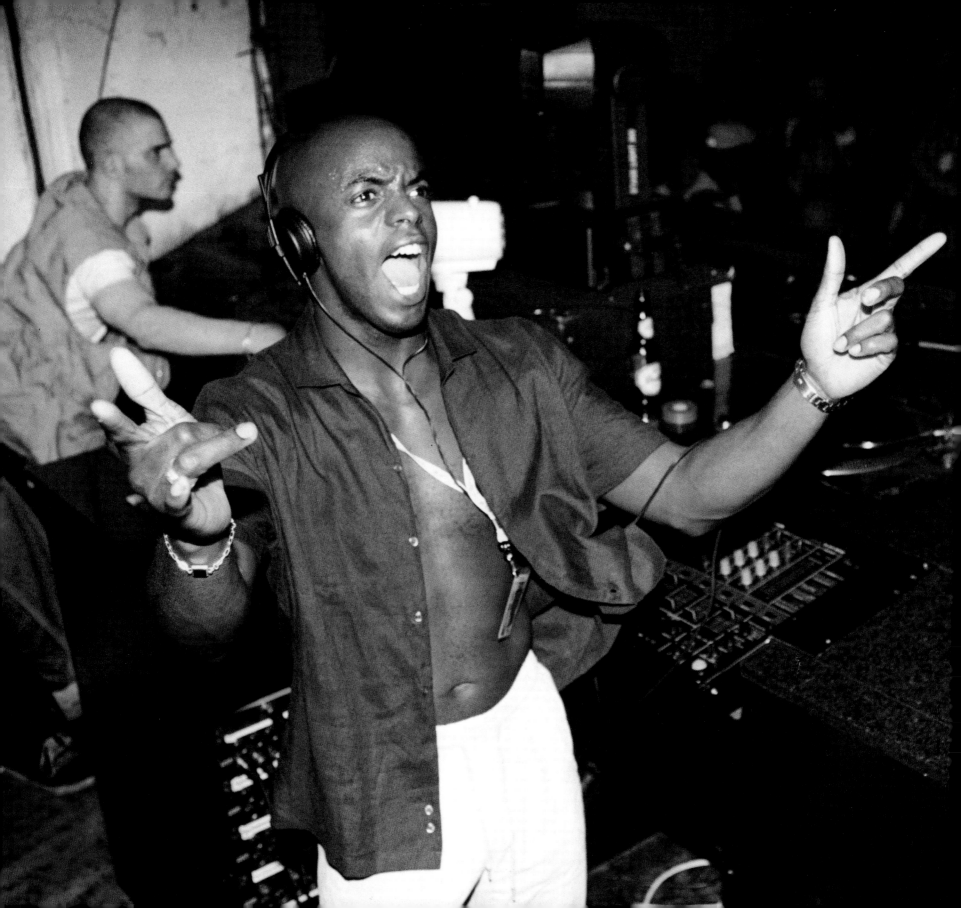

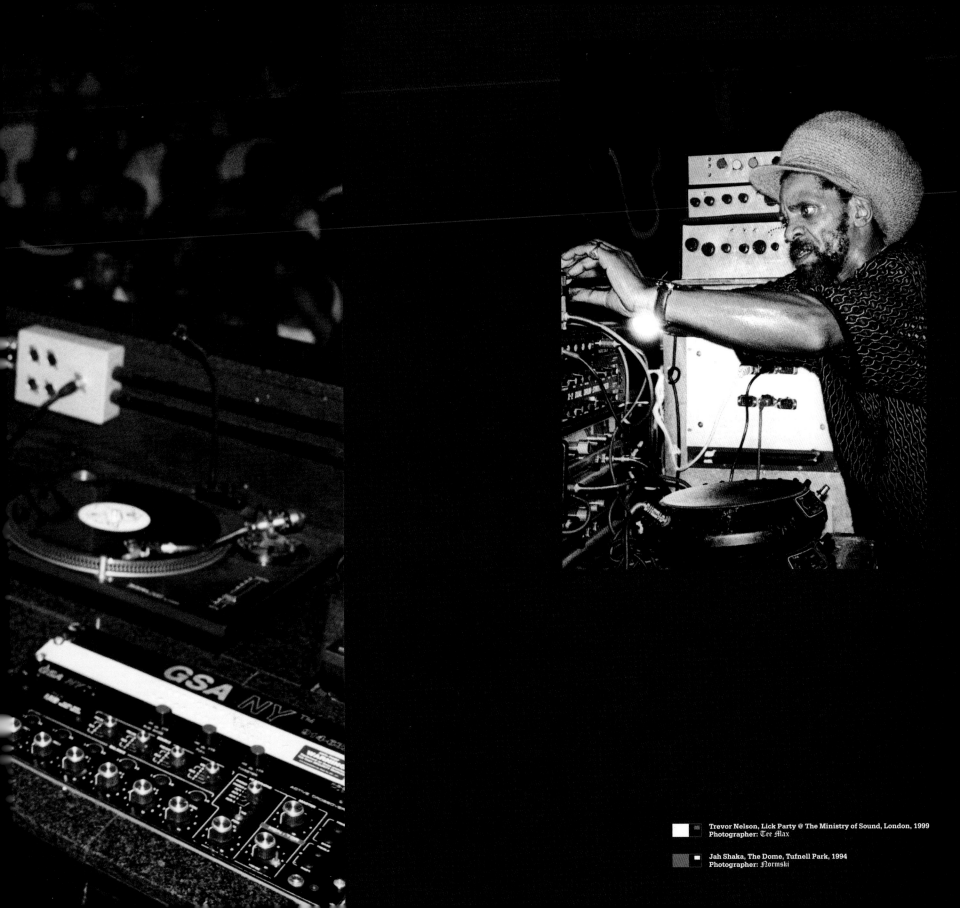

Trevor Nelson, Lick Party @ The Ministry of Sound, London, 1999
Photographer: Tee Max

Jah Shaka, The Dome, Tufnell Park, 1994
Photographer: Normski

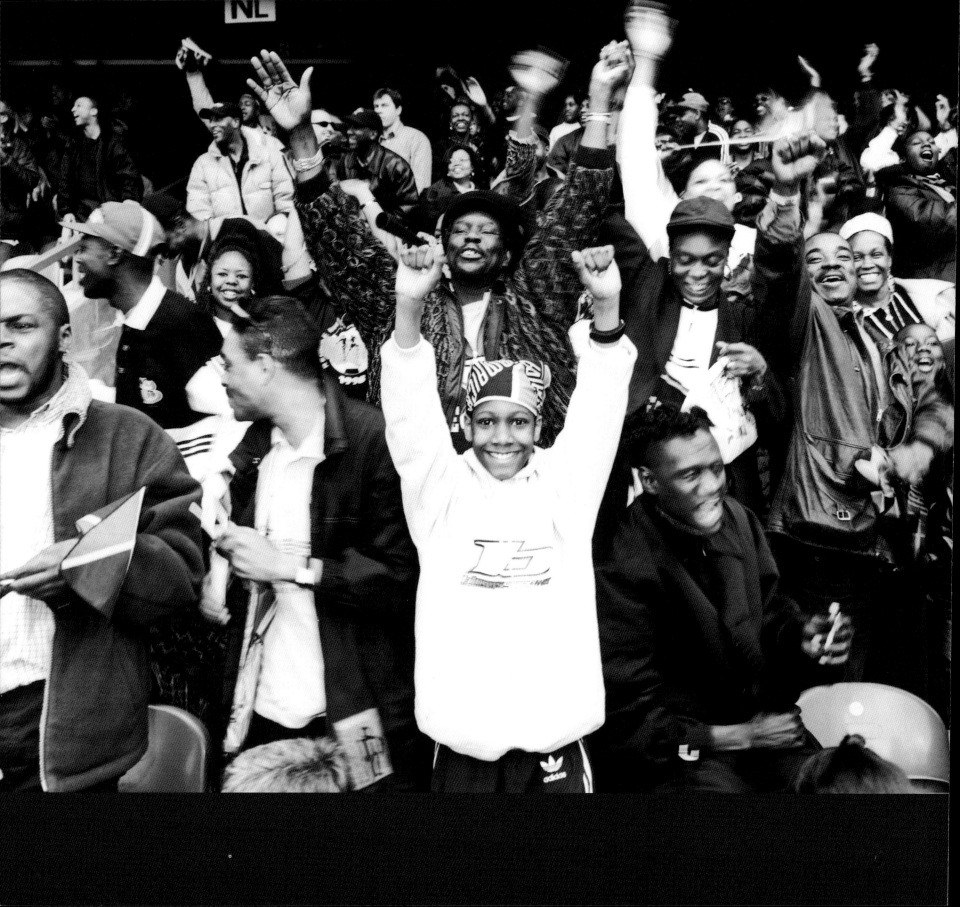

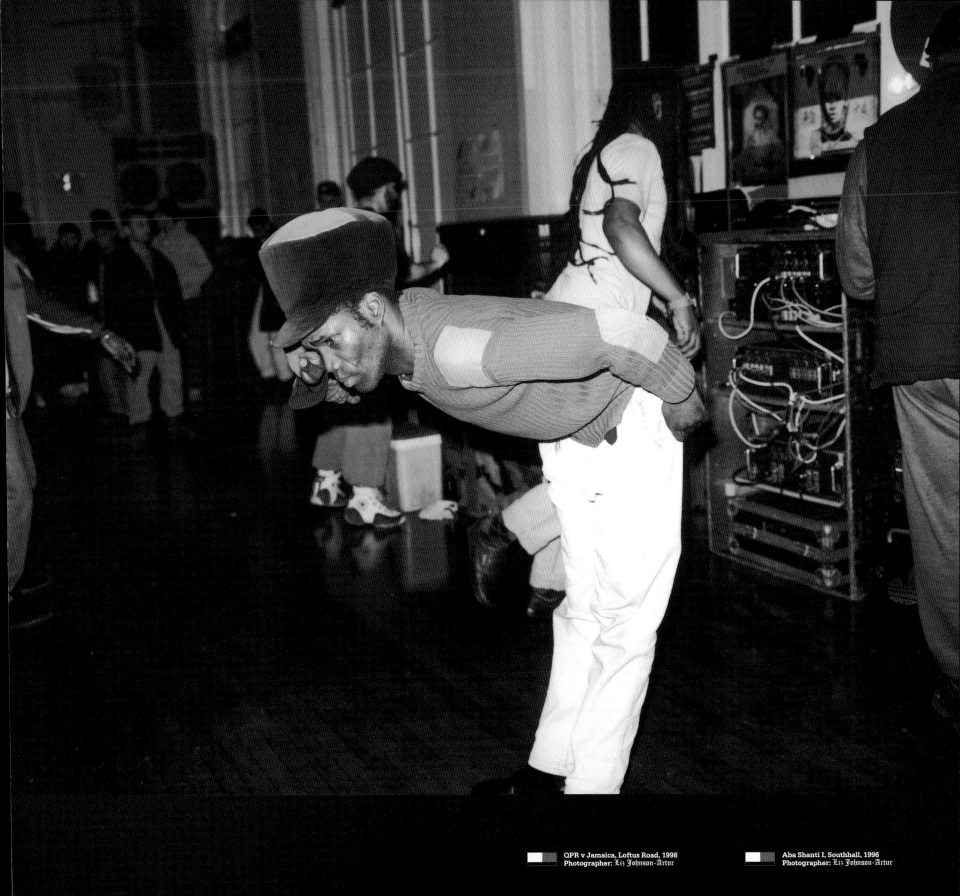

QPR v Jamaica, Loftus Road, 1998
Photographer: Liz Johnson-Artur

Aba Shanti I, Southhall, 1996
Photographer: Liz Johnson-Artur

House of Roots @ The Blue Note, Hoxton 1998
Photographer: Jason Manning

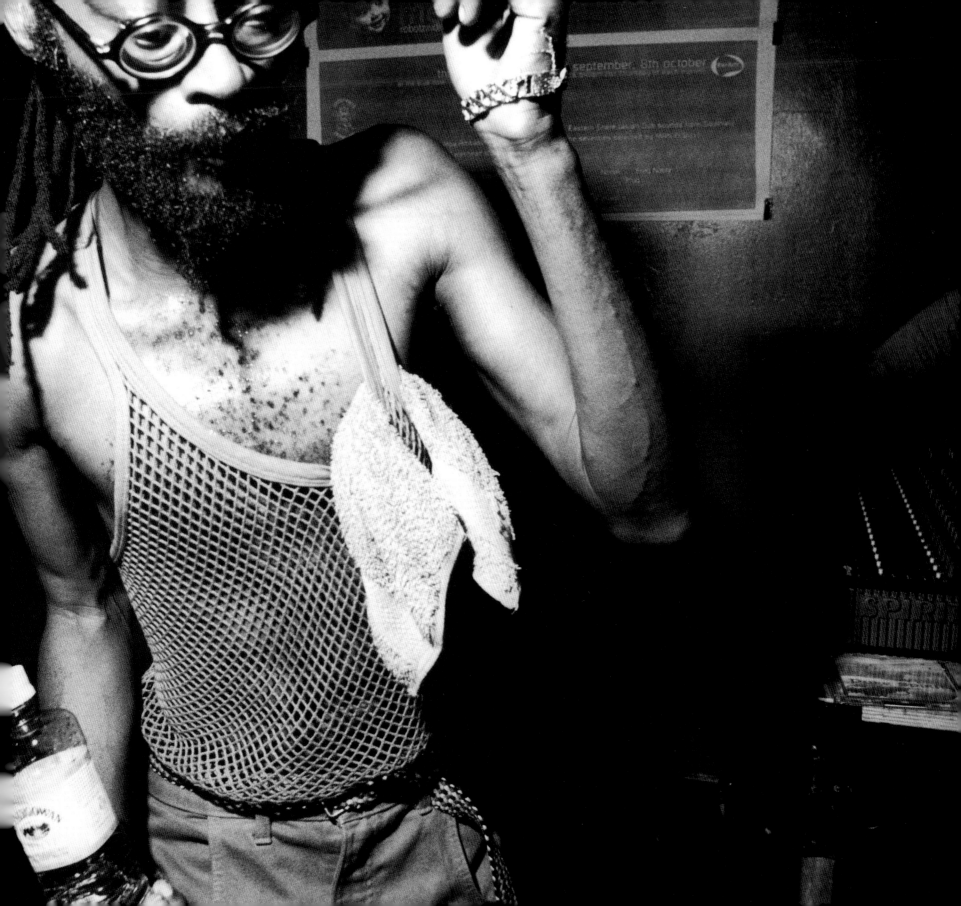

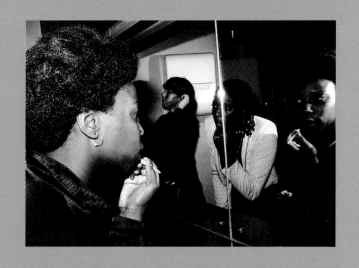
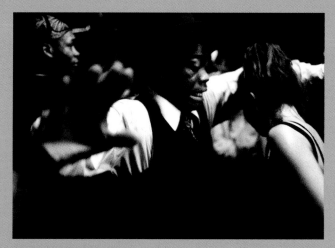
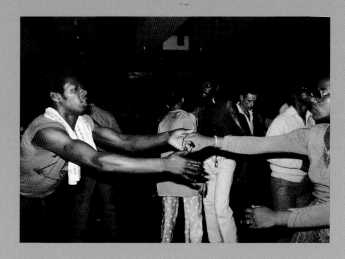
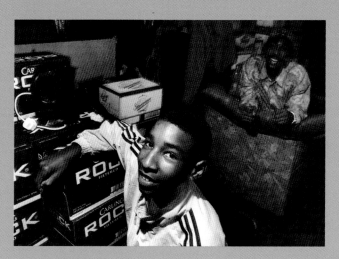

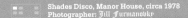 **Shades Disco, Manor House, circa 1978**
Photographer: Jill Furmanovky

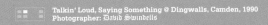 **Talkin' Loud, Saying Something @ Dingwalls, Camden, 1990**
Photographer: David Swindells

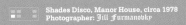 **Shades Disco, Manor House, circa 1978**
Photographer: Jill Furmanovky

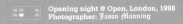 **Opening night @ Open, London, 1998**
Photographer: Jason Manning

Voodoo Magic @ The Empire, Leicester Square, 1995
Photographer: Michael Williams

Voodoo Magic @ The Empire, Leicester Square, 1995
Photographer: Michael Williams

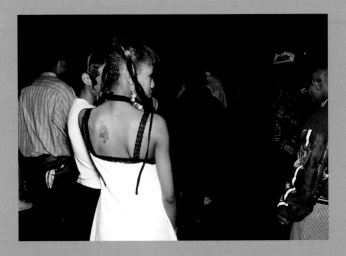

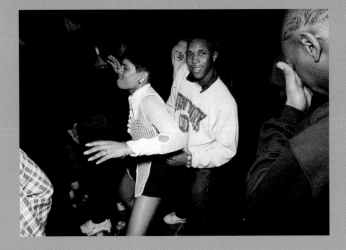

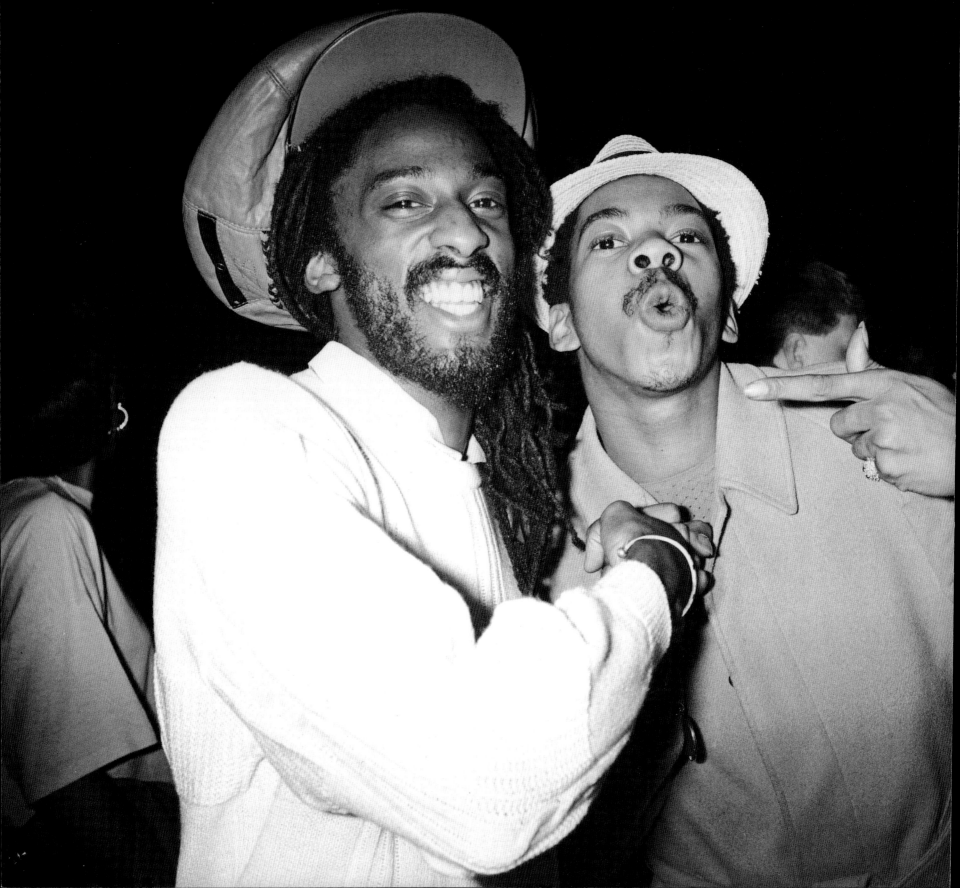

Drummie Zeb and Smiley Culture, Sickle Cell charity event, London, 1986
Photographer: Normski

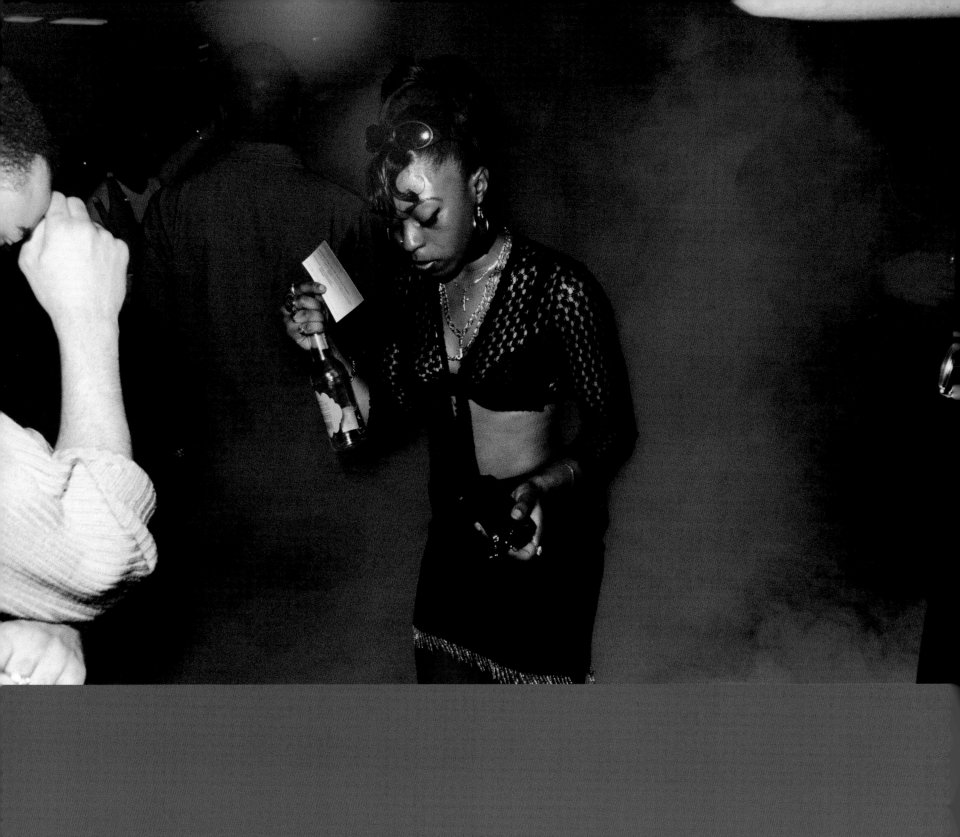

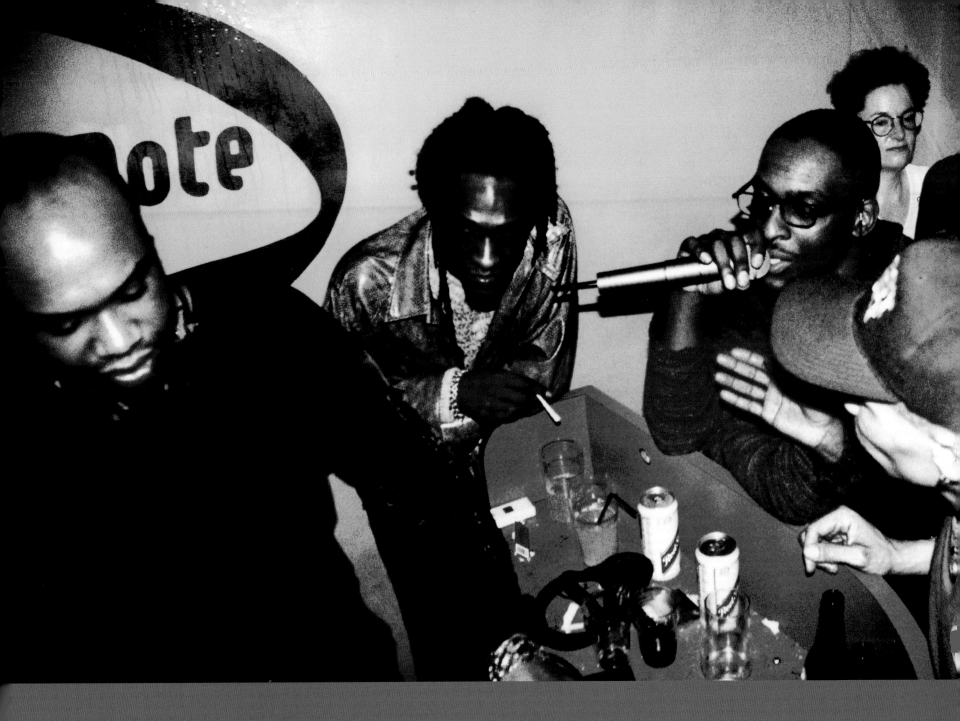

Liberty's @ The Colosseum, London, 1999
Photographer: Darren Regnier

Grooverider, Fabio, Cleveland Watkiss and Goldie, Metalheadz @ The Blue Note, Hoxton, 1997
Photographer: Eddie Otchere

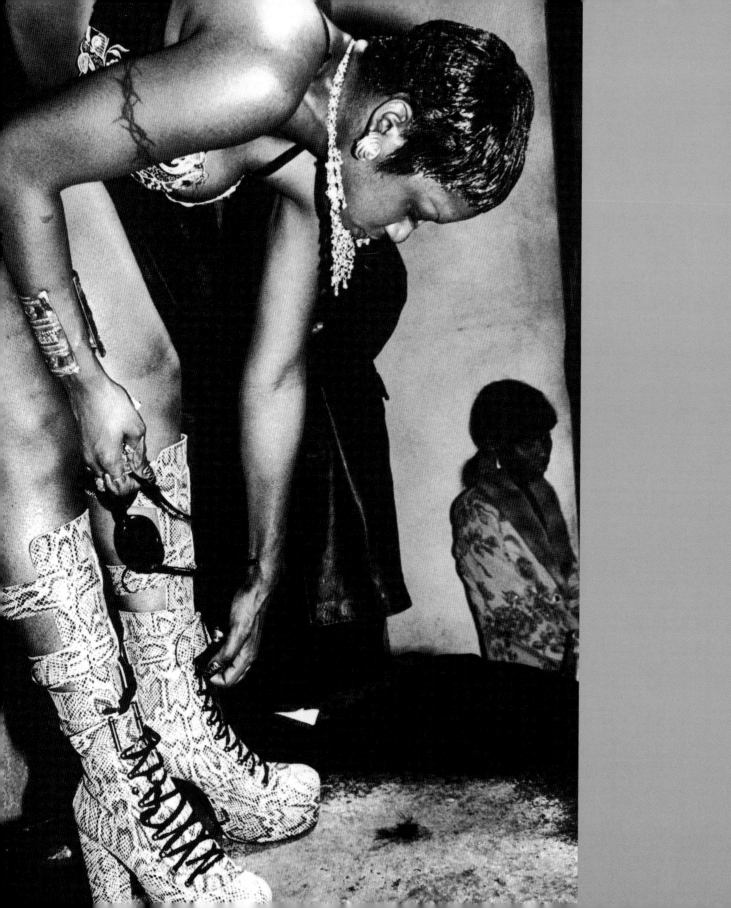

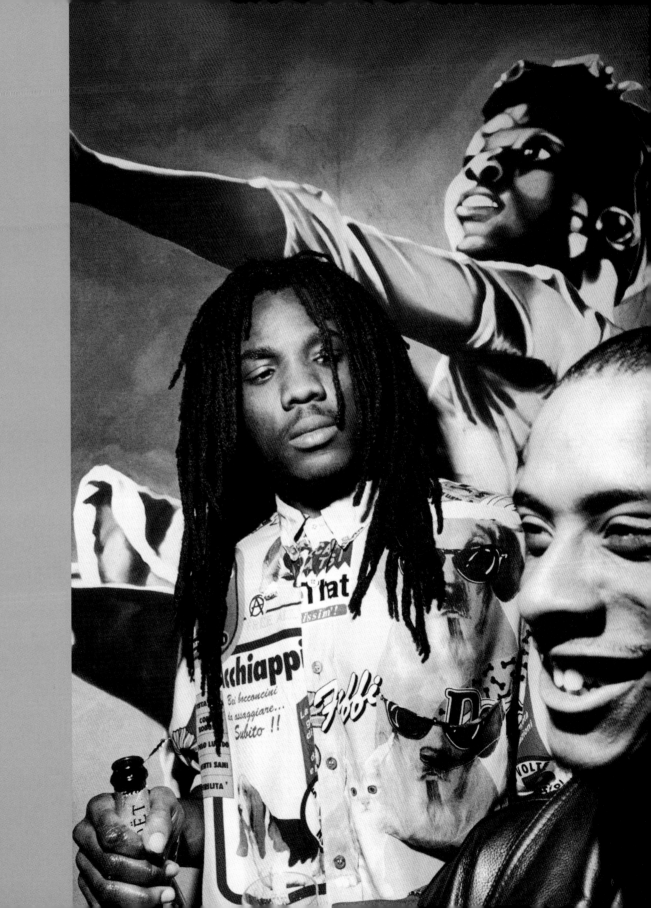

The Temple, London, 1997
Photographer: Charlie Freed

Twice As Nice @ The Colosseum, London, 1998
Photographer: Jason Manning

Spoony

The Dreem Teem became synonymous with suits, shirts and ties, and we often got pictured that way, and that made it easier for people to do it too and not look out of place.

From 1996 to 1997 the clubs were brilliant because it was something brand new; brand new to the people playing the music and brand new to the people coming into the club. What you were seeing was a snapshot of London; cosmopolitan, - well-dressed people, just partying, it was a carnival atmosphere with four walls and a roof.

For me, it was all about the Arches on the Embankment at Southwark Bridge. That typified the look and the sound, with people having whistles and the horns-men were there and the girls in wicked outfits, in a funky old venue. You'd stand back and think, wow, this is something different. There were clubs before that, like Garage City at the Coliseum, but this was where UK Garage started having its own identity.

To be honest though, personally, the whole D&G, Moschino thing, the whole printed labels on the outside thing, was not what it was about for me. It was about wearing black trousers and a black shirt and a belt and shoes, quite plain but quite smart. I've been ironing my own clothes since I was about eight and washing my own white shirts every day when I came home from school, so it was easy to go from doing that while I was at school to doing it for myself.

People have often said, you guys, the Dreem Teem started this whole thing off. There is an element of truth in it, 'cos the Dreem Teem became synonymous with suits, shirts and ties, and we often got pictured that way, and that made it easier for people to do it too and not look out of place. But I saw the whole thing change and start developing. I actually think there were more people out there that wanted to dress smart but felt they couldn't. Then they saw a few people do it and followed suit. To stand in a club and see everyone in shirts and trousers with shirts tucked in and leather-soled shoes and girls in dresses and sandals as opposed to trainers and track-suit bottoms, that was totally different. Maybe it was a black thing; the whole glam, dressing-up, going out and partying thing. If you see old videos and stuff, it wasn't suits they were wearing but they were getting that 'fro as high as they could and the shirt was as wide as it could be; the image was definitely there.

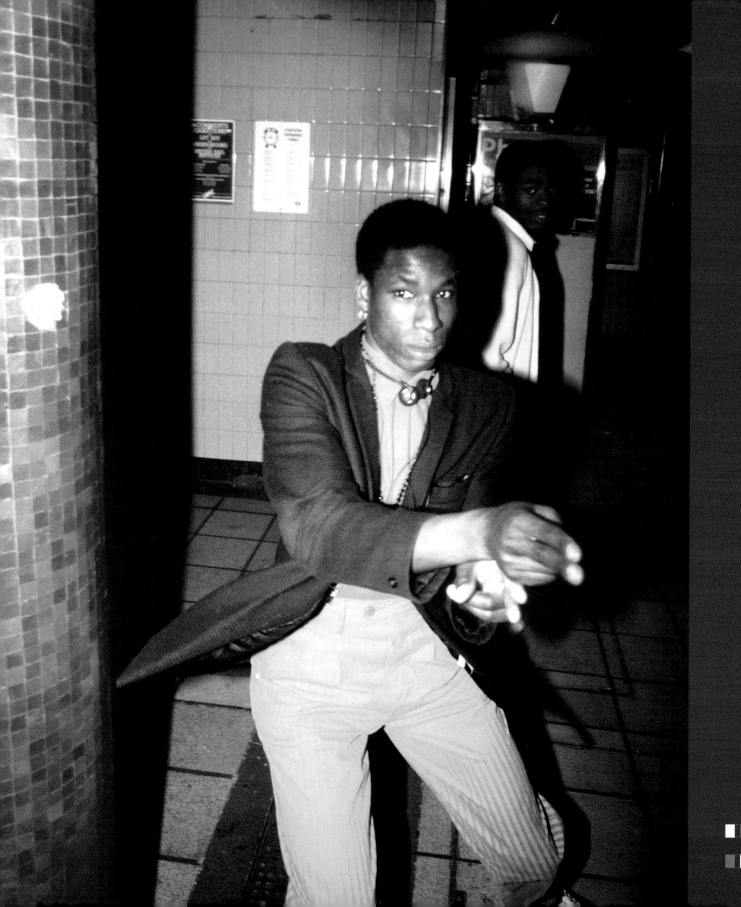

Brixton Tube station, 1986
Photographer: Normski

Stage 3, Old Kent Road, 1999
Photographer: Liz Johnson-Artur

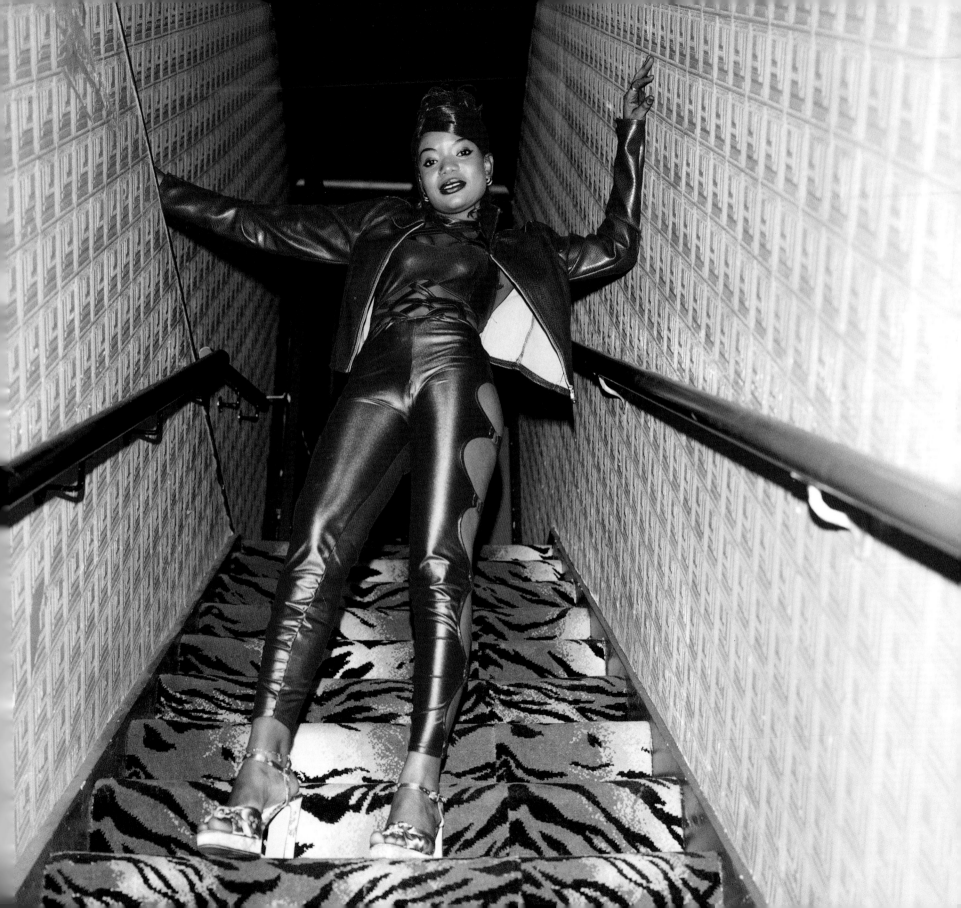

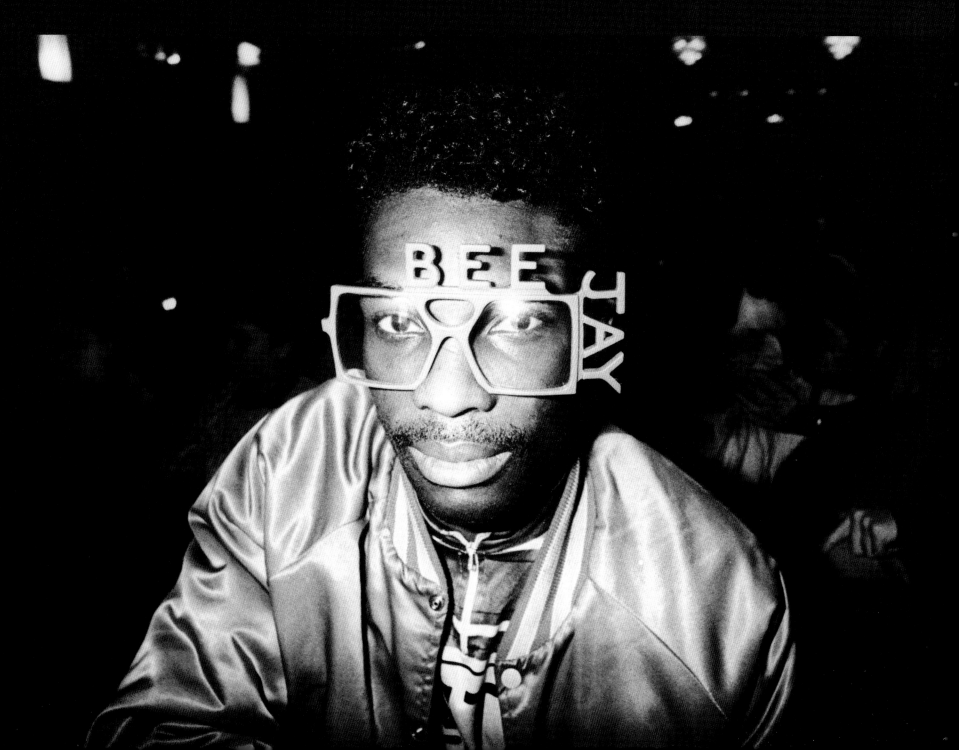

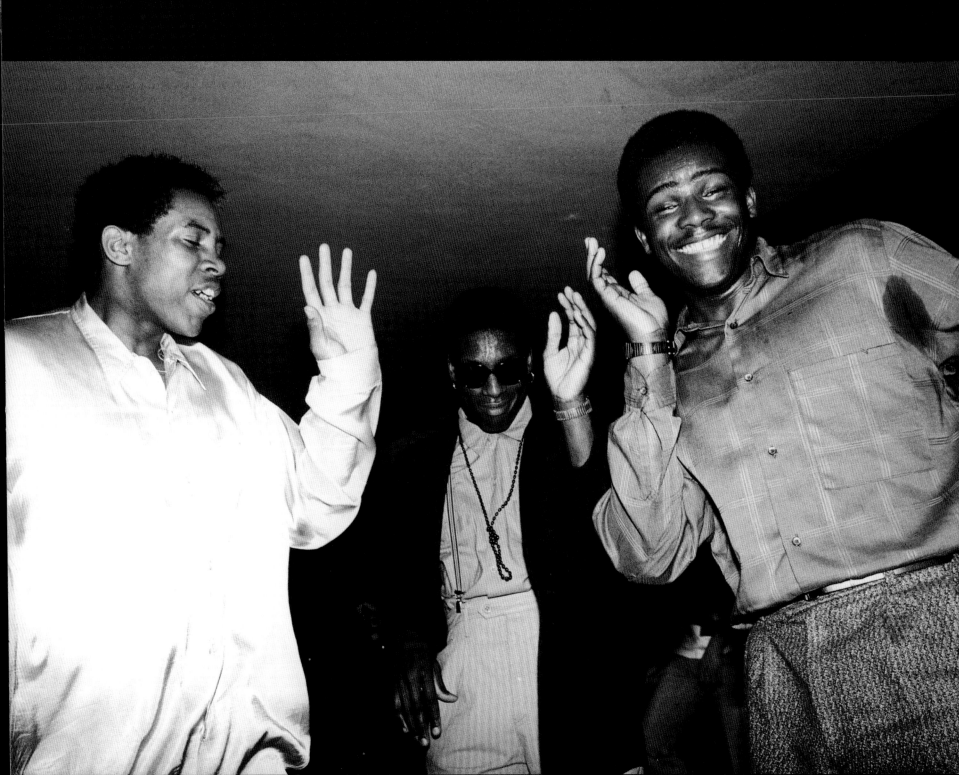

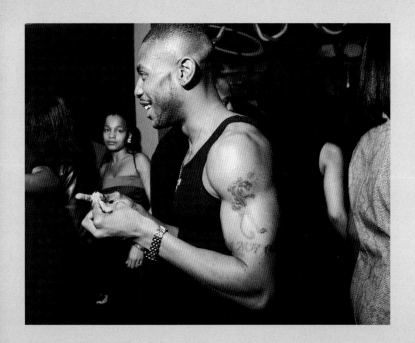

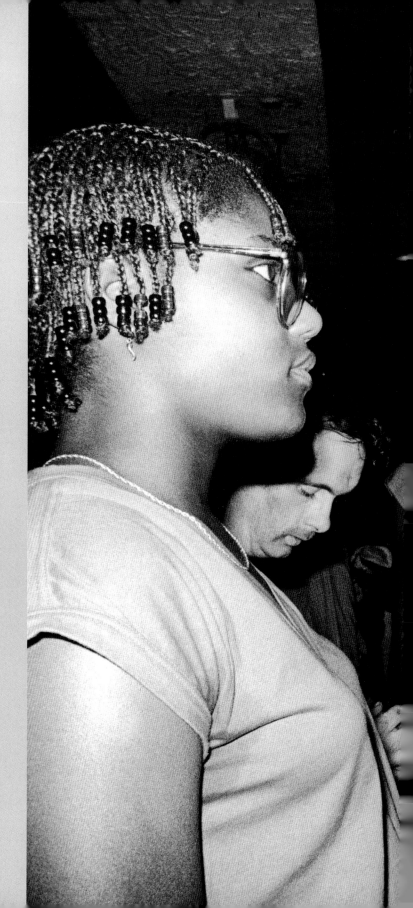

Twice As Nice @ The End, London, 2000
Photographer: Ewen Spencer

Shades Disco, Manor House, circa 1978
Photographer: Jill Furmanovsky

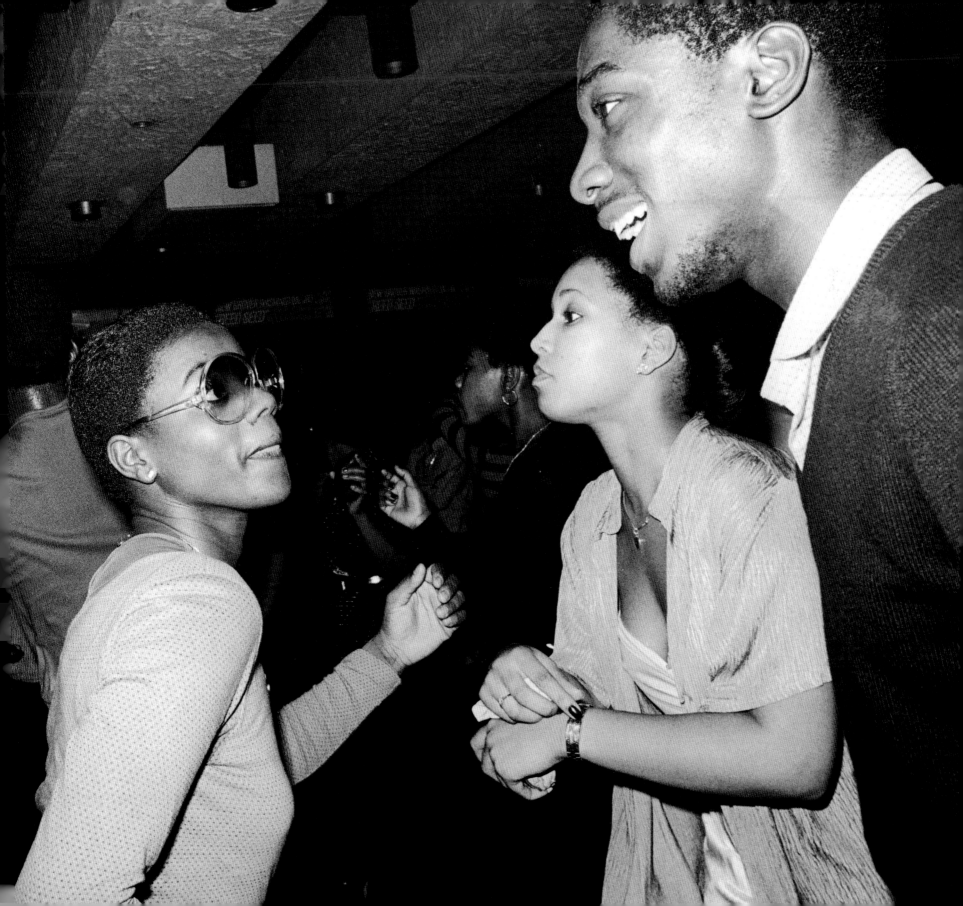

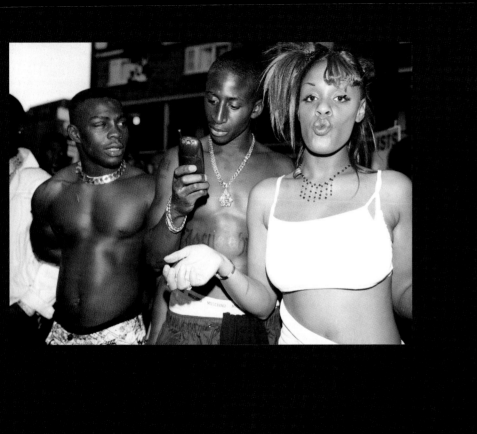

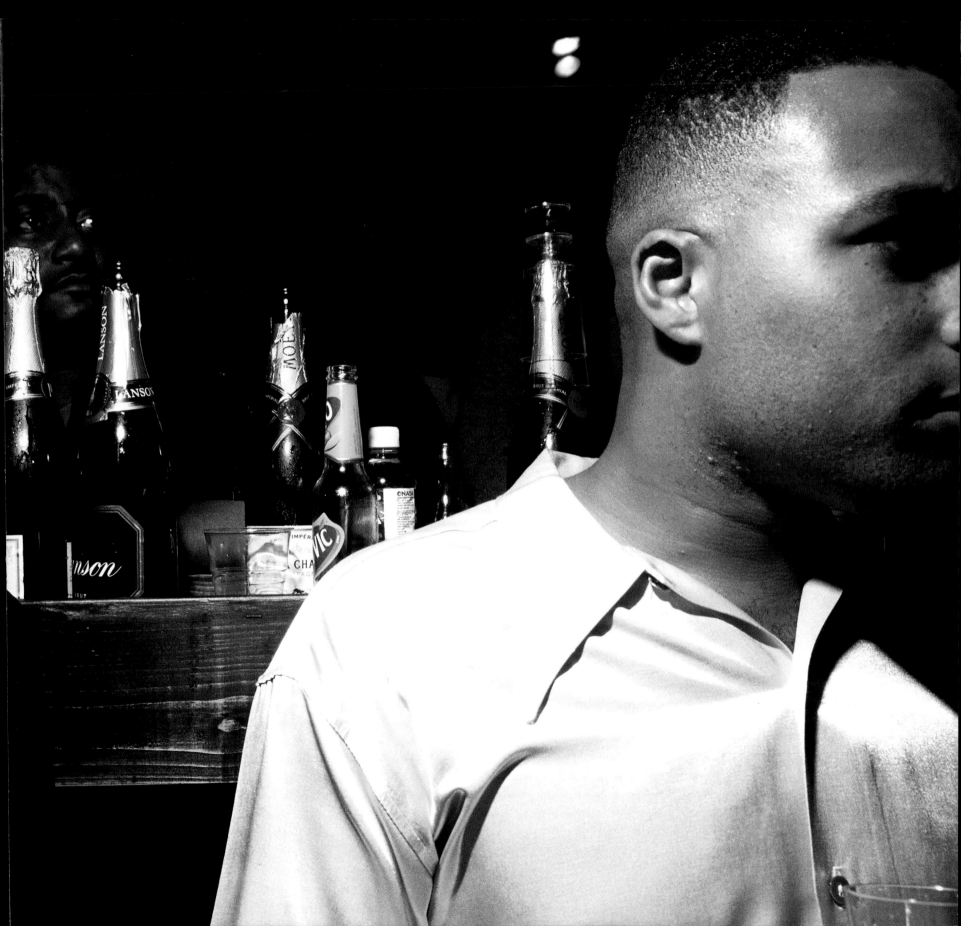

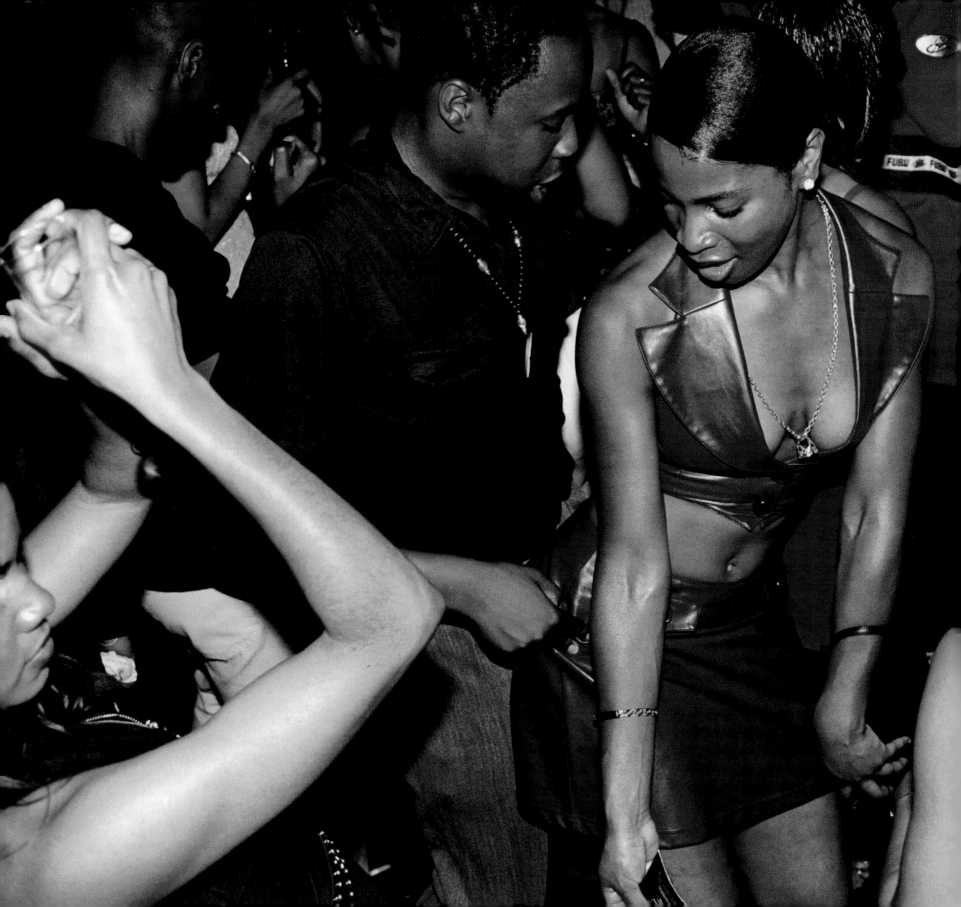

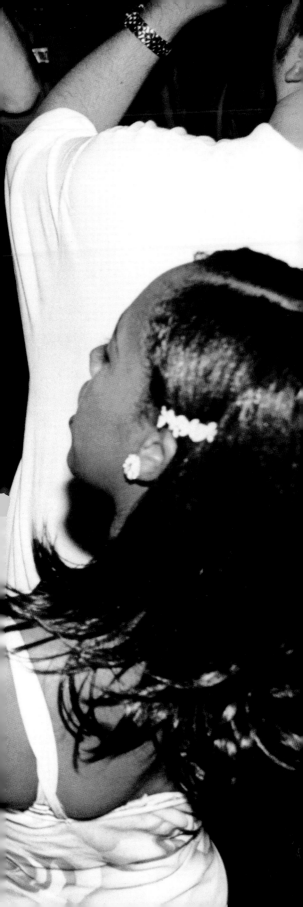

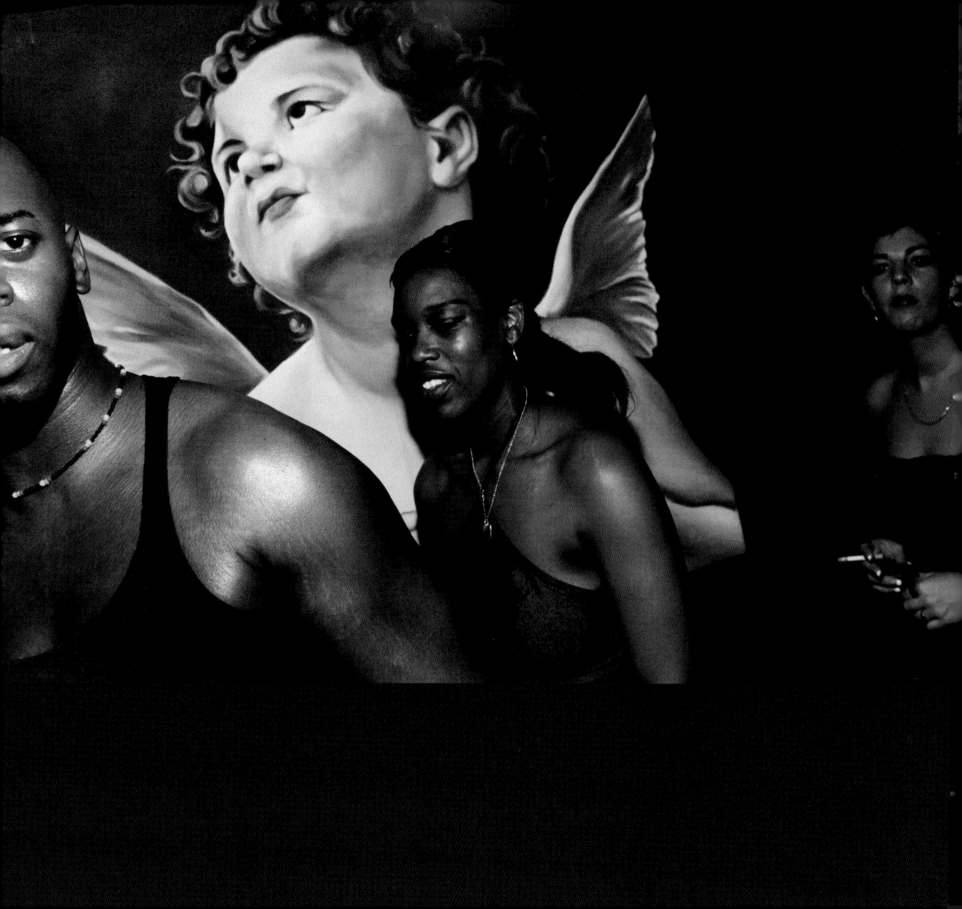

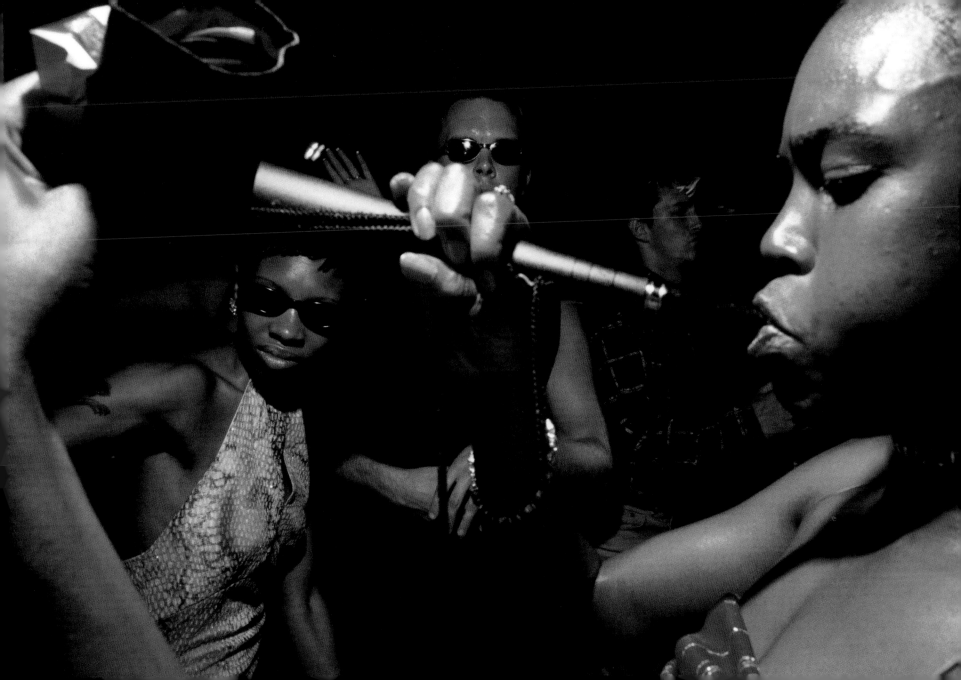

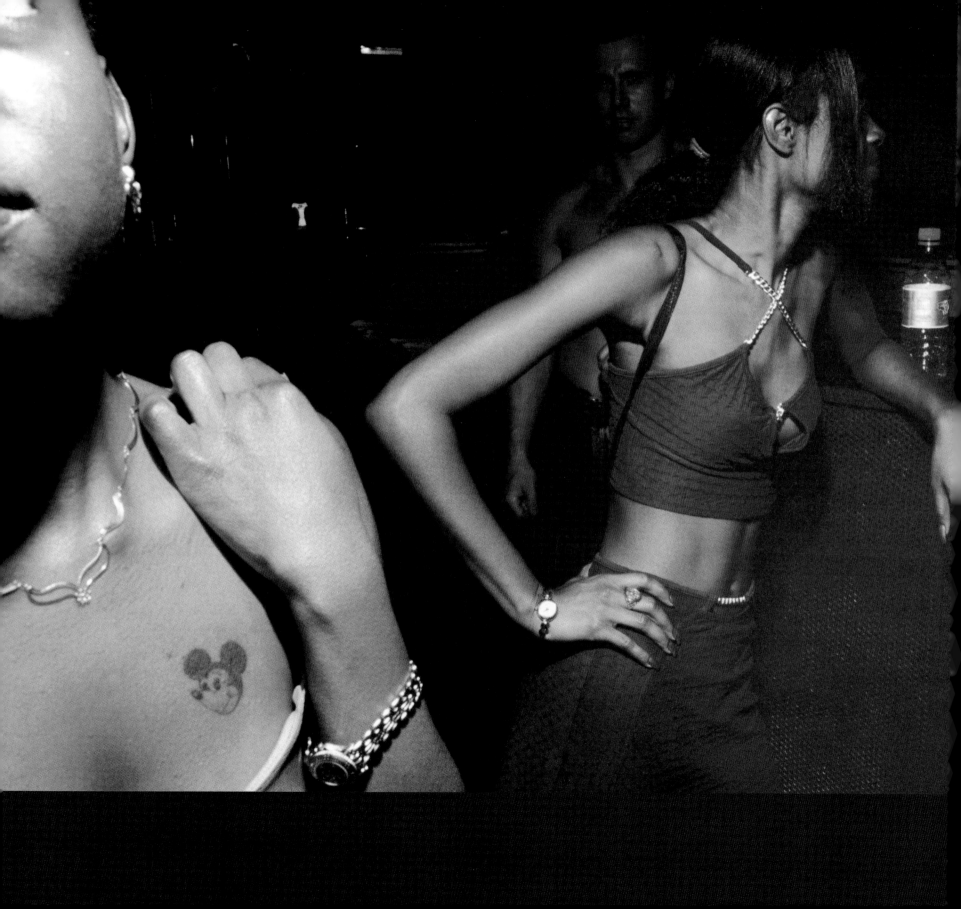

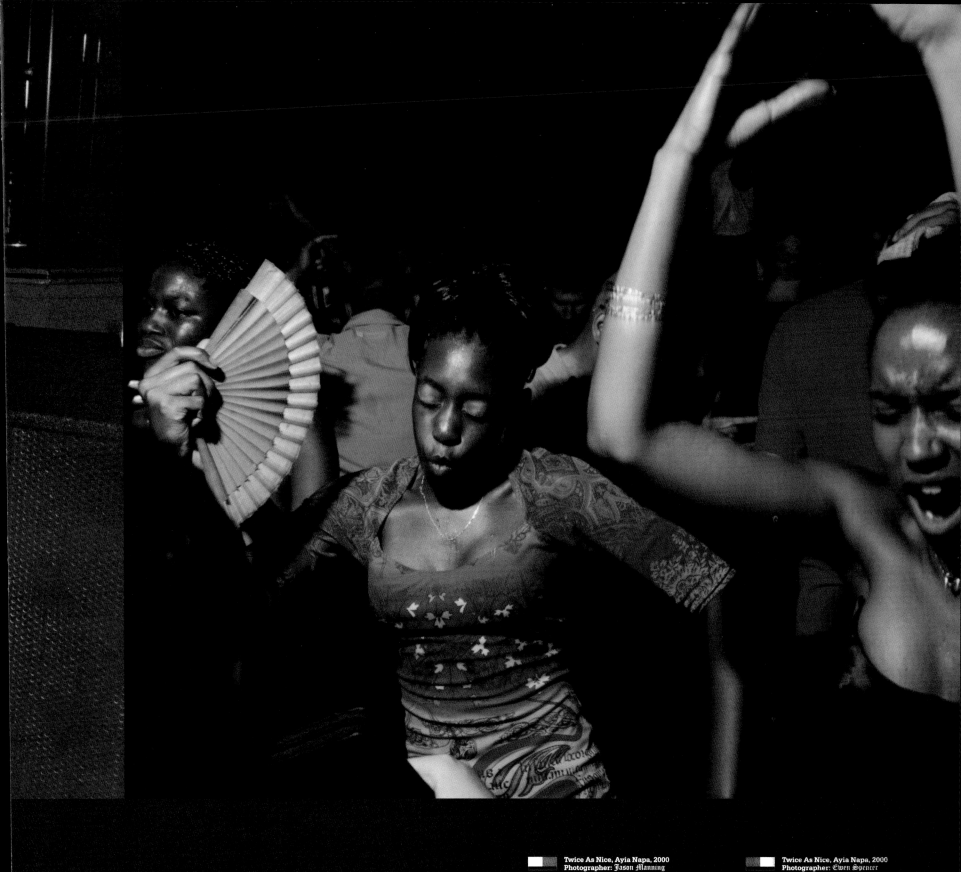

Twice As Nice, Ayia Napa, 2000
Photographer: Jason Manning

Twice As Nice, Ayia Napa, 2000
Photographer: Ewen Spencer

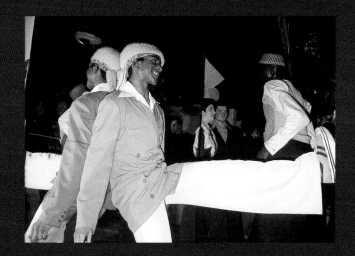

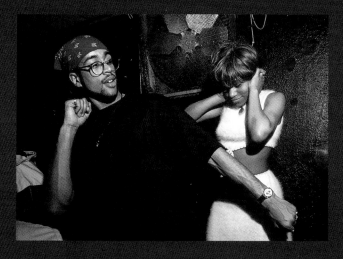

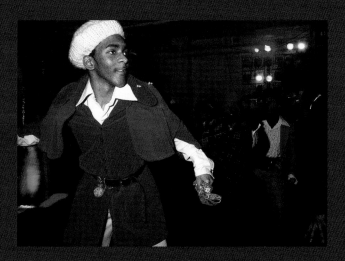

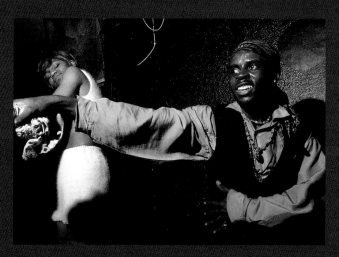

The Performance Club, London, 1988
Photographer: David Swindells

Carwash, London, 1988
Photographer: David Swindells

Funkin' Pussy, London, 1995
Photographer: David Swindells

Funkin' Pussy, London, 1995
Photographer: David Swindells

Pandemonium, London, 1988
Photographer: David Swindells

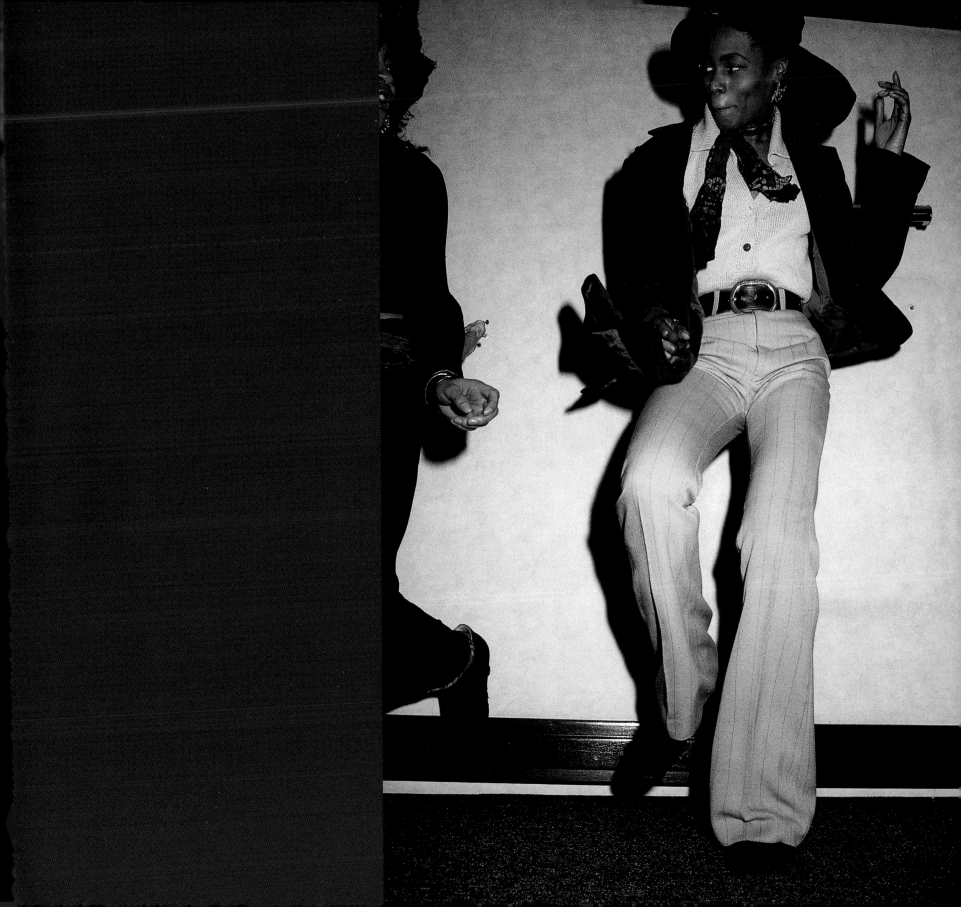

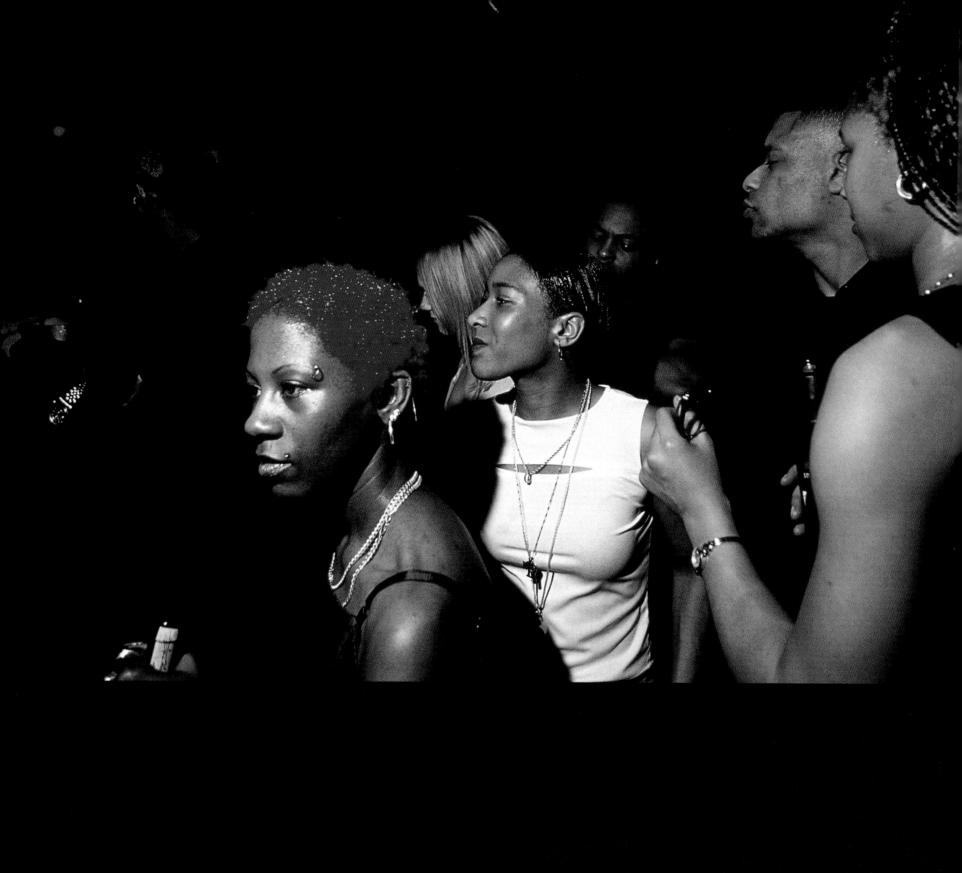

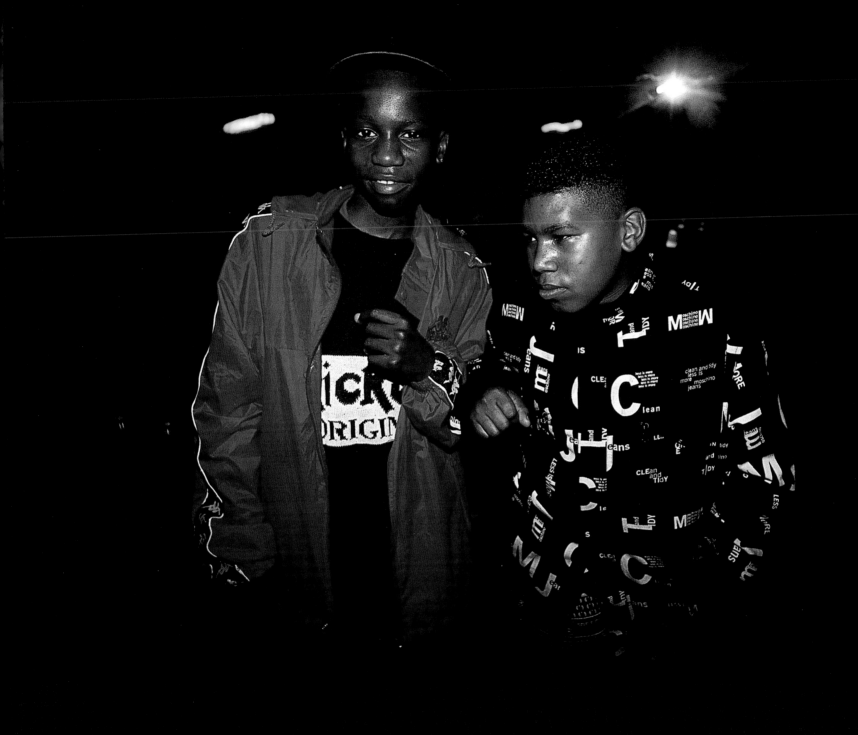

Twice As Nice @ The End, London, 2000
Photographer: Kamila Kicinska

Club It, Under 18 Night, Brentford, 1999
Photographer: Gordon Munro

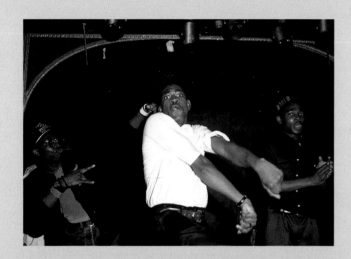

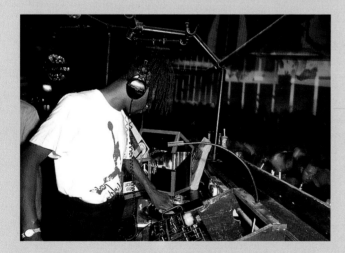

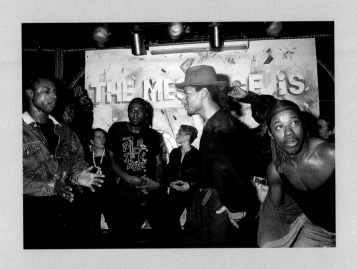
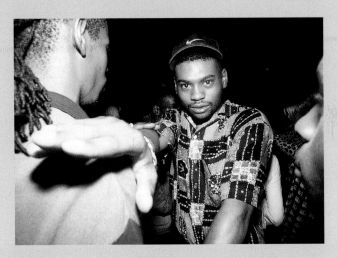
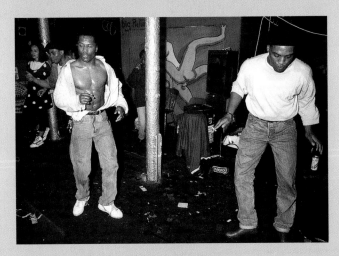
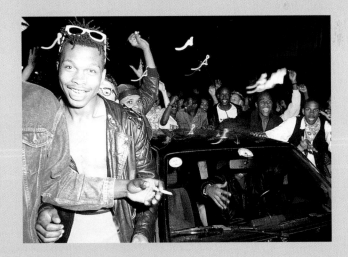

Twice As Nice @ The End, London, 2000
Photographer: Ewen Spencer

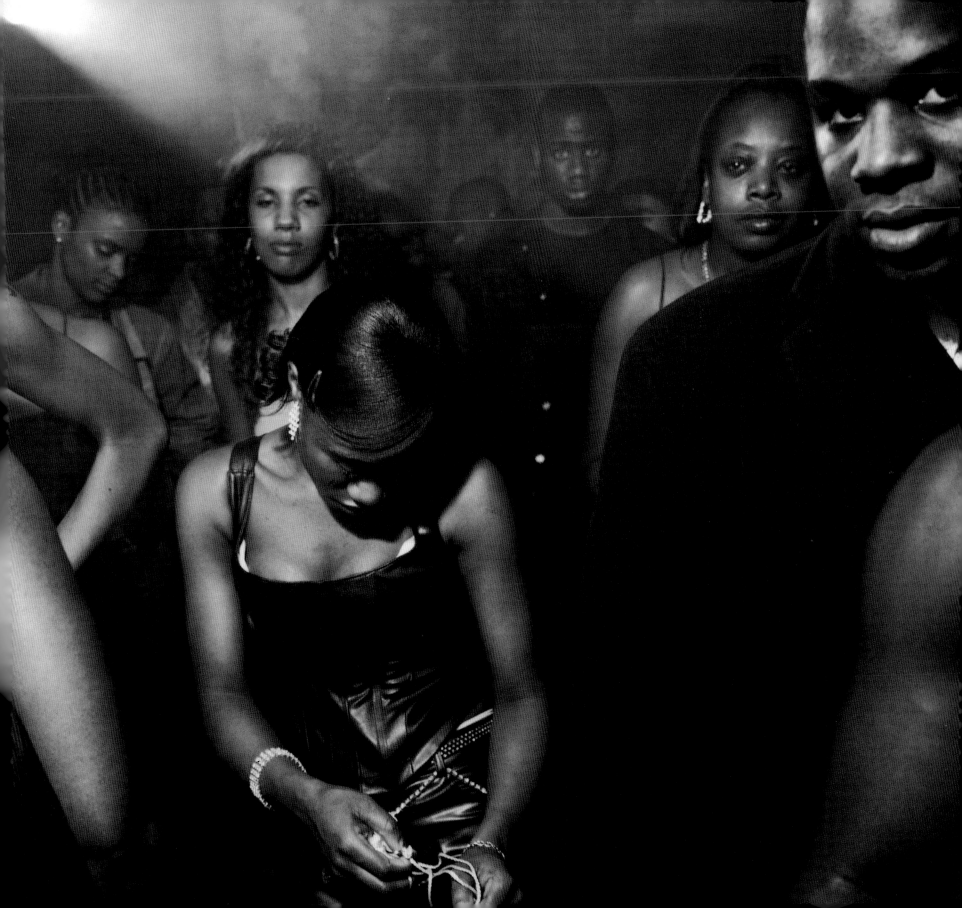

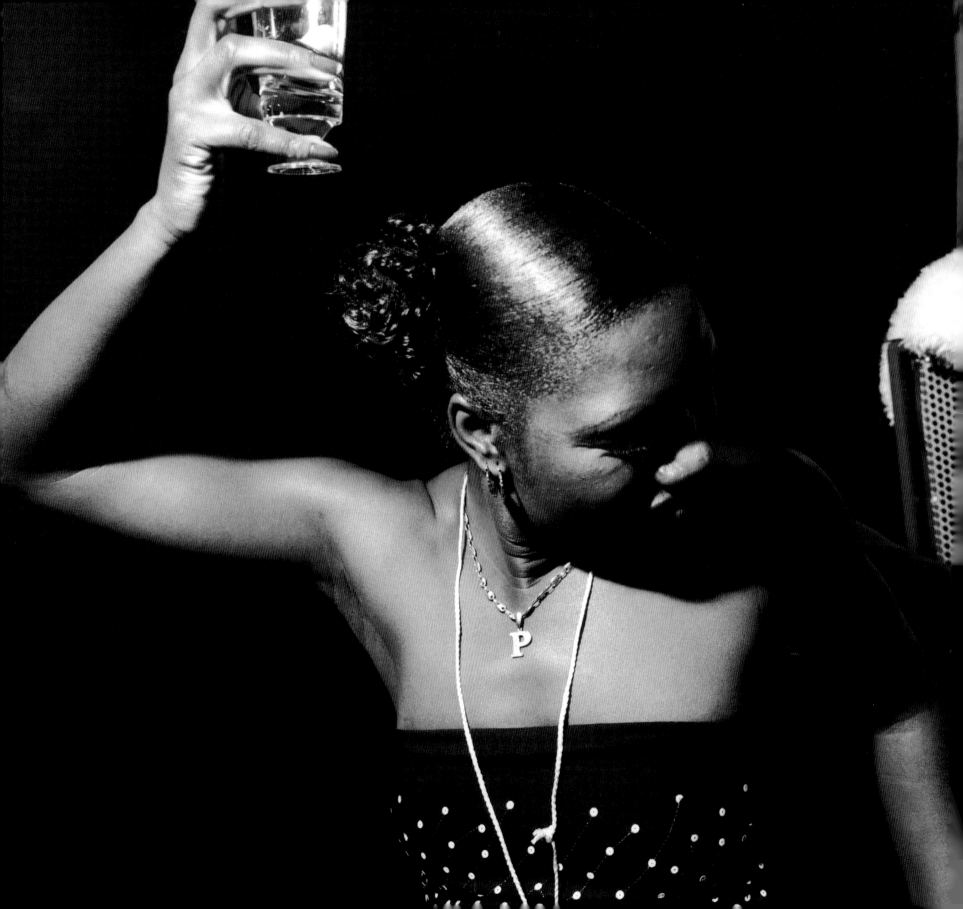

Twice As Nice @ The End, London, 2000
Photographer: Ewen Spencer

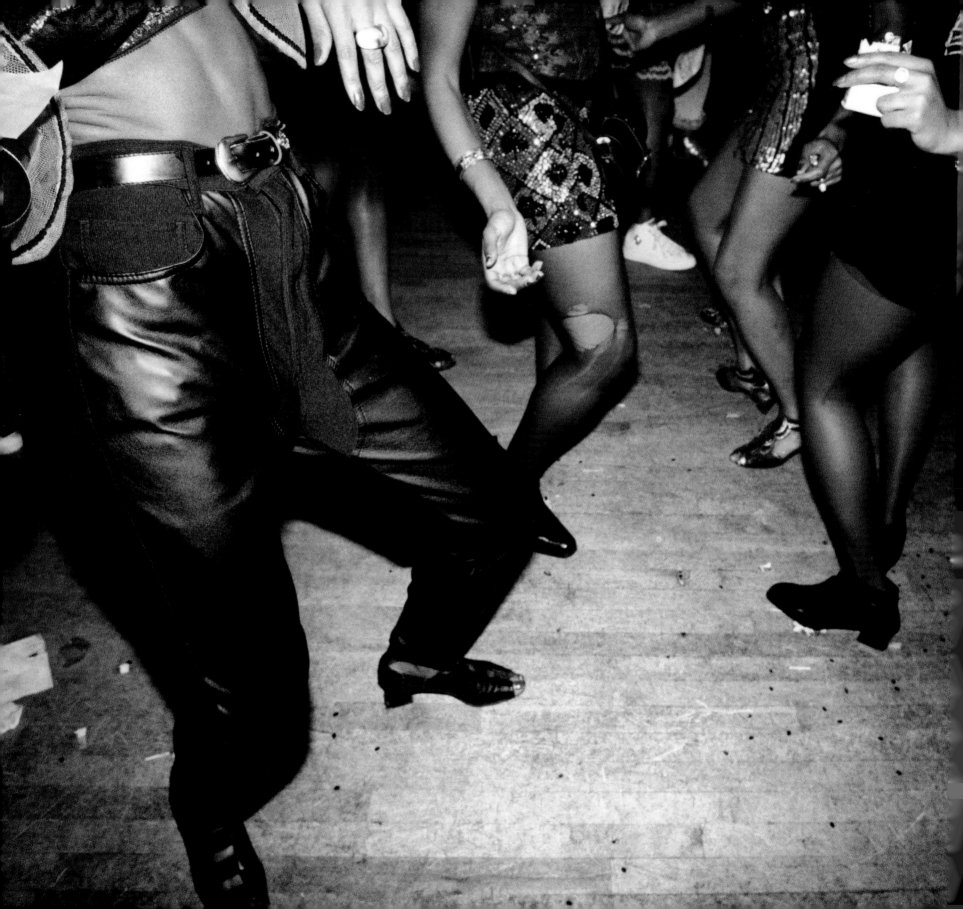

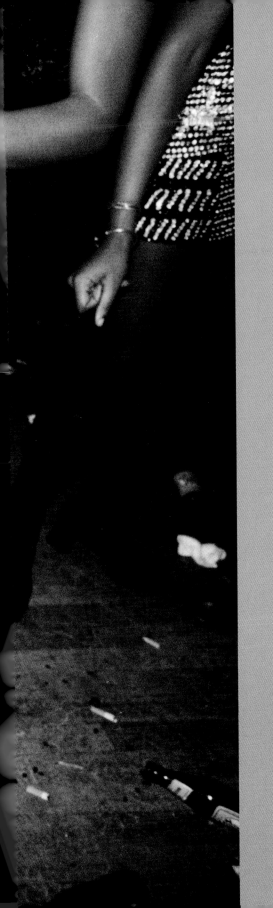

Reggae Dance, Hammersmith Palais, 1994
Photographer: Michael Williams

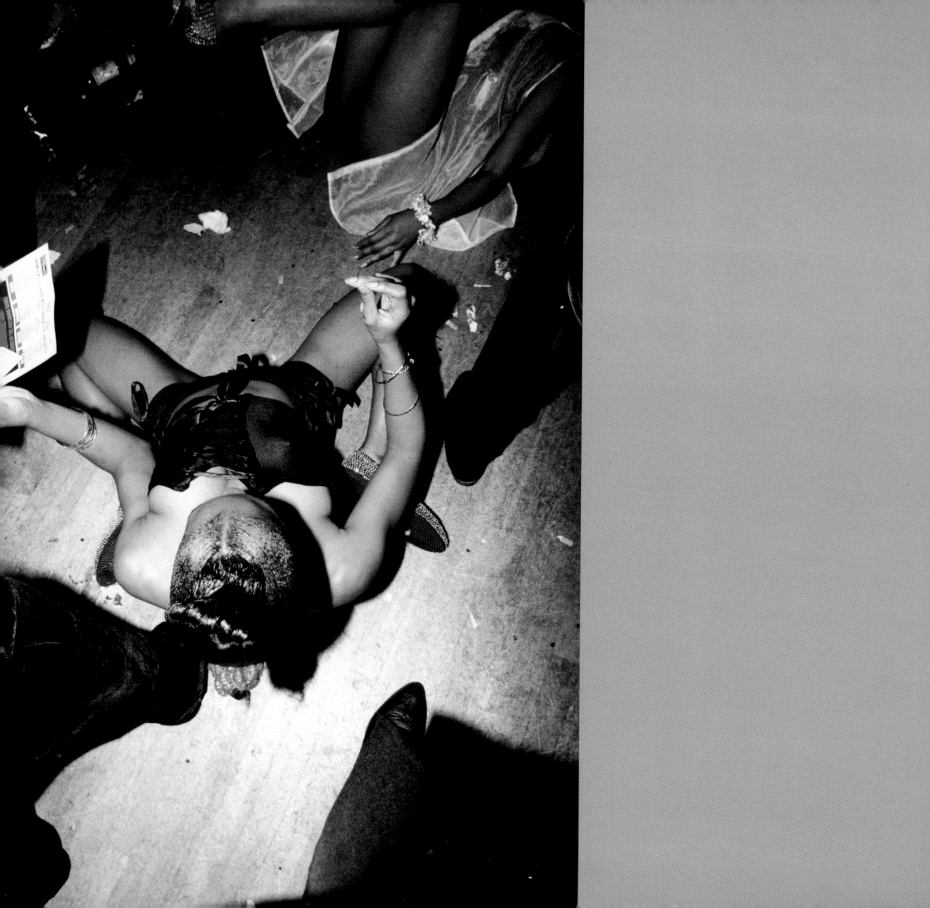

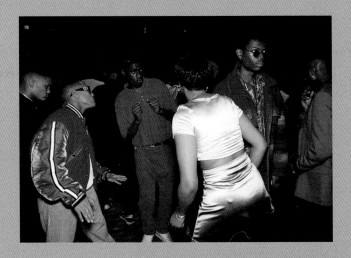

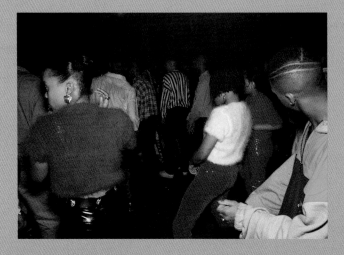

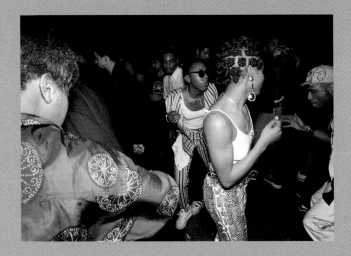

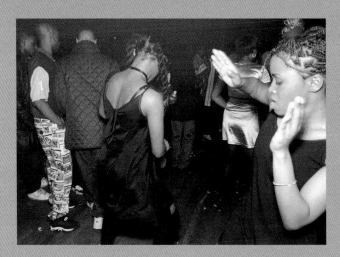

Voodoo Magic, The Empire, Leicester Square, 1995
Photographer: Michael Williams

Voodoo Magic, The Empire, Leicester Square, 1995
Photographer: Michael Williams

Voodoo Magic, The Empire, Leicester Square, 1995
Photographer: Michael Williams

Voodoo Magic, The Empire, Leicester Square, 1995
Photographer: Michael Williams

Reggae Dance, Hammersmith Palais, 1994
Photographer: Michael Williams

JuneSappong

I was always changing my hair. I went through everything, from the worst weaves to a big afro, to extensions, you name it.

I started going to clubs aged 16 in 1994 when I began doing work experience at Kiss FM. I'd go out from Thursday until Sunday night and somehow get up for Monday morning. My favourite clothes back then were Morgan, Jane Norman, Top Shop; really rubbishy high street stuff, that to me looked great.

Before that, during school days when I was 12 or 13 in the late 1980s, I was more of a shell-suit and Wallabees girl; it was multi-coloured jump suits and who had the best shell-suit. Kappa were the best, coolest ones, that's what all the older kids at school like my brother and his friends wore. But the problem was my mum wouldn't buy me Kappa so I had to make do with a dodgy old purple one from Walthamstow Market. To try and be cool I'd make sure I had the right shoes. So I'd have Wallabees, Kickers, Caterpillars and pink Reebok Aerobics with white netting on the top. And I was the first person in my area to get Air Jordans, because my dad lived

in America and he sent me a pair of the very first ones. Other people had them in red and black, but I was the first person to get them in blue and grey, which weren't available over here.

After shell-suits there were Ali Babas, the big trousers that all the girls used to wear. You'd wear those with a tight lycra top and Reebok Aerobics. You'd roll up your Ali Babas and have diamond socks underneath. The real diamond socks were the ones with the gold pin on them. I never had those; mine were two pairs for £5 from Walthamstow Market.

In about 1990, straight jeans came into fashion for girls, with vest tops; and leggings with a belly top. Throughout all that I was always changing my hair. I went through everything, from the worst weaves to a big afro, to extensions, you name it. For a stage I had really short, bleached hair, then I went to short relaxed hair, then I got a bit bored with that and grew it out into a big afro, which took two years. But after that I had it relaxed again and it was long. Then short styles started coming in when Jada Pinkett first cut her hair and all the girls were copying her, so I had that for a while.

When I turned 16 or 17, things kind of just changed. Whereas before, my friends and I were all wearing the same thing, suddenly it was about who could come up with the best outfits. So that's when we were wearing Morgan and Top Shop, Tammy Girl and River Island. For us, back then, those labels represented style; they were like our version of Gucci. But even today I'm not one of those people obsessed with labels. I always mix everything. I'll put on a pair of Jimmy Choo shoes or Manolos with a Top Shop t-shirt and if it looks good, as far as I'm concerned, it is good.

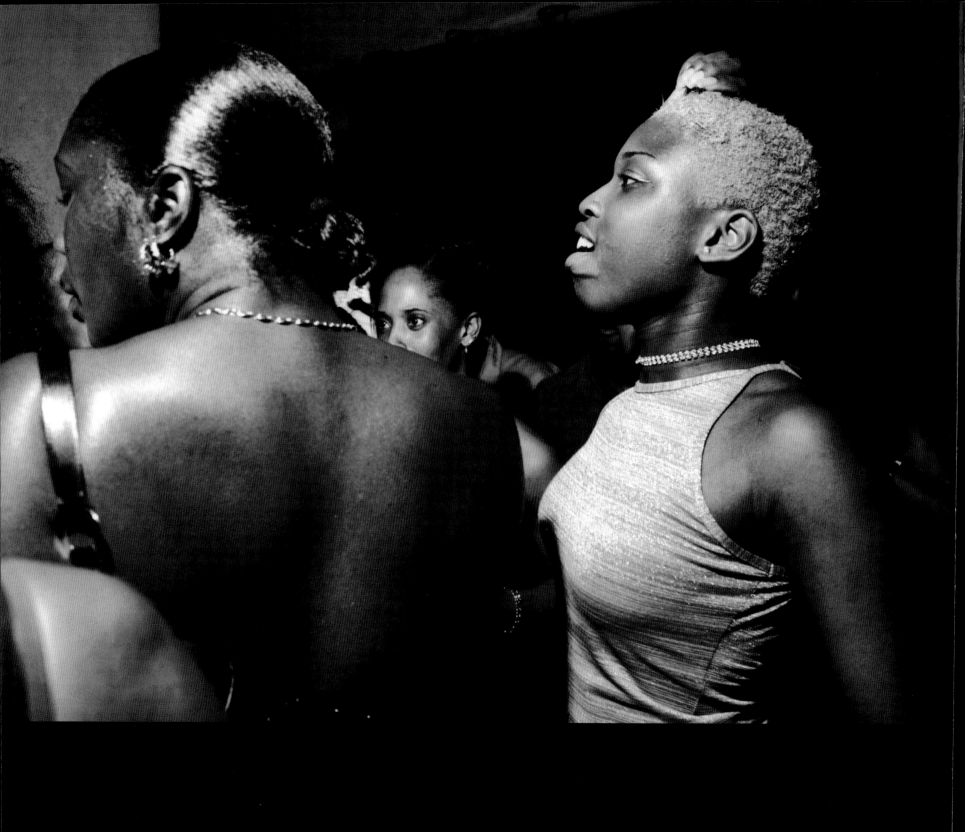

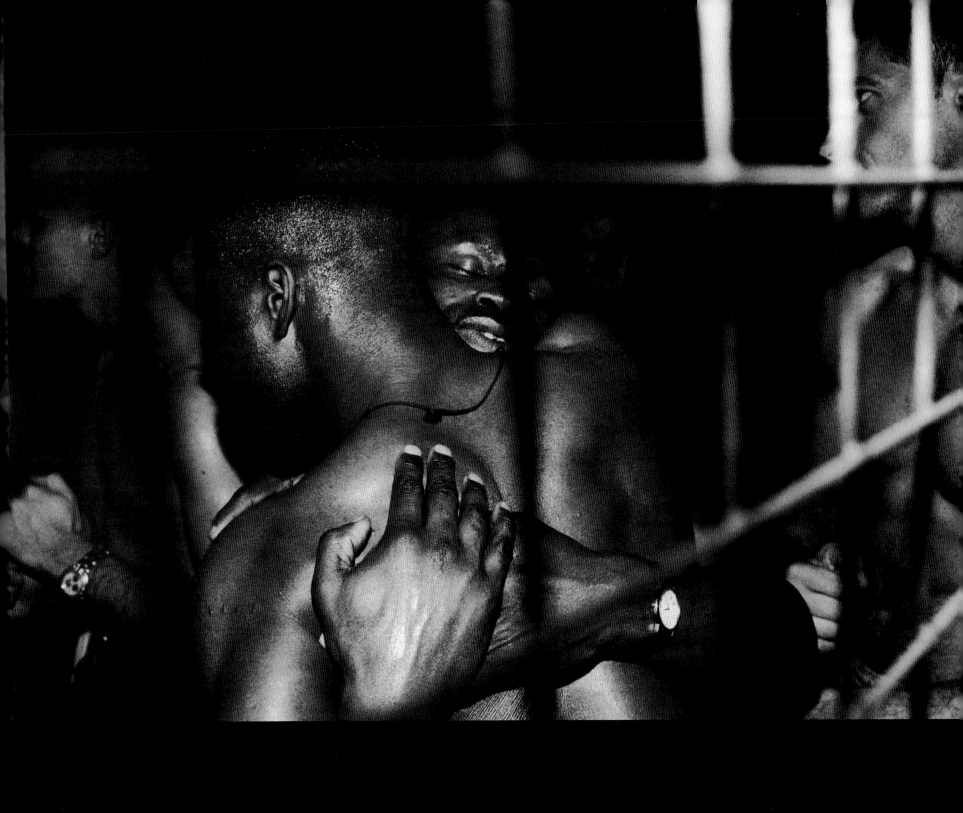

Old Kent Road, London, 2000
Photographer: Ewen Spencer

Queer Nation @ Substation South, Brixton, 1999
Photographer: Darren Regnier

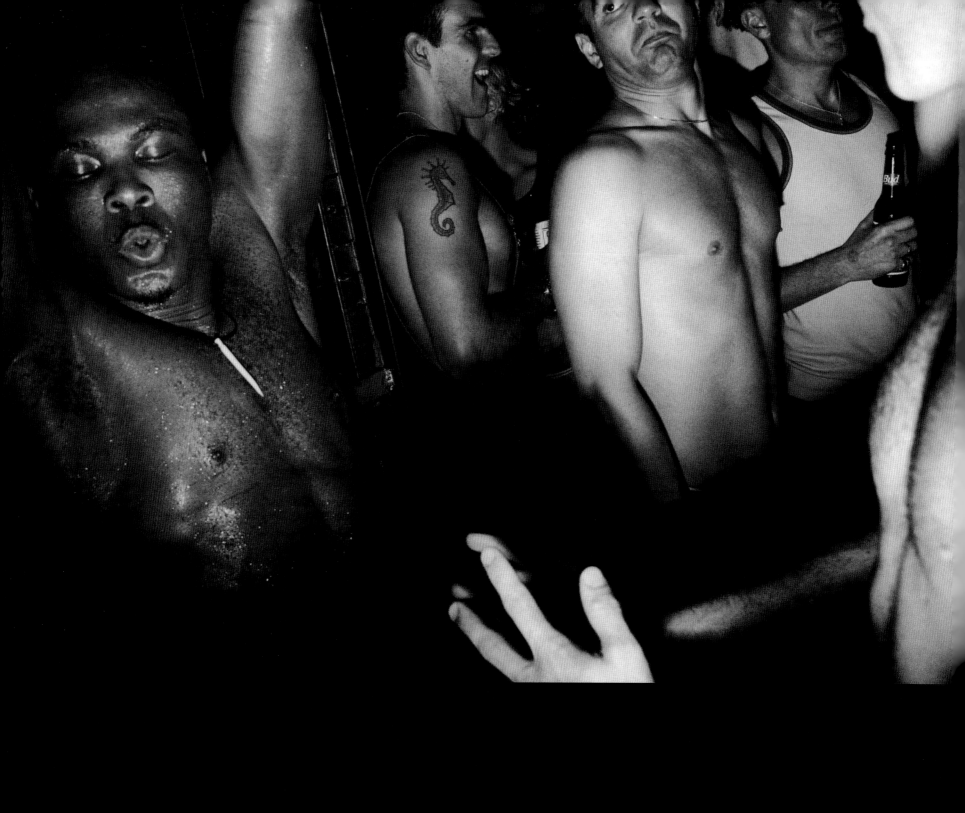

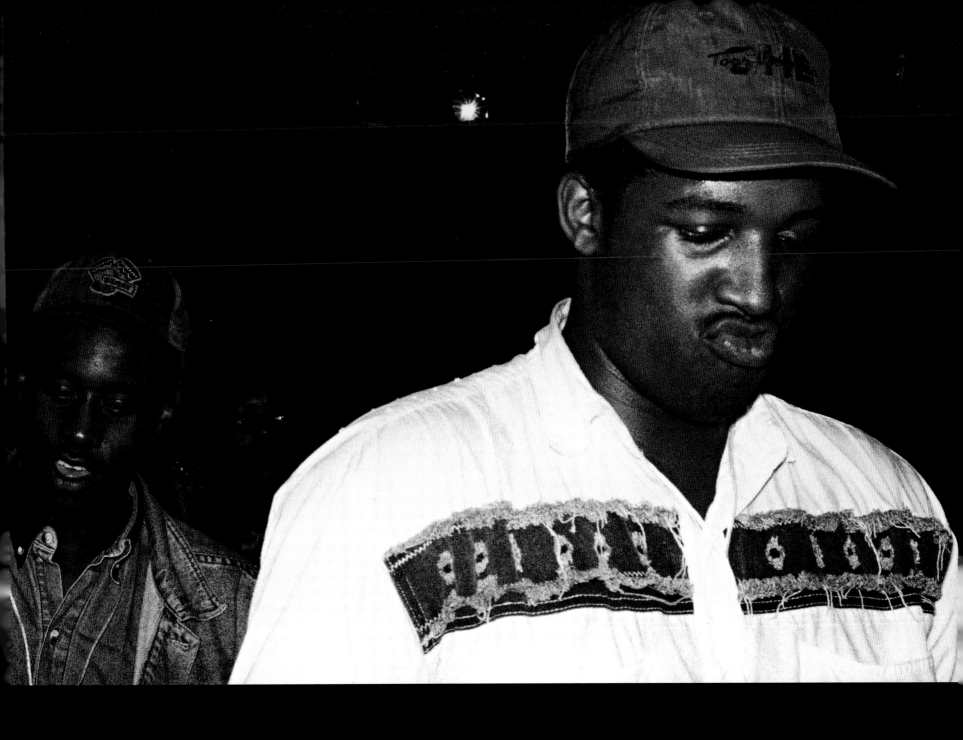

Queer Nation @ Substation South, Brixton, 1999
Photographer: Darren Regnier

Southport Soul Weekender, 1994
Photographer: Steve Lazarides

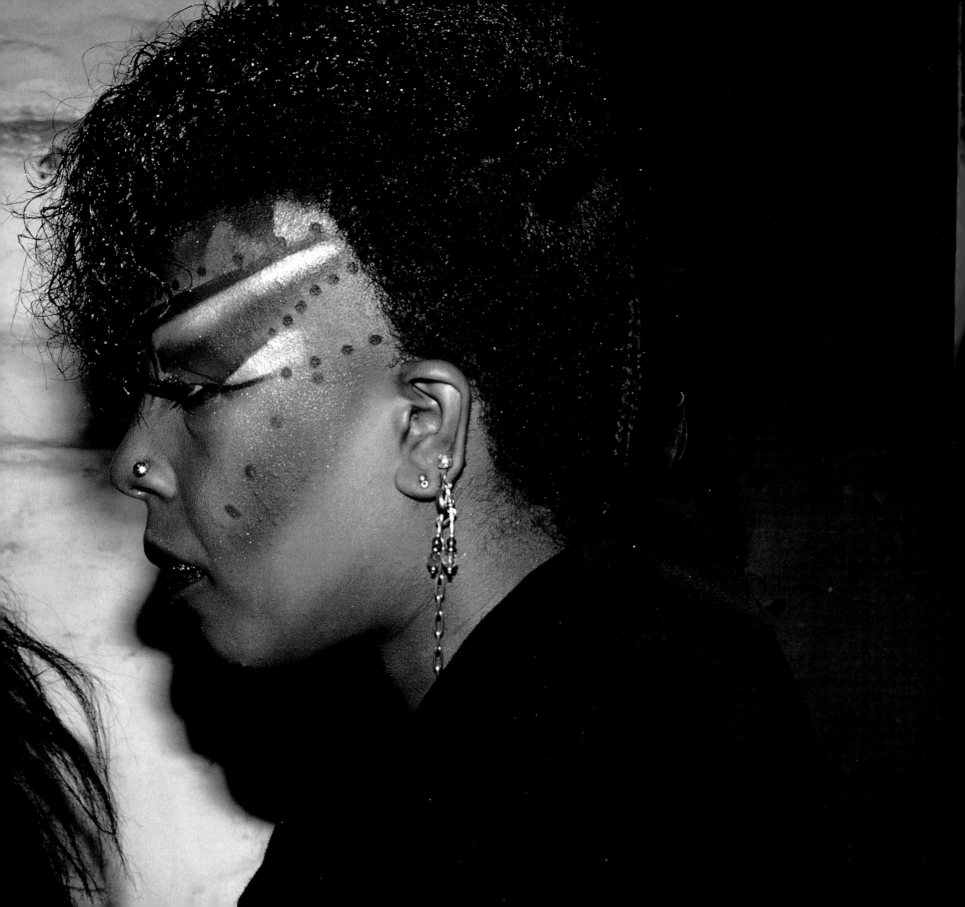

The Batcave, London, circa early 1980s
Photographer: Ted Polhemus

May Day Ball, Oxford, 2000
Photographer: Kamila Kicinska

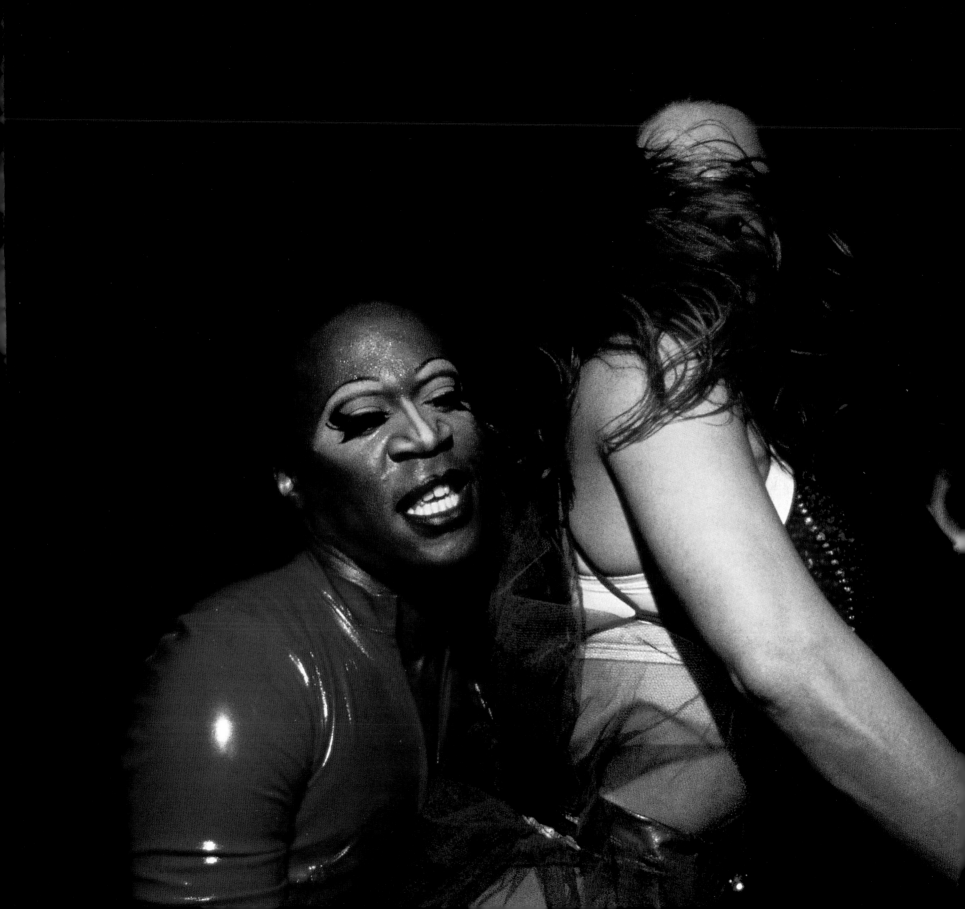

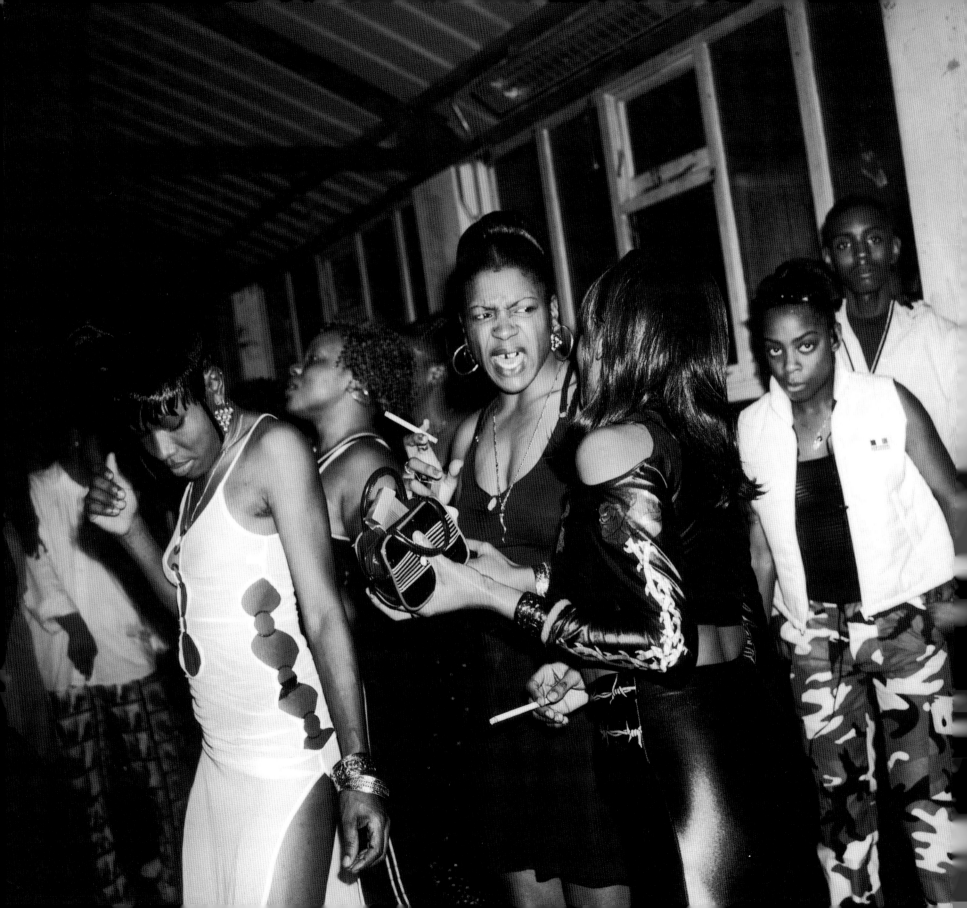

Harlesden, 1997
Photographer: Liz Johnson-Artur

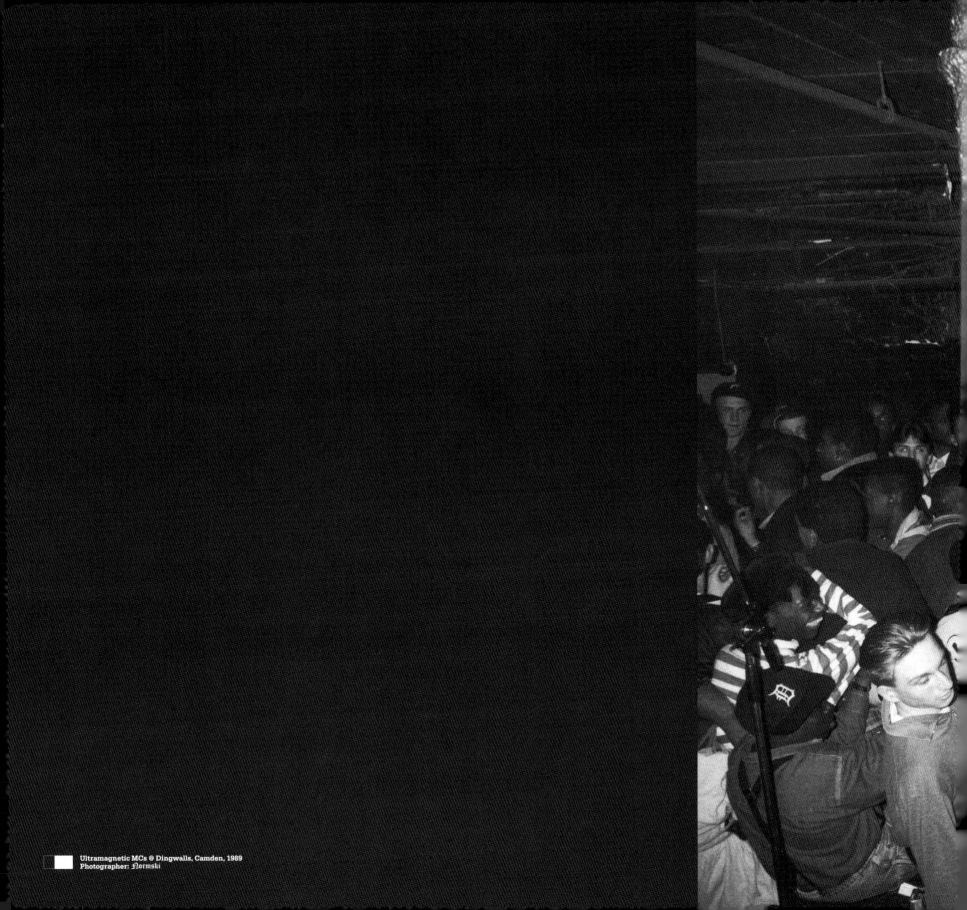

Ultramagnetic MCs @ Dingwalls, Camden, 1989
Photographer: Normski

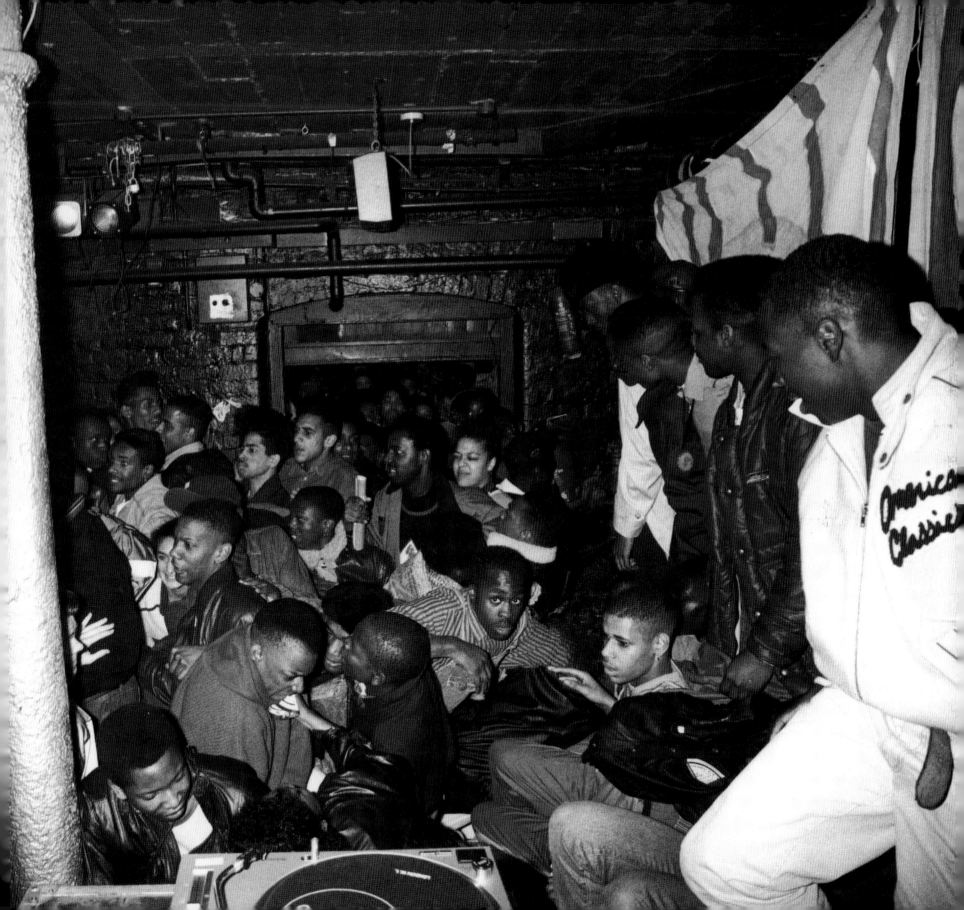

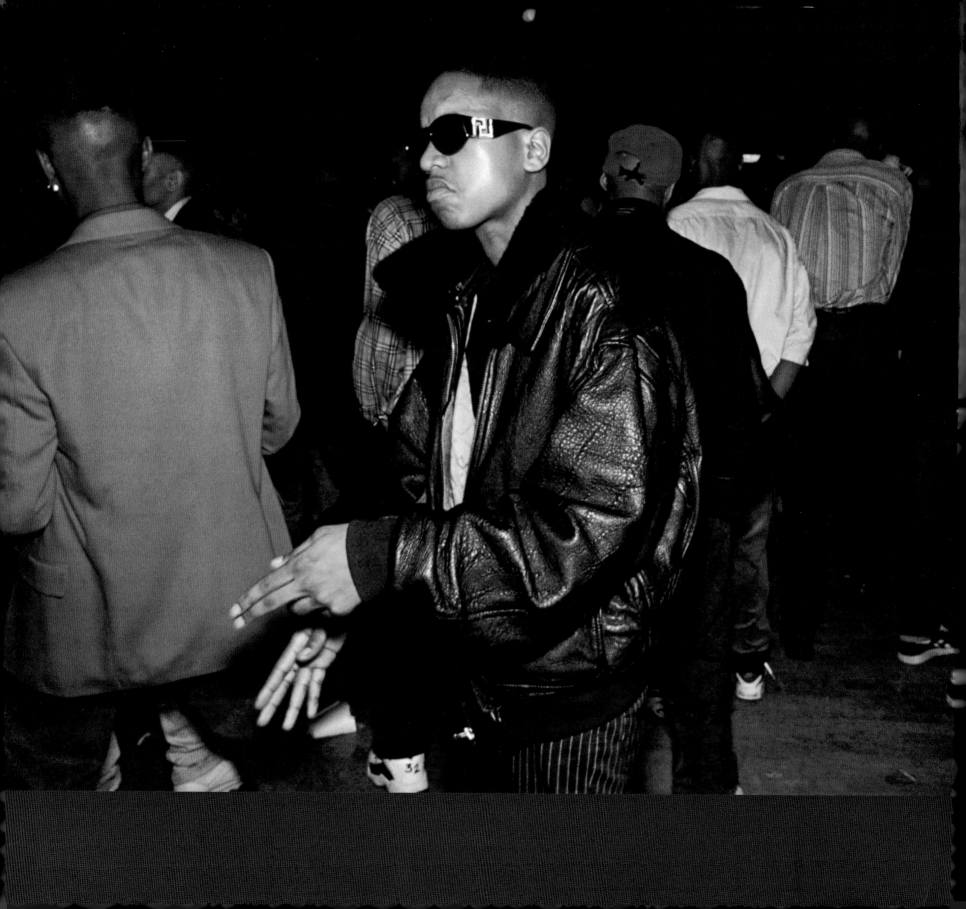

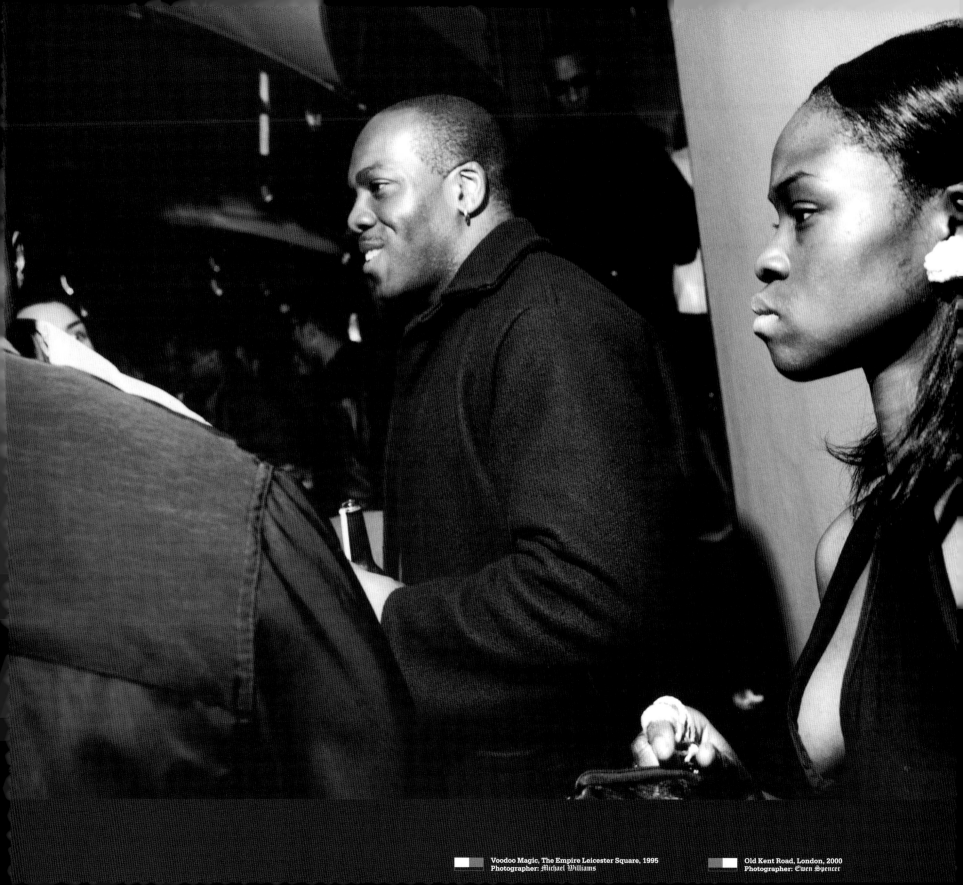

Voodoo Magic, The Empire Leicester Square, 1995
Photographer: Michael Williams

Old Kent Road, London, 2000
Photographer: Ewen Spencer

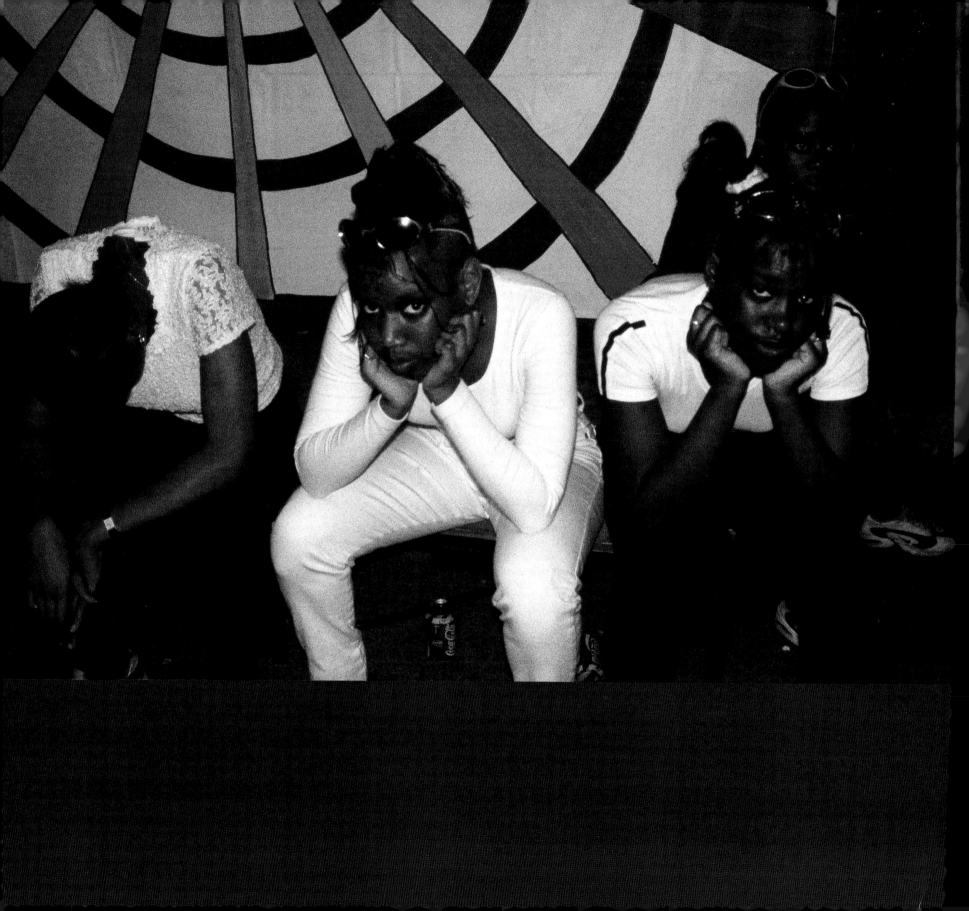

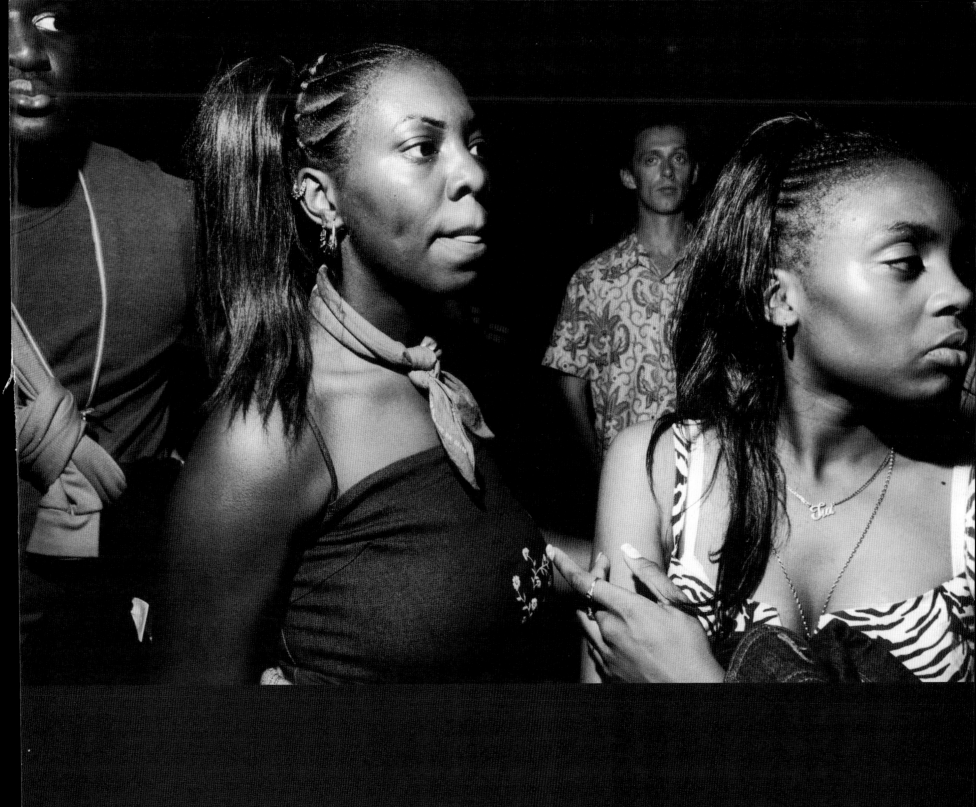

Under 18 Night, Kingston-on-Thames, 1996
Photographer: Courtney Hamilton

Notting Hill Carnival, 2000
Photographer: Jason Manning

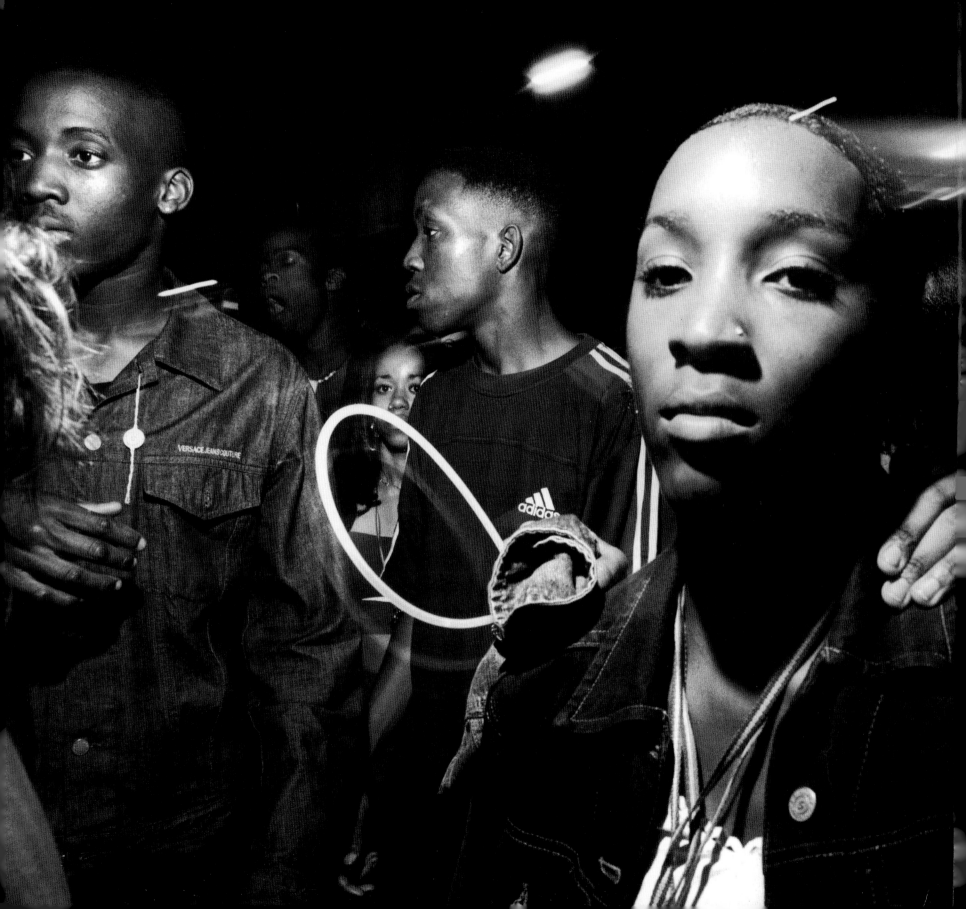

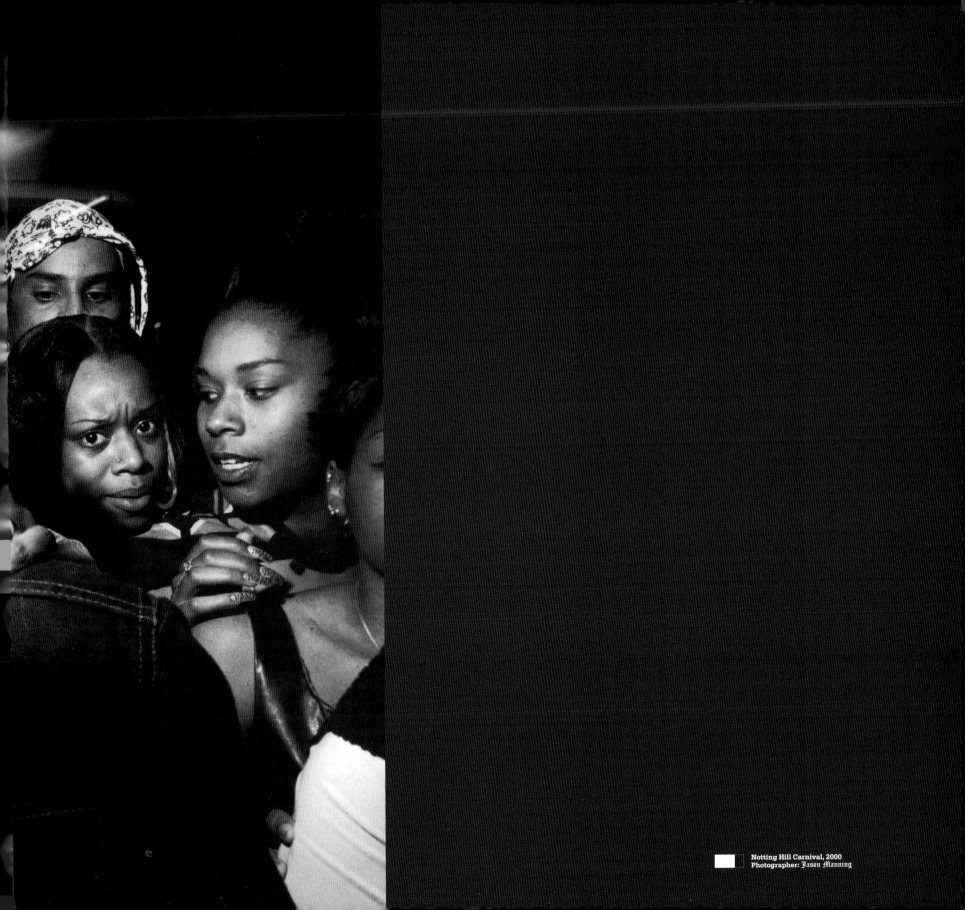

Notting Hill Carnival, 2000
Photographer: Jason Manning

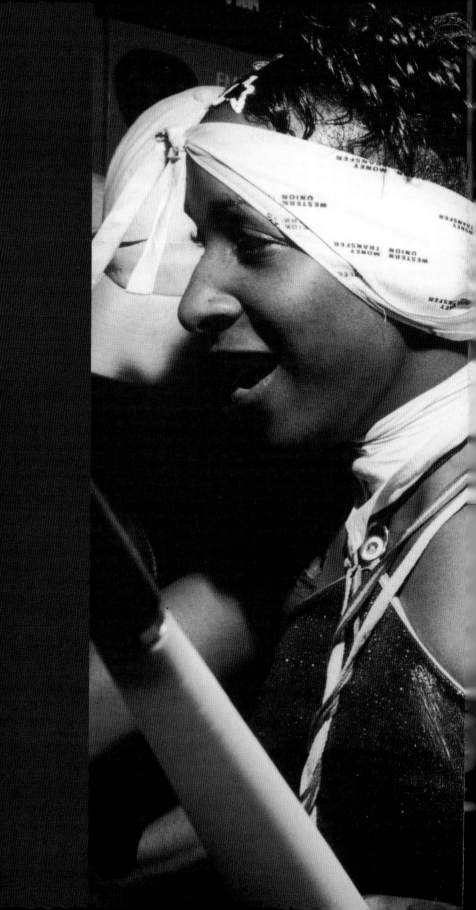

Notting Hill Carnival, 2000
Photographer: Jason Manning

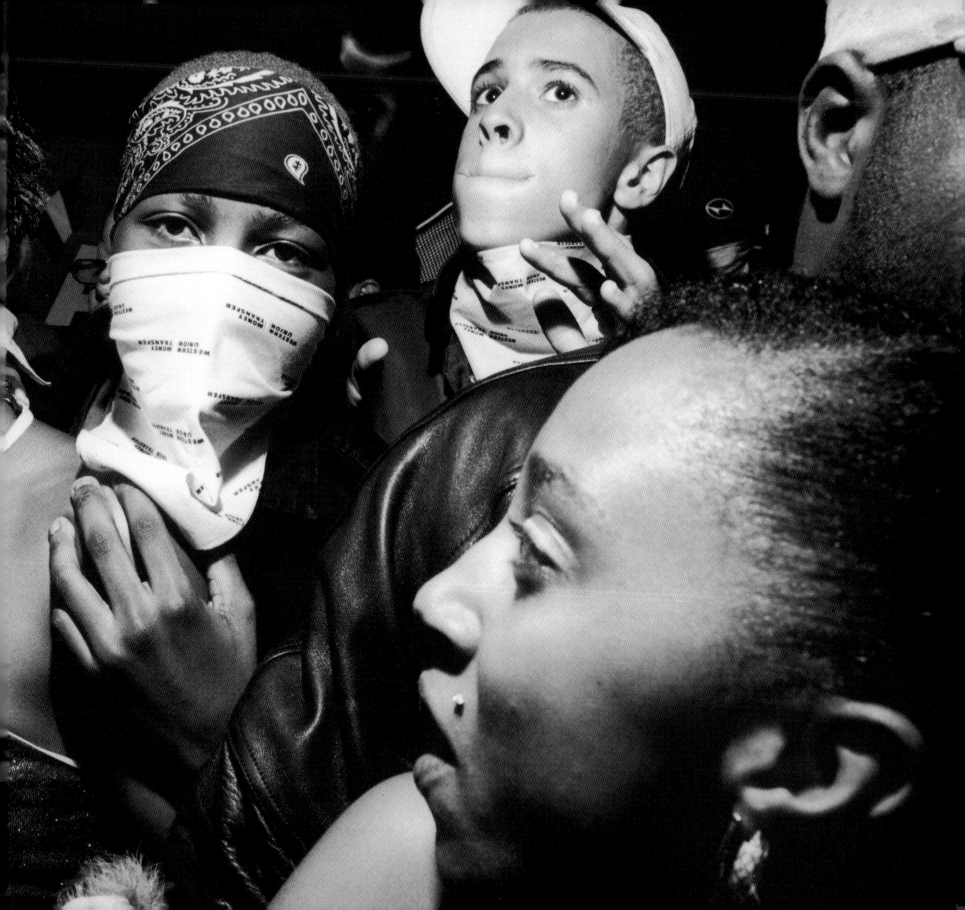

First published in 2001 by
Booth-Clibborn Editions Limited
12 Percy Street, London W1T 1DW
www.booth-clibborn.com

Compiled by **Steve Lazarides** and **Jake Cunningham @ PYMCA**
Project co-ordinated by **Dean Ricketts @ The Watch-Men Agency**
Design by **BigCorporateDisco**
Written by **Ekow Eshun**
Project managed by **Jon Swinstead @ PYMCA**
Edited by **Liz Farrelly @ Booth-Clibborn Editions**
Original concept by **Steve Lazarides**

With thanks to all the photographers and everyone else who made this
book possible, Norman Jay, Trevor Nelson, Spoony, June Sappong,
Tristan Dellaway, Justine Clayton, Steve Caesar, Steve Parkin,
Adam Dewhurst, Dave Hill, Ruth and Ian, Mark and Sian, Lola Wallace,
Tom Broadbent, Susana Vazquez-Liston, Gary Robson, Michael Powney,
Gerry McKeown at CDI , David Robinson, all the staff at PYMCA.

Cover picture: True @ Hanover Grand, March 2001
Photographer: **Jason Manning**

A Cataloguing-in-Publication record for this book
is available from the publisher.

ISBN 1-86154-217-8

Printed and bound in Hong Kong